D0743239

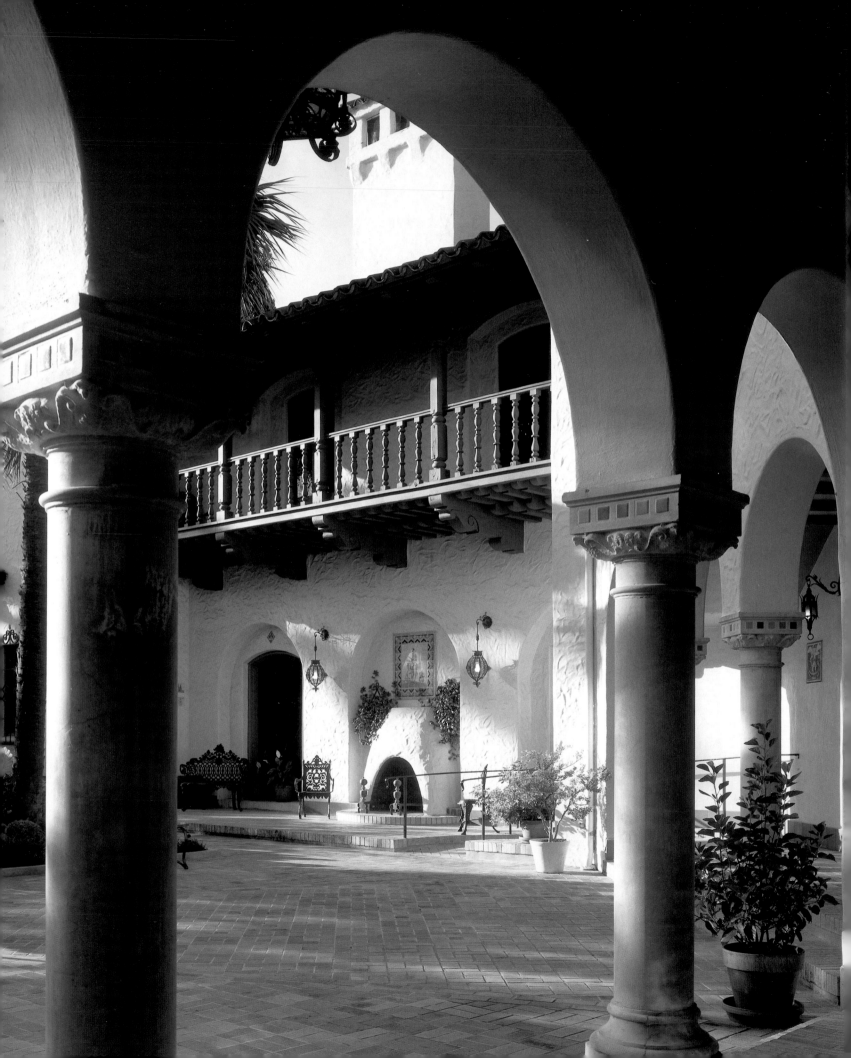

Modern Art at the McNay

A BRIEF HISTORY AND PICTORIAL SURVEY OF THE COLLECTION

With an introduction by

WILLIAM J. CHIEGO

TheMcNay

THE MARION KOOGLER MCNAY ART MUSEUM

San Antonio, Texas

McNay Art Museum
Board of Trustees

Trustees

Mr. W. Lawrence Walker, Jr.
— *President*

Mrs. Arthur T. Stieren
— *Vice President*

Mrs. L. Lowry Mays
— *Secretary*

Mr. Allan G. Paterson, Jr.
— *Treasurer*

Mrs. Michael Baucum

Mrs. William J. Block

Mr. J. Bruce Bugg, Jr.

Mr. Jonathan C. Calvert

Mr. E. H. Corrigan

Mrs. Ben F. Foster, Jr.

Mr. Thomas C. Frost

Mrs. Hugh Halff, Jr.

Ms. Karen Jennings

Mr. Walter Nold Mathis

Mr. William H. McCartney

Mr. Jesse H. Oppenheimer

Alice C. Simkins

Mr. Joe M. Westheimer, Jr.

Mr. Harold J. Wood

Honorary Trustees

Mr. Robert Halff

Mrs. Nancy B. Hamon

Mrs. Nancy B. Negley

Emeritus Trustees

Mr. Walter F. Brown

Mrs. George J. Condos

Mr. Alan W. Dreeben

Mr. George H. Ensley

Mr. Charles E. Foster

Mr. George C. Hixon

Mrs. H. T. Johnson

Jeanne Lang Mathews

Mrs. B. J. McCombs

Mr. Michael J. C. Roth

Ethel Thomson Runion

Mr. Thomas R. Semmes

Mr. Gaines Voigt

Advisory Trustees

Mrs. J. R. Hurd
— *President, Friends of the McNay*

Dottie Braunschweiger
— *Docent Chairman*

Contents

Preface

THIS BRIEF HISTORY AND PICTORIAL SURVEY of modern art at the Marion Koogler McNay Art Museum is the first comprehensive publication on the collection since the *Marion Koogler McNay Art Institute Selective Catalogue*, published in 1980 to mark the museum's twenty-fifth anniversary. From a total collection of nearly fourteen thousand works of art, some three hundred fifty were selected for this publication, one-third of them acquired since 1990. Whereas the *Selective Catalogue* was organized alphabetically, this volume has been arranged in roughly chronological order in two sections, one for European art, and one for American art. The motivating idea is to give the reader a sense of the range of the museum's holdings across all media, decade by decade, and to take advantage of the opportunity such a publication presents of bringing together on the page works that are seldom if ever seen together in the galleries.

This book was a collaborative effort of many staff members during a busy year of restoration and renovation of the original McNay mansion. The objects were selected by the curatorial staff, in their individual areas of expertise and responsibility; I made the selections for painting and sculpture prior to 1945. Thanks go to MaLin Wilson-Powell, Curator of Art after 1945 and Curator of Exhibitions; Linda Hardberger, Curator of the Tobin Collection of Theatre Arts; and Lyle Williams, Curator of Prints and Drawings, for their contributions. The decision to include or exclude works of art was often difficult, and many more objects were worthy of inclusion. Quality and representativeness were the final criteria; the intent is to show the best works and to accurately reflect the collection's greatest strengths.

I am grateful to Ann Millett, Semmes Foundation Curatorial intern for 2000–2001, who initiated work on this book as one of the key projects of her year at the McNay.

She drew up countless lists as we added or deleted objects before reaching a reasonable corpus.

My particular thanks go to Heather Lammers, Collections Manager, who undertook the daunting task, with photographer Michael Jay Smith, of producing photographs that would assure high-quality reproductions. She also oversaw the accurate recording of the information for the captions of each work. I am grateful to James Beach, Assistant to the Collections Manager, who re-measured all the paintings and assisted Lyle Williams in performing that even larger task for the prints and drawings collection. I am also indebted to Linda Hardberger and Curatorial Assistant Lisa Endresen for gathering information on the theatre arts collection.

For their assistance in editing the brief history of the collection, I thank the curatorial staff as well as Rose Glennon, Curator of Education. Finally, this project has been aided every step of the way by my assistant, Melissa Lara Castellon, who carefully prepared the essay manuscript with assistance from Capital Campaign Coordinator Linda Valencia.

A collection such as the McNay's is not built in a day, and I am therefore indebted to all the board members and staff of the McNay since the museum was founded over fifty years ago. Following in the path set by Marion Koogler McNay, and with the support of our members and friends near and far, the McNay has become one of the finest and most distinctive museums of modern art in the nation.

WILLIAM J. CHIEGO
Director

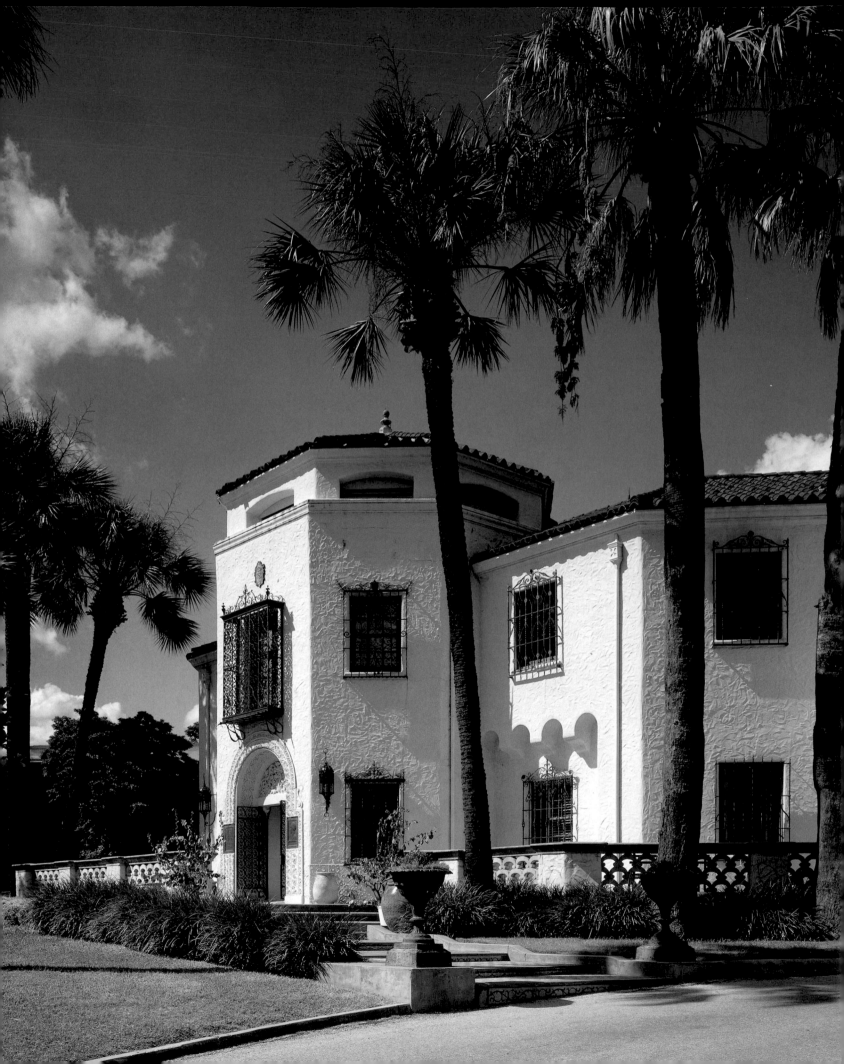

WILLIAM J. CHIEGO

A Brief History of the Collection

THE MARION KOOGLER MCNAY ART MUSEUM was established in 1950 by the will of Marion Koogler McNay (1883–1950) as the first museum of modern art in Texas. Founded for "the advancement and enjoyment of modern art," the museum on its opening in 1954 was fortunate to begin with Mrs. McNay's superb collection of European and American art, her beautiful Spanish Colonial–revival style mansion, and twenty-three acres of surrounding gardens. Although she built one of the most important private art collections and a notable private residence in Texas, Mrs. McNay was not a native of the state. Born Jessie Marion Koogler in DeGraff, Ohio, she was the only child of Dr. and Mrs. Marion Koogler. Her physician father went to work for the Santa Fe Railroad when Jessie was a young girl, and she spent most of her youth in El Dorado, Kansas. The town's name was prophetic for the Kooglers, for while living there, Dr. Koogler acquired several thousand acres of land on which oil was discovered, thereby making the family's fortune.

Marion—as she later chose to be called —enrolled at the University of Kansas where she began her study of art; she then attended the School of the Art Institute of Chicago from 1903 to 1905, and again from 1911 to 1913. After her father's retirement from the railroad, the family returned to Marion, Ohio, and she distinguished herself as an art supervisor for the city schools.

At this time, during World War I, she met and fell in love with Don Denton McNay. Although he had enlisted in the army, they married in 1917 and moved to his posting in Laredo, passing through San Antonio. After only ten months

together, McNay was sent to Florida before assignment overseas, and there he succumbed to the worldwide influenza epidemic of 1917. Although Marion remarried several times, she later returned to her first husband's name, which the museum bears today.

Marion returned to Texas in 1926 and married Dr. Donald T. Atkinson, a prominent San Antonio ophthalmologist. She commissioned noted local architects Atlee and Robert Ayres to build a grand home in the Spanish Colonial–revival style on the Gonifacio Rodriguez farm, purchased by Dr. Atkinson in the early 1920s. She renamed the property Sunset Hills. Beautifully embellished with ceramic tile from around the world, wrought-iron window grilles, gates, and lanterns, coffered and stenciled ceilings, graceful archways, and intricately paneled doors, the house itself was a work of art.

IT WAS IN THE 1920S that Marion Atkinson began to form a serious art collection. As an artist, she was particularly adept at watercolor painting, and this talent appears to have influenced her collecting taste. From the beginning, she demonstrated an eye for spontaneous works with bold forms and strong color in which the artist's hand was evident. On summer visits to Taos and Santa Fe, New Mexico, she became an important patron of the Taos Society of Artists, acquiring many fine watercolors and a large collection of Native American and New Mexican folk art. She acquired several dozen *santos*—both *retablos* (paintings) and *bultos* (sculptures) —when Catholic churches in New Mexico were replacing these folk art masterpieces

Marion Koogler McNay

9

with store-bought church art from the East. These simple yet powerful works suited her taste for bold color and form, and their roughhewn, naïve character answered her love for seeing the artist's hand at work. Mrs. McNay also acquired fine collections of Rio Grande blankets, paintings by artists of the American Indian school established in Santa Fe by Dorothy Dunn, as well as ceramics, jewelry, and furniture.

Although Diego Rivera's *Delfina Flores* (p. 164) was apparently the first painting she purchased, reflecting her taste for folk art, Marion McNay's attention soon shifted to European paintings and works on paper, especially artists of the French school. Her taste for the bold, colorful, and spontaneous is evident throughout her acquisitions, as is her desire to be comprehensive in collecting modern art. This effort grew over the years as her plans to establish a museum developed. To this purpose, two dealers above all assisted her—for American art, Edith Halpert of the Downtown Gallery, New York, and for European works, Dalzell Hatfield of Los Angeles.

The survey of modern French art presented by her collection begins with the Neo-Impressionism of Georges Seurat and Camille Pissarro, and the Post-Impressionist experimentation of Paul Cézanne. Cézanne's unfinished landscape, *Houses on the Hill* (p. 47), is a perfect example of Mrs. McNay's love for works that demonstrate the process of painting. Done late in the artist's life, when he painted many watercolors in which the white of the paper is a crucial compositional element, *Houses on the Hill* was an audacious choice but a natural one for Mrs. McNay. Equally characteristic of her daring was her selection of Vincent van Gogh's *Women Crossing*

Santo Niño Santero
New Mexican, active ca. 1830–1860
Nuestra Señora de los Dolores
Wood with water-soluble paint
Bequest of Marion Koogler McNay
1950.261

Rafael Aragón
New Mexican, ca. 1796–1862
Nuestra Señora de Guadalupe
Water soluble paint on panel
Bequest of Marion Koogler McNay
1950.290

the Fields (p. 50). A late, unfinished work, like the Cézanne, it shows every mark the artist made.

Marion often sought the unusual rather than the typical. A work such as Paul Gauguin's pastel *Eve* (p. 49), with its formal purity, spatial compression, and expressive color, is more powerful than conventionally beautiful. The museum's great Picasso collage, *Guitar and Wine Glass* (p. 72), is remarkable for its combination of Analytic Cubism and Synthetic Cubism; it is a significant document of Pablo Picasso's transition from one style to the next.

Mrs. McNay had a particular love for the works of Raoul Dufy, whose *Golfe Juan* (p. 96) perhaps typifies her taste for spontaneity, strong color, and bold form. Even here her choices were not typical of most American collectors, who favored the artist's watercolors. Instead, three of the four Dufys she acquired were oils. Tellingly, except for two small paintings by Pierre-Auguste Renoir, she did not acquire any Impressionist works save the Pissarro, *Haymakers Resting* (p. 38), itself unusual for having been painted during the short period when the artist was under the spell of Seurat's Pointillism.

Mrs. McNay's own work as a watercolorist greatly influenced her purchases of American art. Her selections were nearly all watercolors, such as the sparkling Impressionist landscapes by Childe Hassam and Maurice Prendergast (both p. 138), the fine still life by Charles Demuth (p. 157), and her many Taos-school watercolors. She kept up with current trends and acquired works by contemporary friends and acquaintances, such as the John Marin watercolor, *Taos* (p. 170), and William Zorach's *Popham Beach* of 1933.

WHEN MARION KOOGLER MCNAY died in 1950, she left a collection of some seven hundred works of art, including paintings and drawings, a few prints, *santos*, and Southwest folk arts, as well as furnishings and decorative arts that she felt would give the museum the feeling of a home. Perhaps she had in mind the great examples of the Phillips Collection in Washington, D.C., and the Isabella Stewart Gardner Museum in Boston. In its ambiance, the McNay is often compared to both.

Before Mrs. McNay's death, her home had already become an informal museum for students of the San Antonio Art Institute, which she invited to occupy a portion of her residence in 1942. After her death, the future of the museum was entrusted to a seven-member board of trustees, who were authorized to make the changes necessary for her home to function as a public institution. Although the new museum continued to provide free space for art classes, the San Antonio Art Institute became a separate entity with its own governing board. Art students still had easy access to the McNay collection, as the trustees decided there would be no admission charge.

In 1953, John Palmer Leeper, director of the Pasadena Museum of Art, became the museum's first director and oversaw the conversion of the McNay mansion into a public museum. The renovations were undertaken with the help of the home's original architects, Atlee and Robert Ayres.

Marion McNay had worked assiduously to create a comprehensive collection of modern art and regarded it as essentially complete at her death. Accordingly, she did not allow the endowment to be used for the purchase of art or capital improvements (unless surpluses exceeded one year's operating expenses by twenty thousand dollars). During the ensuing years, the McNay, like most American art museums, expanded its collections largely through gifts. These gifts began in grand style only one year after the museum's opening, when Dr. and Mrs. Frederic Oppenheimer gave the collection of medieval

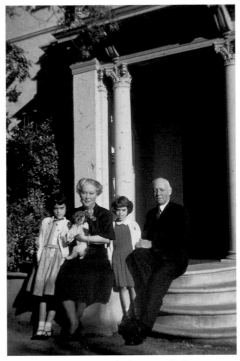

Dr. and Mrs. Frederic Oppenheimer with grandchildren

and Renaissance sculpture and painting they had been forming since the 1920s. The Oppenheimer sons, Alexander and Frederic, added several modern French paintings from the family collection. These included both paintings by Alfred Sisley (p. 34), greatly strengthening the museum's small Impressionist holdings, and a fine early work by Pierre Bonnard, *Children Playing* (p. 58).

Two rooms on the second floor of the McNay home were redesigned to accommodate the Oppenheimer collection of medieval and Renaissance art. The paintings, primarily fragments of altarpieces and portraits, include notable works by Albrecht Bouts, the Master of Frankfurt, and Jan Gossaert (called Mabuse) among the Northern masters, and Taddeo di Bartolo and Alvise Vivarini among the Italian school artists. The sculptures in the Oppenheimer collection, several of which are parts of larger works or ensembles, are French, German, or Netherlandish. The only public collection of its kind in South Texas, the Oppenheimer collection provides a fascinating parallel to the New Mexican religious art collected by Mrs. McNay.

JOHN LEEPER'S THIRTY-SEVEN YEARS as director were marked by continued growth of both the collection and the physical plant, and by the cultivation of support from the community. Most significant for acquisitions was the founding in 1959 of the auxiliary group the Friends of the McNay, the museum's first membership organization, whose primary purpose was raising funds for the purchase of art. From the beginning, these purchases were primarily modern master prints, so that over time the small print collection bequeathed by Mrs. McNay systematically developed into a serious print cabinet that parallels the strengths of the museum's painting collection.

The late 1950s and early 1960s saw other remarkable purchases, permitted by operating surpluses. To Mrs. McNay's fine collection of American watercolors and other works on paper, Leeper added two notable paintings by modernist artists of the Stieglitz group, named for the

legendary American art dealer Alfred Stieglitz, who promoted the careers of the pioneer modernists in America. The acquisition of Marsden Hartley's *Portrait Arrangement* (p. 148) in 1959 and Max Weber's *Conversation* (p. 147), in 1961 set a high standard for future growth of the American painting collection. Robert L. B. Tobin, one of the greatest benefactors of the McNay, gave a work the following year that ranks in importance with the Hartley and Weber, Arthur Dove's *The Brothers* (p. 173), along with ten watercolor studies for it. Ernst Ludwig Kirchner's great *Portrait of Hans Frisch* (p. 78), acquired by Leeper in 1963, provided a modern German counterpoint to Mrs. McNay's strong collection of modern French paintings, and acted as a companion to her few Central European works, such as Paul Klee's *On the River* (p. 89).

Modern sculpture was another area of the collection developed to parallel the painting collection. Emily Wells (Mrs. Lutcher) Brown generously gave funds to acquire important works, from Germaine Richier's *The Leaf* (p. 120), purchased in 1959, to the museum's great Aristide Maillol bronze, *La Nymphe* (p. 112), acquired in 1975. Leeper guided museum purchases of important bronze sculptures of the late nineteenth and early twentieth century: Rodin's *Burghers of Calais* (pp. 40–41) with the assistance of the Tobin Foundation, Antoine-Louis Barye's *Theseus Fighting the Minotaur* (p. 30), and Antoine Bourdelle's *Herakles Archer*, all acquired in the early 1960s. The children of Emily Wells Brown gave funds to build the Brown Sculpture Pavilion, a glass-walled gallery, so that this growing collection could be viewed in natural light. The Sculpture Pavilion and the adjoining Brown Gallery, designed to display large works of art and to host public programs of every kind, opened to the public in 1970.

During the 1960s and 1970s, the Friends of the McNay made possible many of the most rare and important acquisitions for the print collection: single masterworks

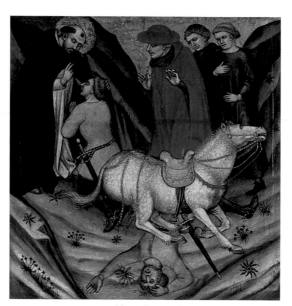

Taddeo di Bartolo
Italian, 1363–1422
Miracle of St. Dominic
Tempera on panel
Gift of Dr. and Mrs. Frederic G. Oppenheimer
1955.11

such as Winslow Homer's great etching, *Eight Bells* (p. 137); Maurice Prendergast's color monotype, *Roma—Flower Stall* (p. 139); Erich Heckel's color woodcut, *Portrait of a Man* (p. 86); and Frank Stella's *York Factory I*. Among the complete suites acquired were Picasso's *Eaux-Fortes Originales pour Textes de Buffon (Etchings Illustrating the Texts of Buffon)* and Jasper Johns's *Figures '0'–'9'*.

THE MODERN COLLECTION grew spectacularly through the bequest of the private collection of Mary and Sylvan Lang in 1975. As John Leeper wrote in the *Selective Catalogue* of 1980, "The Lang holdings complemented the original McNay collection so remarkably that one feels it was formed with the intention of joining it." Whereas Marion Koogler McNay focused on European paintings and American works on paper, Mary and Sylvan Lang favored American paintings and European works on paper, as well as a

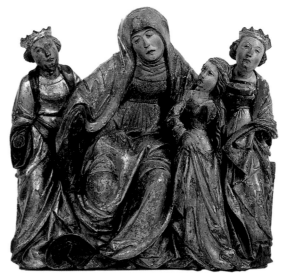

Southern German, 15th century
St. Anne, the Virgin, and Two Attendant Saints
Wood with polychrome and gilt
Gift of Dr. and Mrs. Frederic G. Oppenheimer
1955.71

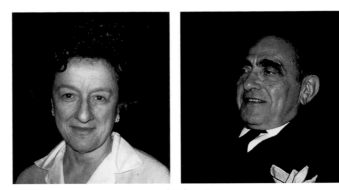

Mary and Sylvan Lang

variety of modern sculpture. Among their American works were Edward Hopper's painting *Corn Hill (Truro, Cape Cod)* (p. 168), probably the public's favorite American painting in the museum. Georgia O'Keeffe's *Leaf Motif #2* (p. 153), Arthur Dove's *Dawn III* (p. 172), and John Marin's *Pertaining to New Jersey* (p. 171), bolstered holdings in artists of the Stieglitz group. Other aspects of American painting illuminated by the Lang collection are Precisionism and Abstraction, represented by artists such as Charles Sheeler and George L. K. Morris, and the expressionism of Ben Shahn, Karl Zerbe, and Max Weber. The Langs' gifts and bequests also brought the first generation of the New York School to the McNay in paintings by William Baziotes and Jackson Pollock.

Although fewer in number, the Langs' European paintings significantly augmented this area of the collection. To Mrs. McNay's rather classical Georges Braque still life, *Glass, Two Apples* (p. 109), the Langs added an earlier Braque still life that imitates Synthetic Cubist patterning. Fernand Léger's *Le Vase Orange (The Orange Vase)* (p. 118) extends the Cubist still-life tradition into the next decade, while Jean Dubuffet's *Faiseur de Grâces (Bestower of Blessings)* (p. 121) brings us fully into the postwar movements. The Lang collection augmented the museum's small group of Central European works, contributing paintings and watercolors by Alexey Jawlensky, Paul Klee, and Lyonel Feininger.

Modern European sculpture added by the Langs, range in date from Edgar Degas's *Femme se Coiffant (Woman Arranging Her Hair)* (p. 43) to Alberto Giacometti's *Bust of Annette IV* (p. 121), with intervening fine works by Henri Matisse, Käthe Kollwitz, Picasso, and Henry Moore. Before the bequest of their collection, the couple donated funds to construct two new galleries. The Lang Galleries, which opened in 1973, permitted the McNay to exhibit their collection and present more ambitious exhibitions.

In 1973, the McNay received from the family of Tom Slick seventeen important works of art, on loan to the museum since the untimely death of the visionary San Antonio businessman in 1963. This generous gift deepened the McNay's painting and sculpture collection in works of the 1950s. Among the important European works are Picasso's *Portrait of Sylvette* (p. 122), excellent paintings by Antoni Tapies and Ben Nicholson, and three major bronzes by Barbara Hepworth. Among the American gifts are two paintings by Georgia O'Keeffe, one of them, *From the Plains I* (p. 171), her late reminiscence of the Texas Panhandle, as well as fine works by the New York School painter Larry Rivers and the Japanese American sculptor Isamu Noguchi.

The rapid growth of the collection made possible by the Lang and Slick collections was aided by gifts from other donors in the 1970s, especially Robert L. B. Tobin and Alice N. Hanszen. Tobin's gifts grew in size and number, for example, Albert Gleizes's four monumental canvases, *Les Quatres Personnages Légendaires du Ciel (The Four Legendary Figures of the Sky)* (p. 110), painted for the Paris world's fair of 1937. Tobin added significantly to the German collection with George Grosz's rare early painting *Der Turner (The Gymnast)* (p. 84) and his watercolor *Encounter in the Street* (p. 85). A passionate collector of scene and costume designs, Tobin was particularly drawn to artists active in the theatre and those who worked in a theatrical style. Qualified on both counts was the Russian-born American painter and designer Eugene Berman. In 1982, Tobin gave more than a dozen of Berman's paintings, dating from the early 1920s to the late 1960s, including *Cassandra* (p. 180), an excellent example of Surrealism in America.

Alice N. Hanszen, a noted Houston collector, made possible the acquisition of several major works during the 1970s, and gave Piet Mondrian's *The Tree* (p. 66), an unusual work by the modern Dutch master. Hanszen funded primarily American purchases: Max Weber's monumental gouache, *Surprise* (p. 146); Paul Manship's lovely bronze, *Atalanta* (p. 158); and Walt Kuhn's Cézanne-inspired still life, *Apple Basket* (p. 161). She also funded the acquisition of two contemporary works, Gene Davis's painting *Moroccan Wedding* (p. 213) and Louise Nevelson's *End of Day Nightscape V* (p. 220), a painted wood assemblage.

Built in 1975, the Jack and Adele Frost Wing was a timely gift from Adele Frost in memory of her husband. These three interconnecting rooms provided badly needed space for a burgeoning collection, and completed the necklace of galleries around the great central courtyard of the museum, linking the wings of the original McNay mansion. In addition to the construction of the Brown, Lang, and Frost galleries, the 1970s saw Marcia Koehler's donation of the impressive Marcia and Otto Koehler Fountain and adjoining esplanade, which greatly enhanced the entrance to the McNay.

THE MCNAY CELEBRATED its twenty-fifth anniversary with the publication in 1980 of *The Marion Koogler McNay Art Institute Selective Catalogue,* the first publication on the collection since the catalogue prepared for the McNay's opening in 1954. The collection had increased substantially, as had the physical plant, and the McNay would continue to expand throughout the 1980s.

The ability to use any of Mrs. McNay's original endowment for acquisitions was a thing of the past, as the expense of operating a larger museum escalated. Nevertheless, Leeper, with the support of the Friends of the McNay, had made major progress in establishing a fine collection of modern European and American prints, paralleling the painting and sculpture collection. From 1977 to 1980, Margaret Batts Tobin gave the McNay one of its most notable holdings, a set of ten color prints, known as the Durand-Ruel set, by Mary Cassatt. One of the few complete sets in America, the Cassatts are among the American expatriate artist's most important achievements. This extraordinary gift increased the print collection's reputation for the rare and exceptional and further distinguished it for having complete suites as well as individual masterworks. With such gifts and constant acquisition support from the Friends of the McNay, the collection achieved critical mass in size as well as quality, and the need for new space was apparent.

The museum was therefore grateful to receive a gift of funds in 1981 from Jerry Lawson and her mother, Mrs. C. G. Glasscock, to construct a print gallery and

Tom Slick

study room. The following year the Jerry Lawson Print Gallery opened, and with the help of the Friends of the McNay, the adjoining print study room was fully equipped. The provision of a dedicated gallery with appropriate light controls, where the permanent collection and traveling exhibitions could be shown, and the addition of a study room where students, collectors, and others could see works in storage, encouraged many more gifts.

Jerry Lawson had been an important print collector in the previous decade and had given numerous works. Her collecting increased with Leeper's help, as did her gifts to the collection, during the 1980s. Among her gifts were contemporary masterworks by Jasper Johns and entire suites of prints, such as Georges Braque's *Hesiod's Theogonie* (p. 109).

Other donors followed Jerry Lawson's lead and increased their gifts. Among them was Ruth Magurn, for many years a curatorial staff member of the print room at Harvard University's Fogg Art Museum. Her gifts comprised early nineteenth-century French lithographs by such artists as Carle Vernet and Théodore Géricault, and works by German Expressionist artists of the early twentieth century, including Franz Marc, Erich Heckel, and Käthe Kollwitz.

The Friends of the McNay were responsible for the greatest number of acquisitions, allowing the museum to build the print collection carefully. Joining the great masterworks of the collection purchased in the previous decade were Francisco Goya's *Los Borrachos (The Drunkards)* (p. 23) after Velázquez, Rodolphe Bresdin's *The Good Samaritan,* George Bellows's *A Stag at Sharkey's* (p. 151), and Edward Hopper's *The Henry Ford* (p. 169).

Jeanne Lang Mathews, with her husband Irving Mathews, followed in the footsteps of her parents, Mary and Sylvan Lang, and added significant works to the collection in a variety of media during the 1980s and early 1990s. These included paintings by Abraham Rattner and Wojciech Fangor, a small sculpture by Jean Arp, and a unique example of Art Nouveau furniture, an *écritoire-bibliothèque (writing desk–bookcase)* by Hector Guimard (p. 61).

By far the greatest number of gifts from the Mathews, however, are works on paper, among them, prints by Braque, Picasso, Georges Rouault, and Joan Miró. Jeanne Mathews has continued with these gifts after her husband's death, adding prints by Henri Matisse, Louise Nevelson, and Jim Dine, among other works.

Alice C. Simkins, following in the footsteps of her aunt, Alice N. Hanszen, added several important objects to the collection in the 1980s. An important painting by Renoir, *The Serenade* (p. 44), and a fine painting by Fernand Léger, *Le Papillon Blanc (The White Butterfly)* (p. 119), were given in memory of her aunt and on the occasion of the opening of the Tobin Wing. In recent years, Alice Simkins continued her gifts, focusing on contemporary prints by such artists as Fannie Hillsmith, Yvonne Jacquette, and Aline Feldman.

The opening of the Tobin Wing in 1984 had major implications for the future, signaling an expansion of the museum's collecting scope. The wing, given by Margaret Batts Tobin in memory of her parents, gave a new home to the McNay Art Museum Library and to the theatre arts collection of her son, Robert L. B. Tobin. At the Tobin Wing's inauguration, Robert Tobin gave his remarkable assemblage of rare books on the history of scene and costume design and commenced an active program of exhibitions from his vast holdings. Afterward, his mother also gave a large number of works by pioneer British designer Edward Gordon Craig.

Within a year after the Tobin Wing was completed, the museum was fortunate to receive a gift from Jane and Arthur Stieren for construction of a new addition dedicated to the storage and support of the permanent collection, and to the reception, storage, and preparation of traveling exhibitions. The three-story addition featured a large freight elevator, a loading dock, and a receiving area that linked temporary storage to the storage areas for painting and sculpture, prints and drawings, and theatre arts. Completed in 1987, the Stieren Wing gave the McNay its first proper art storage facility as well as a new flexibility for accommodating traveling exhibitions and changing installations of the permanent collection.

The Stieren gift also represented the first stage of a capital campaign to raise new endowment and make necessary capital improvements. Nancy Hamon established an endowment for curatorial programs, and the McNay trustees named the museum's central patio for

Blanche and John Leeper

her mother, Estelle Blackburn. The Brown Foundation endowed the John Palmer Leeper directorship, and several donors established new endowments for youth education. Elizabeth Huth Coates founded an endowment for exhibitions, later augmented by Jane and Arthur Stieren with a separate and larger Endowment Fund for Exhibitions. Carolyn Brown Negley gave funds to improve the landscaping of the grounds; completed in 1989, the improvements included a curving roadway from the main entrance on New Braunfels Avenue, water features, and a stairway from the parking areas to the main entrance, graced throughout by plantings.

THE YEAR 1990 WAS A MILESTONE in the history of the McNay, as John Palmer Leeper, director since the museum opened in 1954, retired from his post and William J. Chiego, director of the Allen Memorial Art Museum, Oberlin College, was appointed by the trustees in 1991 to succeed him. The first order of business was the completion of design work and construction of an auditorium, for which funds were already in place. Many years before, Leeper had pointed out the need for a facility for lectures, concerts, film programs, and similar events, and funds for planning it were given by Russell Hill Rogers in the early 1980s. After Rogers's death, the Russell Hill Rogers Fund for the Arts moved this project forward. With major gifts from the Semmes Foundation and the Tobin Foundation, and with many smaller gifts, the Blanche and John Leeper Auditorium was completed in January 1994; the multiple-purpose facility was designed for social events as well as lectures, concerts, and other performances. Its completion

was the capstone of the capital campaign that had commenced with the Stieren Wing, completed in 1987.

The new auditorium increased the variety of programs and events the museum could present and the number of visitors it could serve. It also took pressure off the galleries as event space, allowing the Brown Gallery once again to display art year round after serving as the McNay's education and event center for many years.

The 1990s were years of continued development of the permanent collection, especially in theatre arts and prints and drawings, but also in painting and sculpture. To serve the needs of the most rapidly expanding areas of the collection, curatorial posts in prints and drawings, and in art after 1945, were added to the curatorship in theatre arts established with the support of Robert L. B. Tobin.

A massive effort to mat and properly house more than half of the prints and drawings collection prepared all the works on paper for exhibition. The ability to show more works has encouraged gifts. Important print acquisitions were made possible by the Friends in several areas, with the greatest emphasis on post–World War II artists: Joseph Cornell, Robert Rauschenberg, Robert Motherwell, Jim Dine, Eric Fischl, and Terry Winters, among others. German Bauhaus and American modern works were also acquired, including prints by Josef Albers, Grit Kallin-Fischer, and László Moholy-Nagy in addition to George Bellows, Stuart Davis, and Marsden Hartley.

The Gallery of the McNay, another auxiliary membership group that functioned during the 1980s and early 1990s, helped to build the print collection, particularly in works from the golden era of Mexican printmaking by artists such as José Clemente Orozco, Leopoldo Méndez, and Francisco Dosamantes. The Gallery also funded the purchase of contemporary European and American works by Georg Baselitz, Chuck Close, and others.

Individual collectors continued to have a great impact on the strengthening of the print collection in the 1990s. Ruth Magurn bequeathed a fine and varied group of works in 1991. These include French lithographs such as a

Main entrance of the museum

rare print by Charles Philibert, Comte de Lasteyrie, from the earliest days of the medium, and another work by the master of color lithography, the Neo-Impressionist Paul Signac. She also bequeathed German Expressionist prints by Max Beckmann and Ernst Ludwig Kirchner, among others. Carol Johnson, with her brother John Aronovici, permitted the museum to choose a representative selection of etchings, copper etching plates, and drawings by her father, early twentieth-century San Francisco printmaker John Winkler. Joe and Janet Westheimer gave funds for the purchase of fine prints ranging from late nineteenth-century French works by Auguste Lepère and Jean Forain to a contemporary woodblock by Sol Lewitt.

By far the most important gift of the 1990s, however, came through Jerry Lawson's bequest in 1994 of over one hundred prints, predominantly French and American works. Among the French prints are four Tahitian color woodcuts by Paul Gauguin, and Henri Ibels's and Henri de Toulouse-Lautrec's separate suites of eleven lithographs for *Le Café Concert*. Outstanding among the American prints are nineteen works by Jasper Johns, including *Decoy II* and *Ventriloquist* (both p. 217). Equally remarkable are Lawson's twenty-one prints by Picasso, including the entire suite of *Les Saltimbanques*, and four early impressions by the Spanish master Francisco Goya, including a rare proof impression of *Que Sacrificio! (What a Sacrifice)* from *Los Caprichos (Follies)* (p. 22).

Jerry Lawson's bequest also contained unusual groups of drawings, paintings, and sculptures, collected more from personal taste and less systematically than her print collection. Noteworthy among the paintings is a rare Arthur B. Davies abstraction, *Listening to the Water Ousel* (p. 145), probably painted around 1915 in the wake of the Armory Show he helped to organize. Three drawings complement the collection particularly well, Eugène Delacroix's drawings of *Hercules Conquering the Nemean Lion* (p. 25), a study for his Palais Bourbon murals; Winslow Homer's drawing Study for *Inside the Bar, Tynemouth* (p. 136); and Toulouse-Lautrec's

A Horseman and His Groom, an early work. A few fine twentieth-century bronzes were also left by Lawson, for example, Gaston Lachaise's *Torso* (p. 172).

In 1995, Evelyn Halff Ruben, sister of collection donor and honorary board member Robert Halff, bequeathed a portion of her collection to the McNay. The most outstanding work designated for the museum was David Smith's sculpture *Stainless Network I* (p. 195). Other significant additions include drawings by Morris Graves and Jean Dubuffet, and prints by a variety of masters: Grant Wood, Picasso, Robert Motherwell, Helen Frankenthaler, Claes Oldenburg, and David Hockney.

In 1996, the McNay was able to make a particularly advantageous acquisition of four Motherwell collages. One of the few masters of the medium after World War II, Motherwell showed a wide range of techniques, from the flung-ink spontaneity of *African Collage #1* (p. 198) to the painterly purity of *Suchard on Orange #5* (p. 221). Acquired as a partial gift of the Dedalus Foundation, they strike a note of French formalism that relates beautifully to the museum's great Picasso collage of 1912 (p. 72).

The museum also focused on developing the painting and sculpture collection. Three fine additions were made to the small pre-Impressionist French painting collection. Chronologically they are Robert Leopold Leprince's *The Waterfall at Reichenbach* (p. 29), Narcisse-Virgile Diaz de la Peña's *Peasant Woman Gathering Wood* (p. 28), and Eugène Boudin's *Trouville* (p. 35), together demonstrating the development of the sketch in nineteenth-century French landscape painting, and the move from studio painting to the plein air work that led to Impressionism.

Similarly, the development of nineteenth-century European sculpture is demonstrated more fully in the McNay collection by the acquisition of three fine bronzes during the last decade. Two works from the beginning of the century, Jean-Jacques Feuchère's *Satan* (p. 24) and Pierre-Jean David d'Angers's *Philopoemen* (p. 27), have recently been supplemented by *L'Homme à l'Outre (Man with a*

Jerry Lawson

Watersack) (p. 60), by the Belgian master of Secession-style sculpture, Georges Minne. While the Feuchère and David d'Angers sculptures share the heroic and idealized figures of the French academic tradition, the Minne strikes a note of anxiety and attenuation new to the collection.

The sculpture collection during the 1990s expanded beyond the galleries to the twenty-three acre hillside site the museum enjoys. With the support of the Russell Hill Rogers Fund for the Arts, two important works of contemporary sculpture made for outdoor settings were acquired: *Horizontal Column of Five Squares Excentric II* (p. 233), a lyrical work by master of kinetic sculpture George Rickey, and an untitled, abstract figural work by Joel Shapiro, which animates the exterior of the Brown Gallery (p. 239).

In the past decade, the twentieth-century painting collection has also grown in targeted areas. The McNay's strength in American modernism relies not only on artists of the Stieglitz group, but also on their contemporaries in the American Abstract Artists group in New York, such as George L. K. Morris, and in the Transcendental Painting group in New Mexico, such as Raymond Jonson and Emil Bisttram. To strengthen these holdings, the museum purchased a wood relief of biomorphic forms by Charles Shaw as well as a rare early painting by Florence Miller Pierce, *Rising Red* (both p. 176).

The American painting collection of the McNay, which now surpasses the European collection in size, received many gifts in recent years from Robert L. B. Tobin. Early in the 1990s Marsden Hartley's *Landscape with Arroyo* (p. 156) joined the strong modernist group, and two paintings by Joan Mitchell, including *Hudson River Day Line* (p. 197), arrived to bolster the holdings of Abstract Expressionism.

Tobin's gifts extended to important works on paper. Among the American works are fine examples by contemporary masters Cy Twombly and Robert Morris, and a watercolor by Andrew Wyeth, *Corn Cutting Knife* (p. 214). The European works consist of Paul Klee's

Creative Polyphony, the museum's fifth work by the artist; Henry Moore's *Ideas for Sculpture* (p. 117); René Magritte's gouache *Two Men with Derbies* (p. 131), the McNay's first work by the Belgian master of Surrealism; and David Hockney's harlequin costume design for *Parade* (p. 135).

In 1999, the year before his death, Robert L. B. Tobin made one of the largest gifts of American paintings in the museum's history. The selection of more than two dozen works helped several facets of the collection. Foremost is a group of eight modernist paintings: a rare William Zorach, *Milking Time (Echo Farm, New Hampshire)* (p. 149), a major two-sided painting by James Daugherty (pp. 154–55); and an important Paul Cadmus, *What I Believe* (p. 182), as well as works by Arthur B. Davies, Louis Eilshemius, George L. K. Morris, and John Storrs. The group of contemporary works is yet larger. Counted among them are Joan Mitchell's *Woods, Country* of 1966; four paintings by Robert Indiana from the early years of the Pop Art movement, one being *The Metamorphosis of Norma Jean Mortenson* (p. 208); and three South Texas "landscapes" by San Antonio artist César A. Martínez. The Tobin gift of American paintings also features a rare work by José Arpa y Parea (p. 143), a Spanish-born artist who was an important force in San Antonio painting early in the twentieth century.

The artists of Texas and, in particular, the artists of San Antonio who have had long and influential careers, have been another focal point for acquisitions. This has resulted from five retrospective exhibitions organized by the McNay from 1996 to 2000 with the sponsorship of museum trustee Harold Wood and his wife, Barbara. With the unprecedented opportunity presented by the retrospective format, the museum has added, by purchase and

Robert L. B. Tobin

gift, works by every artist in the series: Reginald Rowe, Carl Rice Embrey, Kent Rush, César A. Martínez, and Kathy Vargas.

In recent years, the museum has increasingly pursued contemporary art, especially since the establishment of a curatorial post for art after 1945. The earliest acquisition is a pristine, early John McLaughlin painting of 1949 (p. 191). Others are a Jim Parker optical painting of circa 1972 from his *Dot Series* (p. 212), and Kikuo Saito's *Crocodile Song* (p. 223). Recent sculpture acquisitions are wall pieces, such as the Joel Shapiro acquired for outdoors. Leonardo Drew's untitled rusty assemblage (p. 237), though based on a grid, is baroque in its exuberant cascade of found objects, while Donald Judd's untitled box construction of aluminum and Plexiglas (p. 238) is the essence of geometric simplicity, using minimal means for maximum spatial complexity and mystery.

Recent curatorial focus has benefited the prints and drawings collection. An important acquisition of more than two dozen duplicate Mexican prints collected by Carl Zigrosser at the Philadelphia Museum of Art (anchored by the three great artists Diego Rivera, José Clemente Orozco, and David Alfaro Siqueiros), ensures that the McNay's collection of Mexican graphics is one of the finest in the nation. Contemporary prints have been acquired as well, including particularly strong suites by Donald Judd and Agnes Martin.

By far the greatest growth of the collection is underway in the area of the theatre arts. In 1998, Robert L. B. Tobin began to give his vast theatre arts collection to the McNay, intending for the museum to become the repository of the Tobin Collection of Theatre Arts, as envisioned when the Tobin Wing opened in 1984. The initial gifts of Tobin's library of rare books on scene and costume

design, and of designs by Edward Gordon Craig and Robert Indiana, were joined by a group of more than six hundred Russian designs of the early twentieth century, with particularly strong works by four leading artists who designed for Serge Diaghilev's *Ballets Russes* company: Alexandre Benois, Léon Bakst, Natalia Gontcharova, and Mikhail Larionov.

In 1999, Tobin transferred to the McNay his collection of American scene and costume designs, including major works by Robert Edmond Jones, who brought to America the New Stagecraft of British designer Edward Gordon Craig. Followers of Jones in the collection include Donald Oenslager, Jo Mielziner, and Norman Bel Geddes. As American musical theatre is a particular focus, Broadway designers are well represented: the husband and wife team of Jean and William Eckart, Raoul Pène du Bois, Oliver Smith, Ming Cho Lee, Robin Wagner, and Tony Walton. Productions by these and other artists found in the collection are *Pal Joey*, *South Pacific*, *Call Me Madam*, *Damn Yankees*, *My Fair Lady*, *West Side Story*, *Fiddler on the Roof*, and *Into the Woods*.

Subsequent gifts from the Tobin Foundation will focus on three other areas of Tobin's theatre arts collection. First is "artists in the theatre," or designers who were also painters or sculptors, such as Picasso, Berman, and Hockney. Second is the collection of British and other European theatrical designs that primarily focus on twentieth-century ballet; artists represented are Cecil Beaton, Osbert Lancaster, Roger Furse, Oliver Messel, and Leslie Hurry. Third is Tobin's collection of designs for the Italian opera, among the oldest works in the collection, including drawings by Galli Bibiena. The Tobin Collection of Theatre Arts in its entirety is the most comprehensive assemblage devoted to designs for the opera, ballet, and American musical stage in an American art museum.

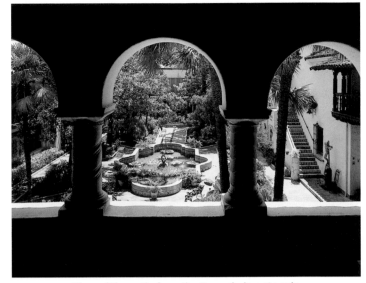

View of the patio from the Oppenheimer Loggia

THE COLLECTION OF THE Marion Koogler McNay Art Museum has grown remarkably since the museum was founded over fifty years ago. This achievement has been accomplished primarily through the generous gifts of many individuals and through strategic purchases with available funds. Although the collection has grown in new areas, such as the theatre arts, and has developed minor areas in Mrs. McNay's collection, such as modern sculpture and prints, into major holdings of the museum, the McNay's commitment to art of the modern era has never wavered.

This pictorial survey captures a growing collection at an important moment, as we complete restoration of the beautiful McNay home that is the historic heart of the museum. The necessary improvements have been made to preserve the legacy of Mrs. McNay, whose vision continues to inspire others. This book is meant to serve as a point of pride as the museum treasures the past and builds for the future.

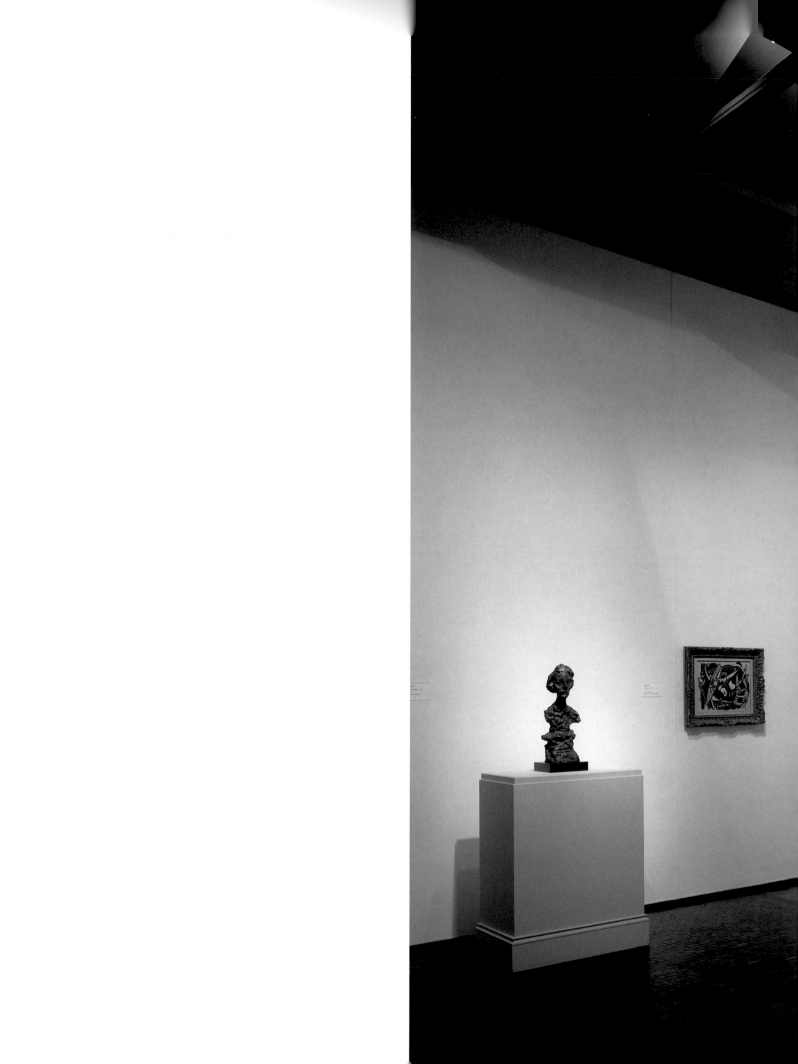

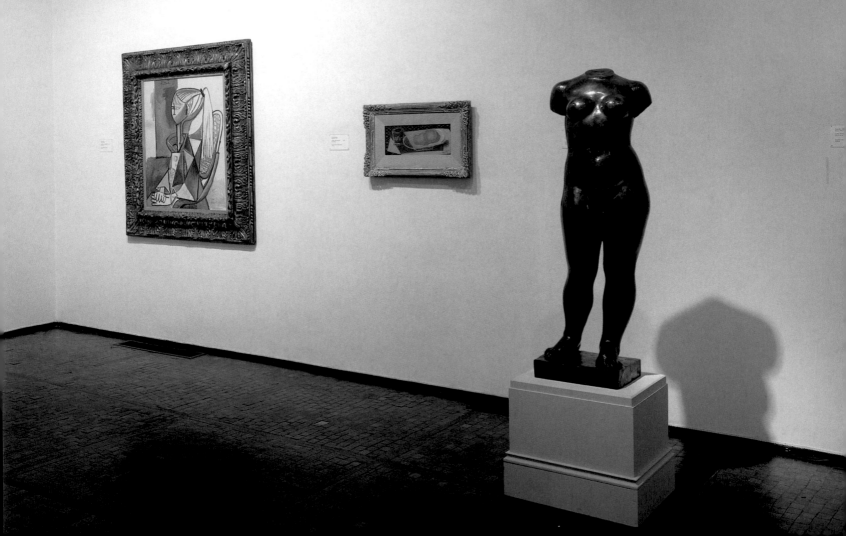

Pictorial Survey of the Collection

FRANCISCO GOYA
Spanish, 1746–1828

Que Sacrificio (What a Sacrifice) from
Los Caprichos (Follies), ca. 1795

Etching, aquatint and drypoint with pen and ink,
plate 7⅞ x 5¹⁵⁄₁₆ in., Delteil catalogue 51, first state
of three
Bequest of Mrs. Jerry Lawson
1994.120

FRANCISCO GOYA

Spanish, 1746–1828

Los Borrachos (The Drunkards), 1778

Etching, plate 12⅜ x 17 in., Delteil catalogue 4,
first state of two
Gift of the Friends of the McNay
1982.19

FRANCISCO GOYA

Spanish, 1746–1828

*Y No Hai Remedio (And There's No Help
for It)* from *Los Desastres de la Guerra
(Disasters of War)*, 1863

Etching and drypoint, plate 5½ x 6⁹⁄₁₆ in., Delteil
catalogue 134, fourth state of four
Gift of Robert L. B. Tobin
1981.40.15

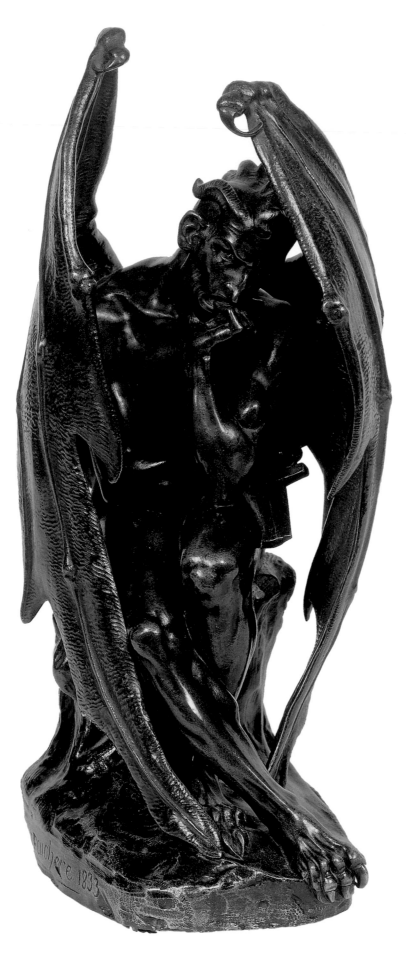

JEAN-JACQUES FEUCHÈRE
French, 1807–1852
Satan, 1833

Bronze, 13¼ in. high
Gift of Robert L. B. Tobin
1993.13.1

EUGÈNE DELACROIX
French, 1798–1863
Hercules Conquering the Nemean Lion, 1849

Graphite on paper, 8³⁄₁₆ x 9³⁄₈ in., Robaut
catalogue 1132
Bequest of Mrs. Jerry Lawson
1994.108

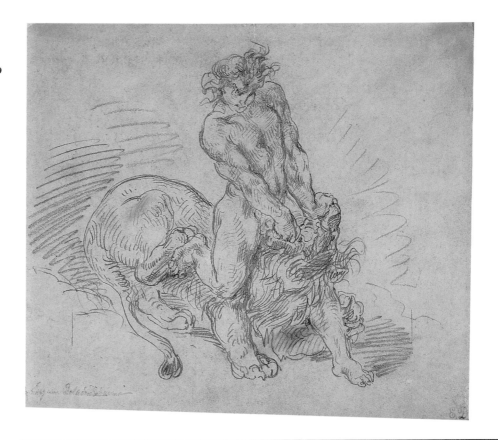

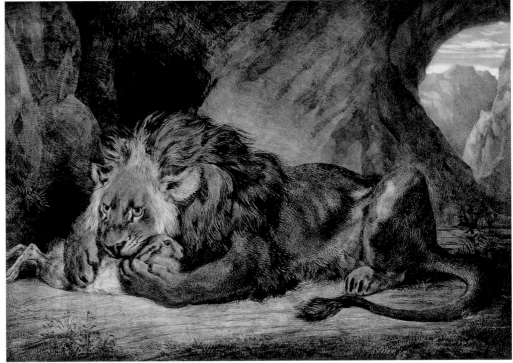

EUGÈNE DELACROIX
French, 1798–1863
Lion de l'Atlas (Lion of Atlas), 1829

Lithograph, image 13 x 18⁷⁄₁₆ in., Delteil
catalogue 79, third state of four
Museum purchase
1964.6

HONORÉ DAUMIER
French, 1808–1879
Rue Transnonain, 1834

Lithograph, image 11 5/16 x 17 7/16 in.,
Delteil catalogue 135
Gift of the Friends of the McNay
1961.4

THÉODORE GÉRICAULT
French, 1791–1824
Cheval Dévoré par un Lion (Horse Devoured by a Lion), 1823

Lithograph, image 7¾ x 9⅜ in., Delteil catalogue 67, second state of four
Gift of the Friends of the McNay
1997.58

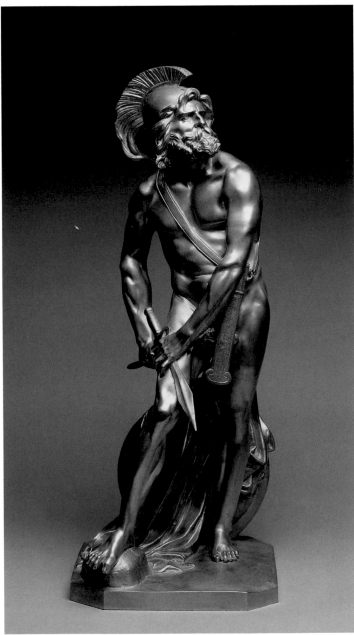

PIERRE-JEAN DAVID D'ANGERS
French, 1788–1856
Philopoemen, 1837

Gilded bronze, 19 in. high
Museum Purchase with funds from the
Estates of Nathalie and Gladys Dalkowitz
1998.15

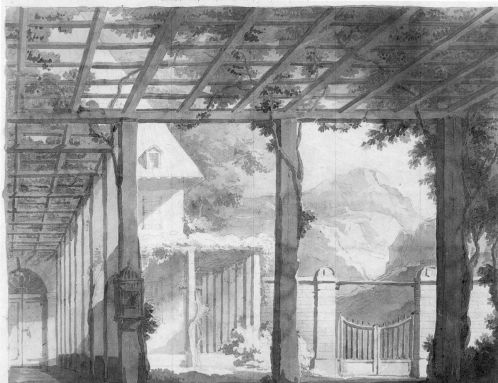

ANTONIO BASOLI
Italian, 1774–1843

Scene design for the Courtyard of Fabrizio's Farmhouse in Act I of *La Gazza Ladra (The Thieving Magpie)*, ca. 1820

Watercolor and graphite on paper,
image 15 11/16 x 20 7/16 in.
Promised gift of the Estate of Robert L. B. Tobin

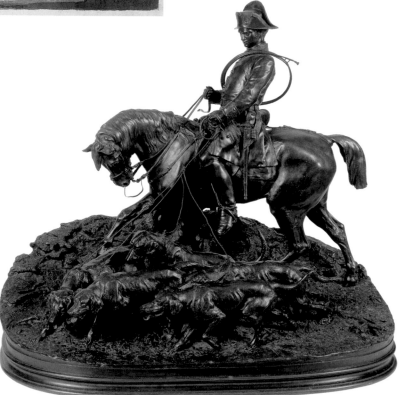

ROBERT LEOPOLD LEPRINCE
French, 1800–1847

The Waterfall at Reichenbach, 1824

Oil on paper mounted on board, 11½ x 8⅜ in.
Museum Purchase from the Ralph A. Anderson, Jr.,
Memorial Fund
1992.9

PIERRE-JULES MÈNE
French, 1810–1879

Mounted Huntsman and Hounds, 1869

Bronze, 26 in. high
Gift of Bernard Black and Hugues-W. Nadeau
1969.41

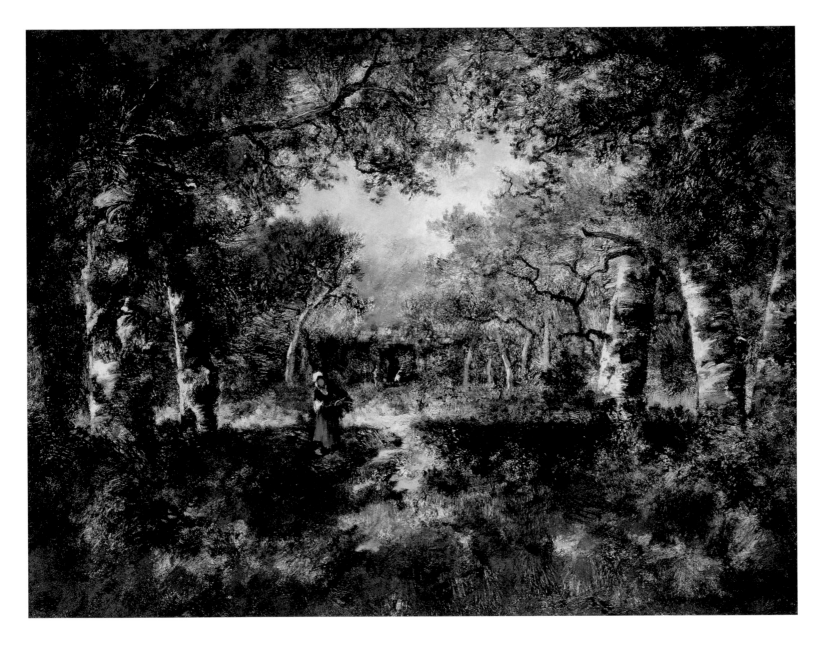

NARCISSE-VIRGILE DIAZ DE LA PEÑA
French, 1807–1876
Peasant Woman Gathering Wood

Oil on panel, 13¾ x 18 in.
Gift of the Estate of Stella C. Herff and the Estates
of Nathalie and Gladys Dalkowitz, by exchange
1995.1

ANTOINE-LOUIS BARYE
French, 1796–1875
Theseus Fighting the Minotaur, 1846–47

Bronze, 17¾ in. high
Museum purchase
1964.1

CHARLES MERYON
French, 1821–1868

L'Abside de Notre Dame de Paris (The Apse of Notre Dame in Paris), 1854

Etching, plate 6⁷⁄₁₆ x 11¾ in., Delteil catalogue 38, fourth state of eight
Gift of the Friends of the McNay
1996.24

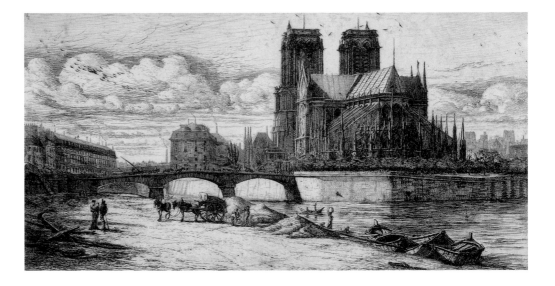

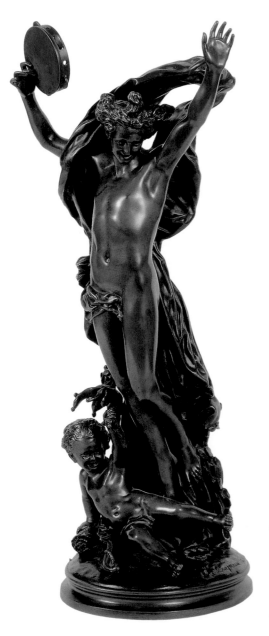

FÉLIX BRACQUEMOND
French, 1833–1919

Portrait of Edmond de Goncourt, 1882

Etching, plate 20 x 13¼ in., Béraldi catalogue 54, eighth state of eight
Gift of Janet and Joe Westheimer
1984.35

JEAN-BAPTISTE CARPEAUX
French, 1827–1875
The Genius of the Dance, ca. 1872

Bronze, 21½ in. high
Museum purchase with funds from Stella C. Herff
1980.18

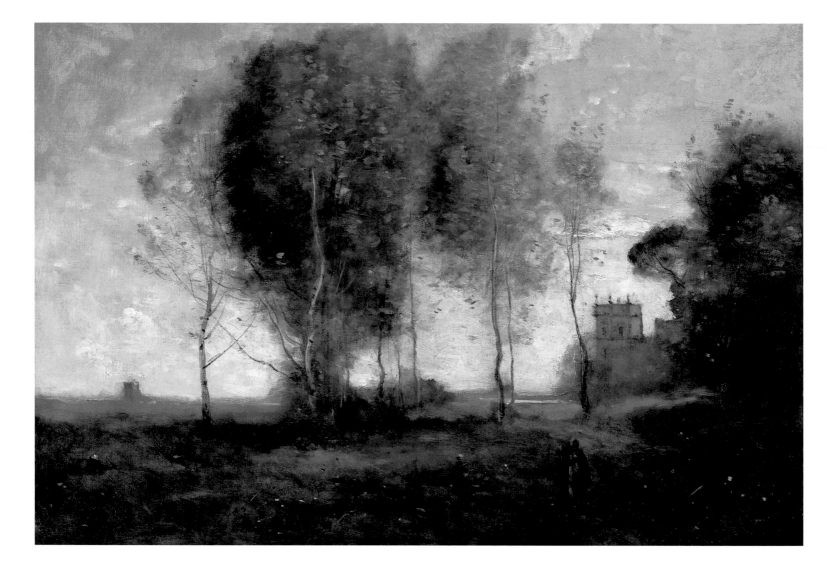

JEAN-BAPTISTE-CAMILLE COROT
French, 1796–1875
Villa of the Black Pines, 1870

Oil on canvas, 14¾ x 21¾ in., Robaut
catalogue 2261
Gift of the Estate of Norine R. Murchison
1985.22

EUGÈNE BOUDIN
French, 1824–1898
Figures on the Beach, ca. 1865

Watercolor and graphite on paper, 5 x 10¼ in.
Bequest of Marion Koogler McNay
1950.17

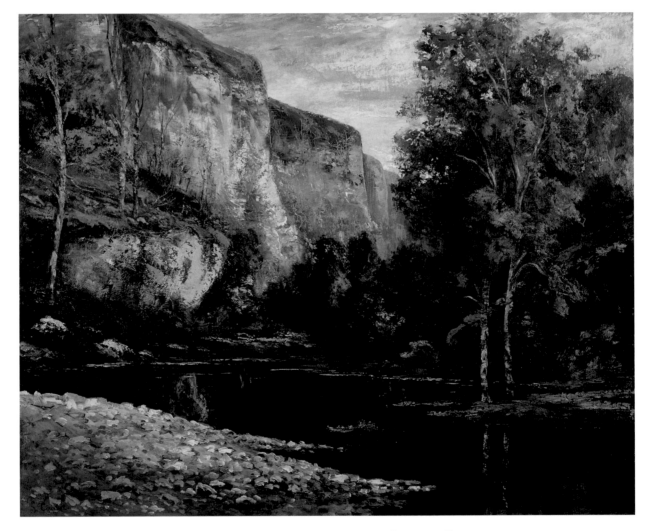

GUSTAVE COURBET
French, 1819–1877
*Le Ruisseau des Puits Noirs (Stream of the
Black Pond)*, ca. 1865

Oil on canvas, 28¾ x 36⅛ in., Fernier catalogue 458
Gift of Mrs. Donald Alexander
1960.9

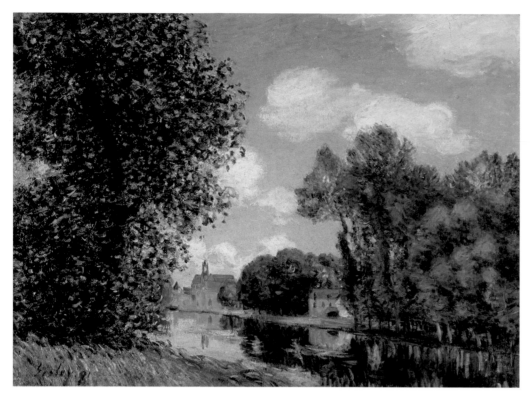

ALFRED SISLEY
British, 1839–1899
The Loing River at Moret, 1891

Oil on canvas, 21⅝ x 28⅞ in.
Gift of Dr. and Mrs. Frederic G. Oppenheimer
1955.1

ALFRED SISLEY
British, 1839–1899
La Route de Saint-Germain à Marly (The Road from Saint Germain to Marly), 1872

Oil on canvas, 18¼ x 24 in., Daulte catalogue 43
Gift of Dr. and Mrs. Frederic G. Oppenheimer
1955.2

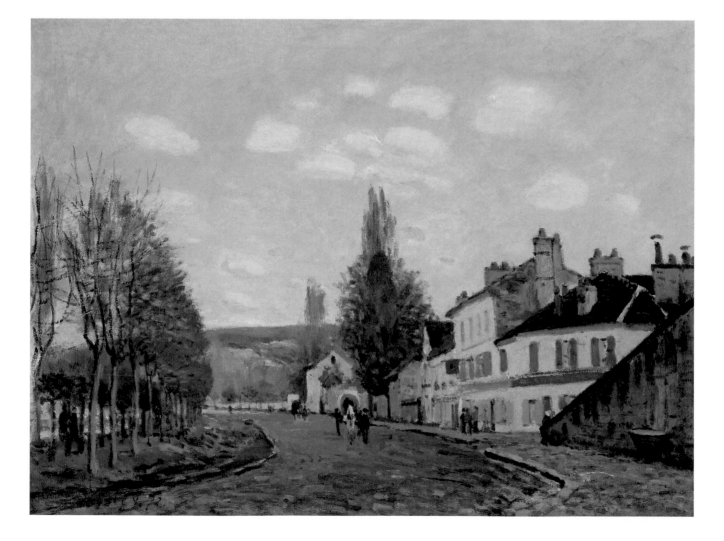

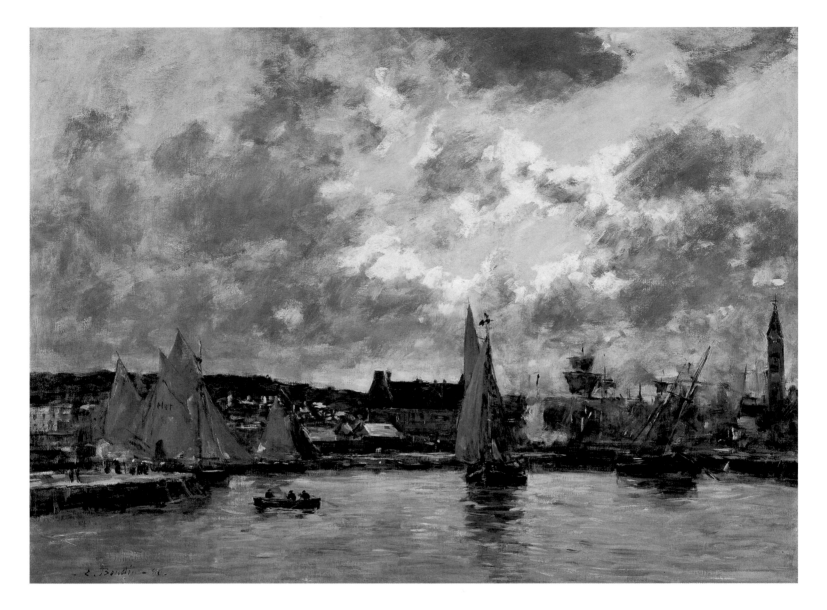

EUGÈNE BOUDIN
French, 1824–1898
Trouville, 1880

Oil on canvas, 21¼ x 29¼ in.,
Schmit catalogue II, 3931
Museum purchase in part with the Helen and
Everett H. Jones Purchase Fund and the Ralph A.
Anderson, Jr., Memorial Fund, with additional funds
from Charline and Red McCombs, and, by exchange,
from the bequest of Gloria and Dan Oppenheimer,
Mrs. Robert Wesselhoeft, Jr., and the Louise C.
Clemens Trust
2001.7

EDOUARD MANET
French, 1832–1883

Liserons et Capucines (Convolvulus and Nasturtiums), 1881

Oil on canvas, 38½ x 22¾ in., Rouart catalogue 378, Venturi catalogue 352c
Gift of Margaret Batts Tobin
1982.66

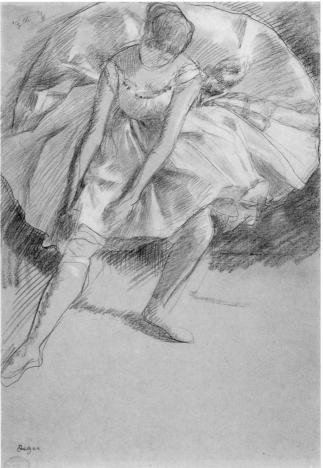

EDOUARD MANET
French, 1832–1883
Les Courses (The Races), **1865**

Lithograph, image 15 3/16 x 20 in., Harris catalogue 41
Gift of the Friends of the McNay
1985.17

EDGAR DEGAS
French, 1835–1917
Seated Dancer, **ca. 1885**

Charcoal and chalk on paper, 15 5/8 x 11 in.
Bequest of Marion Koogler McNay
1950.31

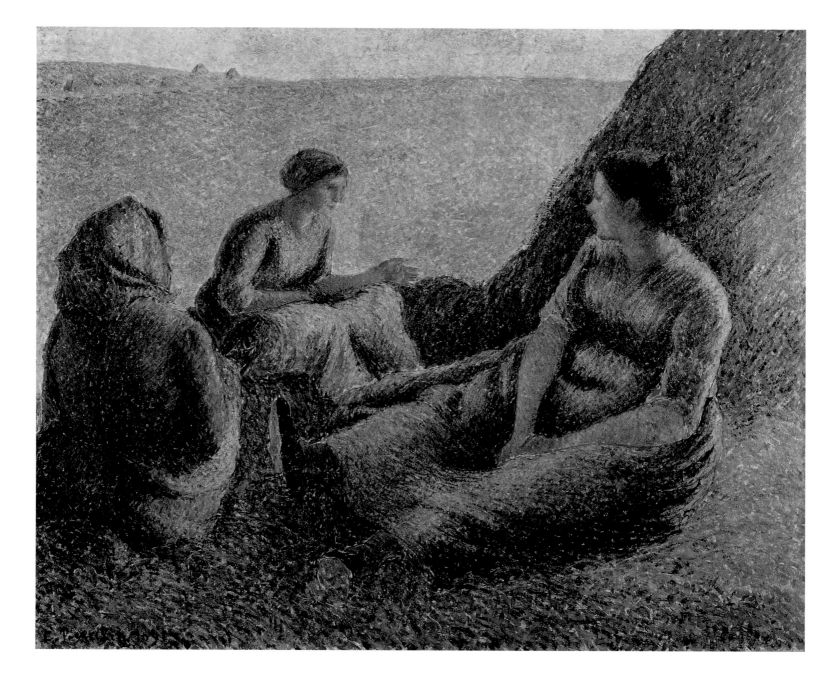

CAMILLE PISSARRO
French, 1830–1903
Haymakers Resting, 1891

Oil on canvas, 25 ¾ x 32 in., Venturi catalogue 773
Bequest of Marion Koogler McNay
1950.115

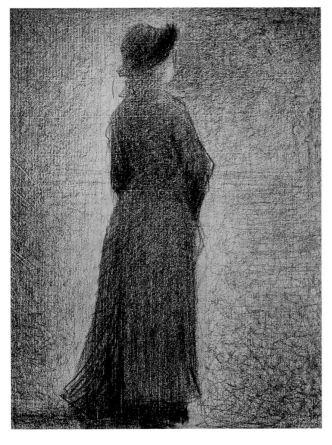

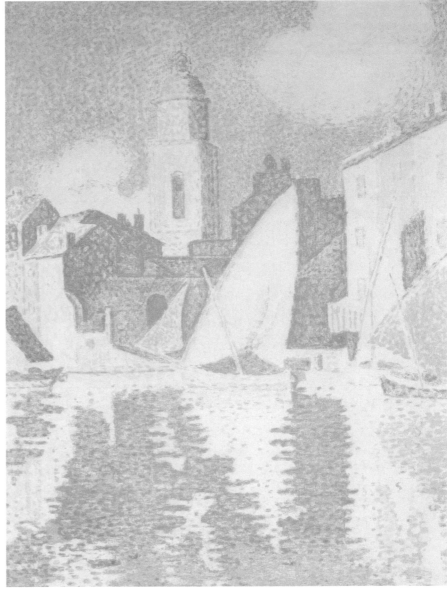

GEORGES SEURAT
French, 1851–1891
Silhouette de Femme (Young Woman),
ca. 1882–84

Conté crayon on paper, 12⅛ x 8¾ in., Herbert
catalogue 501
Bequest of Marion Koogler McNay
1950.137

PAUL SIGNAC
French, 1863–1935
Saint Tropez: Le Port, **1897–98**

Lithograph, image 17⅛ x 13 in., Kornfeld
catalogue 19, second state of two
Gift of Lenora and Walter Brown
1982.14

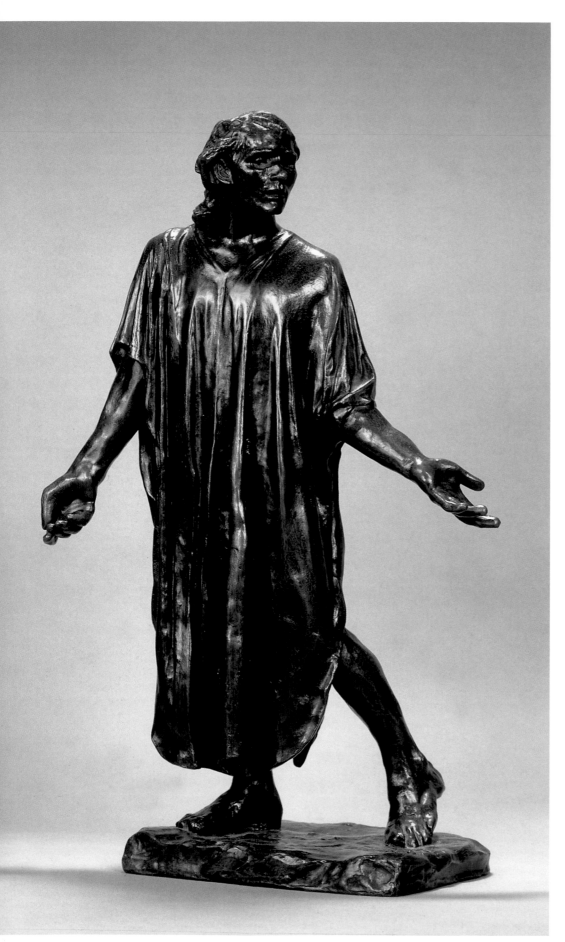

AUGUSTE RODIN
French, 1840–1917
Five studies for the *Burghers of Calais*, late 1890s

left:

Jean de Fiennes
Bronze, 18³⁄₁₆ in. high

opposite, clockwise from upper left:

Andrieu d'Andres
Bronze, 15¹⁵⁄₁₆ in. high

Eustache de Saint-Pierre
Bronze, 18⅝ in. high

Jean d'Aire
Bronze, 18⅜ in. high

Pierre de Wiessant
Bronze, 17¾ in. high

Museum purchase and gift of the Tobin Foundation
1963.1.1–5

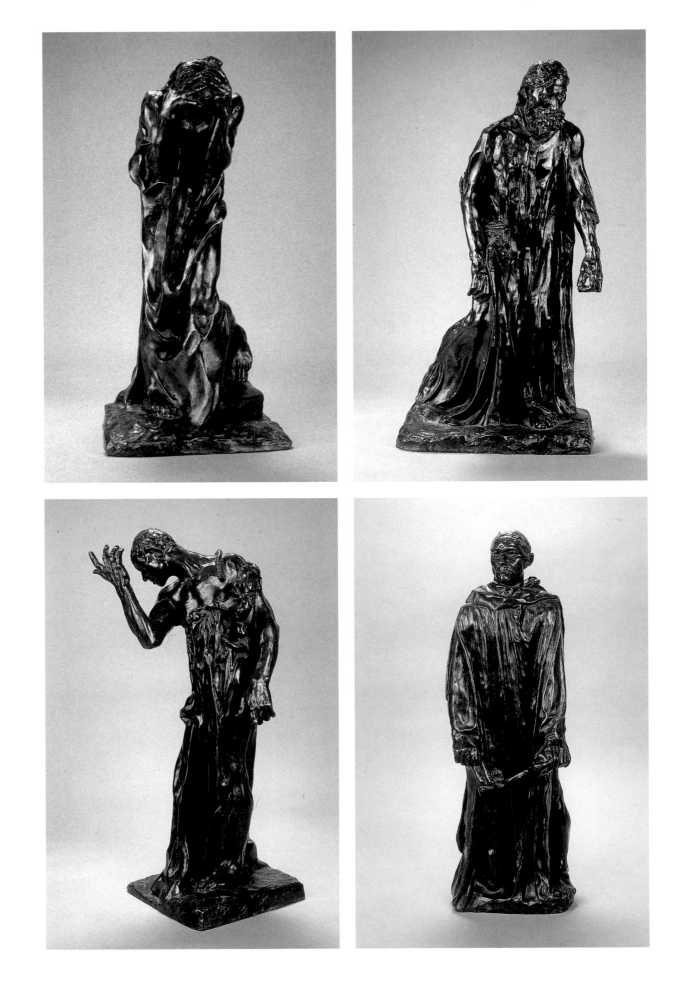

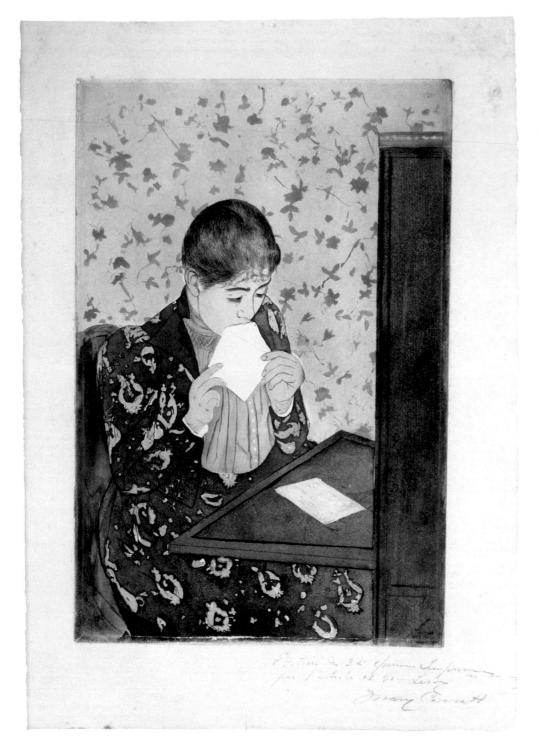

MARY CASSATT
American, 1845–1926
The Letter, ca. 1891

Drypoint, soft-ground and aquatint, plate
13⅝ x 8⅞ in.; Mathews and Shapiro catalogue 8,
fourth state of four
Gift of Margaret Batts Tobin
1978.25

EDGAR DEGAS
French, 1834–1917
*Femme se Coiffant (Woman Arranging
Her Hair)*, ca. 1892, cast 1924

Bronze, 18⅜ in. high
Mary and Sylvan Lang Collection
1975.61

EDGAR DEGAS
French, 1834–1917
Le Sortie du Bain (After the Bath),
ca. 1891–92

Lithograph, image 9¾ x 9⅟₁₆ in., Reed and
Shapiro catalogue 65, first state of two
Gift of the Friends of the McNay
1961.11

MARY CASSATT
American, 1845–1926
The Coiffure, ca. 1891

Drypoint and soft-ground, plate 14⁵⁄₁₆ x 10½ in.;
Mathews and Shapiro catalogue 14, fifth state
of five
Gift of Margaret Batts Tobin
1980.40

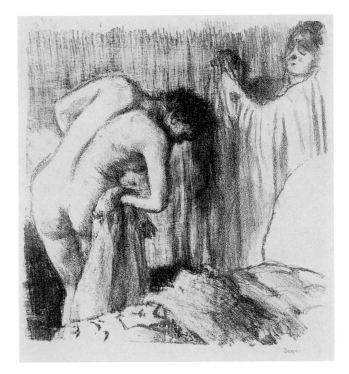

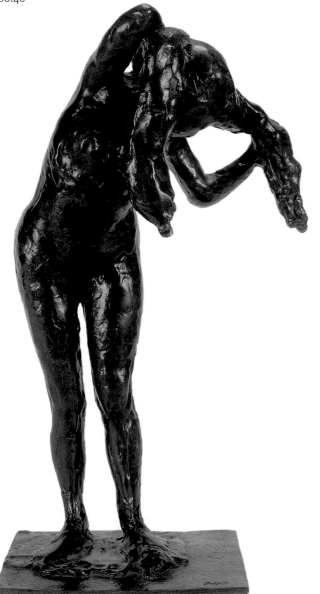

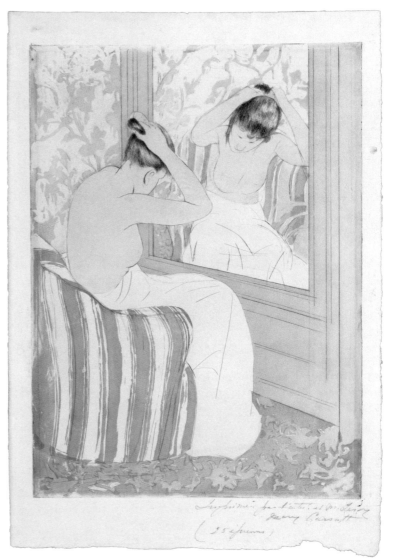

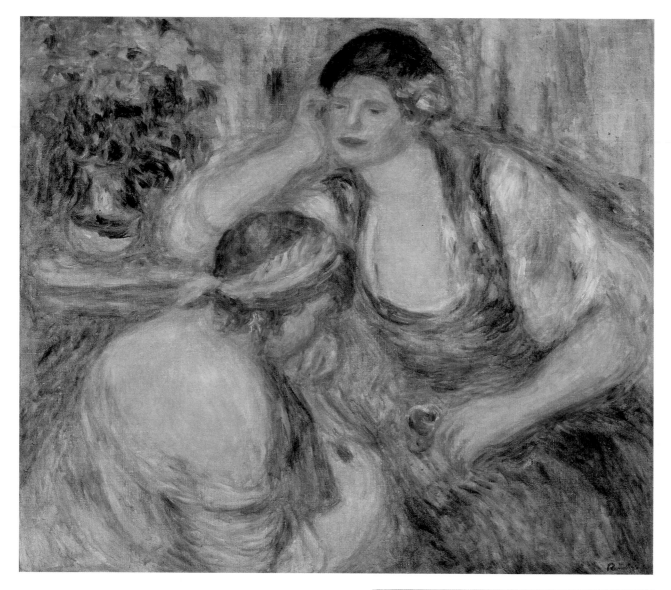

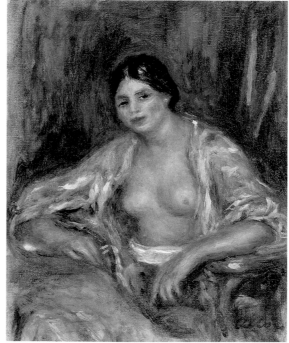

PIERRE-AUGUSTE RENOIR
French, 1841–1919
The Serenade, 1919

Oil on canvas, 26½ x 30¼ in.
Gift of Alice C. Simkins in memory of Alice N.
Hanszen
1980.17

PIERRE-AUGUSTE RENOIR
French, 1841–1919
Gabrielle in Oriental Costume

Oil on canvas, 10¾ x 8⅞ in.
Bequest of Marion Koogler McNay
1950.120

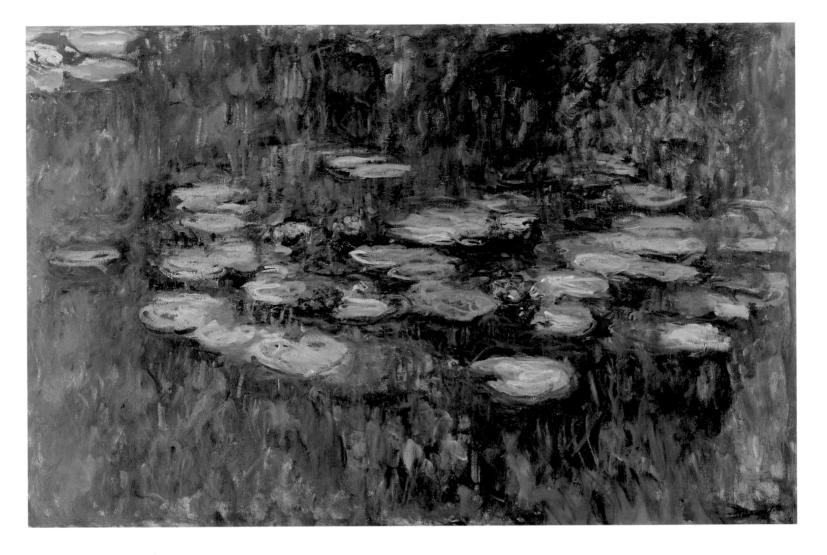

CLAUDE MONET
French, 1840–1926
Nympheas (Water Lilies), ca. 1916–19

Oil on canvas, 51¼ x 78¾ in., Wildenstein
catalogue 1863
Collection of the Tobin Foundation for Theatre Arts

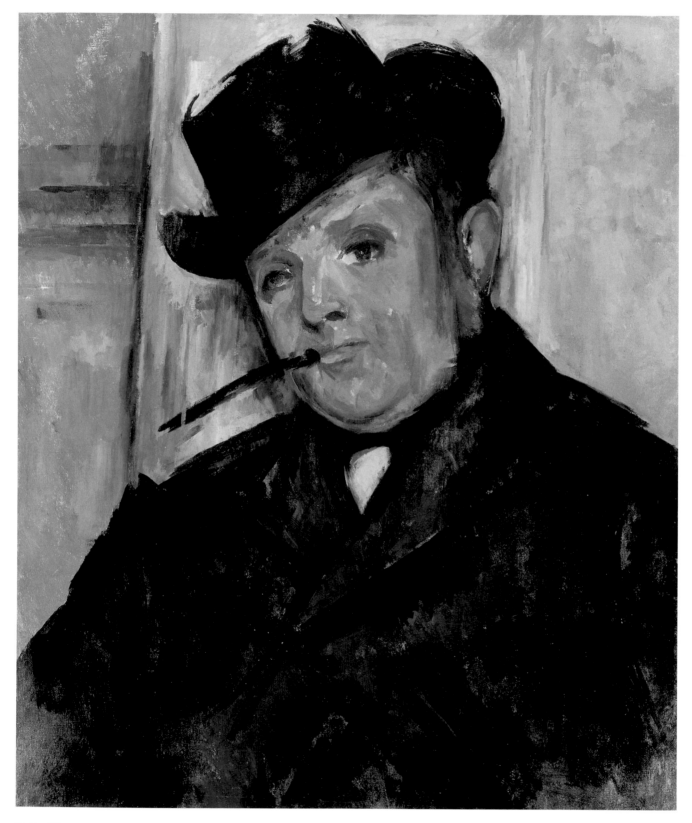

PAUL CÉZANNE
French, 1839–1906

Portrait of Henri Gasquet, ca. 1896–97

Oil on canvas, 22⅛ x 18½ in.; Venturi catalogue 695
Bequest of Marion Koogler McNay
1950.22

PAUL CÉZANNE
French, 1839–1906
Houses on the Hill, 1900–1906

Oil on canvas, 25⅜ x 31⅜ in.; Venturi catalogue
1528
Bequest of Marion Koogler McNay
1950.23

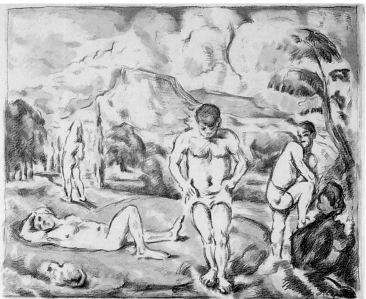

PAUL CÉZANNE
French, 1839–1906
The Bathers, 1898

Lithograph, image 16¾ x 20½ in.;
Venturi catalogue 1157
Gift of Emily Wells Brown
1960.6

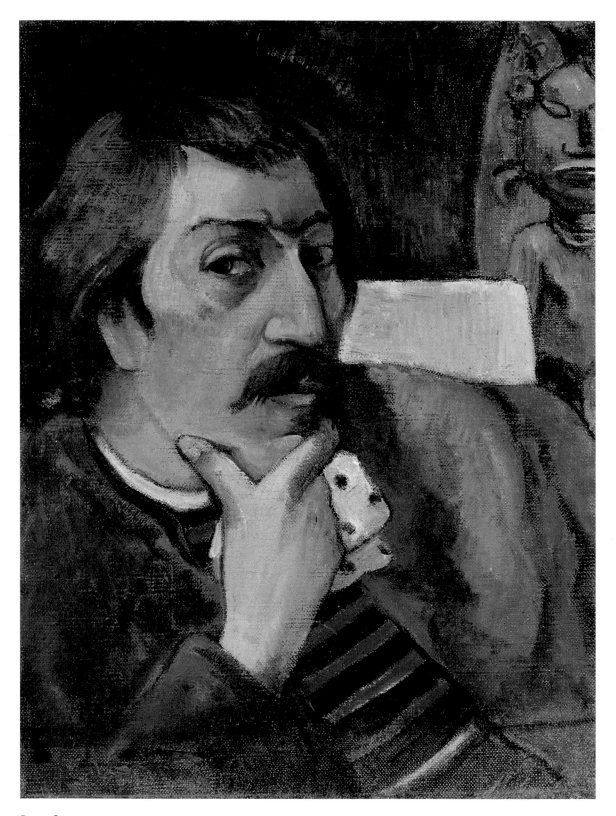

PAUL GAUGUIN
French, 1848–1903
Portrait of the Artist with the Idol, ca. 1893

Oil on canvas, 17¼ x 12⅞ in., Wildenstein
catalogue 415
Bequest of Marion Koogler McNay
1950.46

PAUL GAUGUIN

French, 1848–1903

Sister of Charity, 1902

Oil on canvas, 25¾ x 30 in., Wildenstein
catalogue 617
Bequest of Marion Koogler McNay
1950.47

PAUL GAUGUIN

French, 1848–1903

Eve, 1889

Watercolor and pastel on paper; 13¼ x 12¼ in.,
Wildenstein catalogue 333
Bequest of Marion Koogler McNay
1950.45

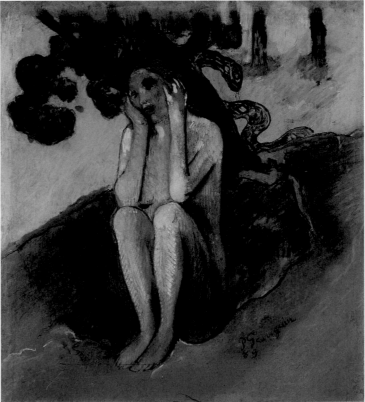

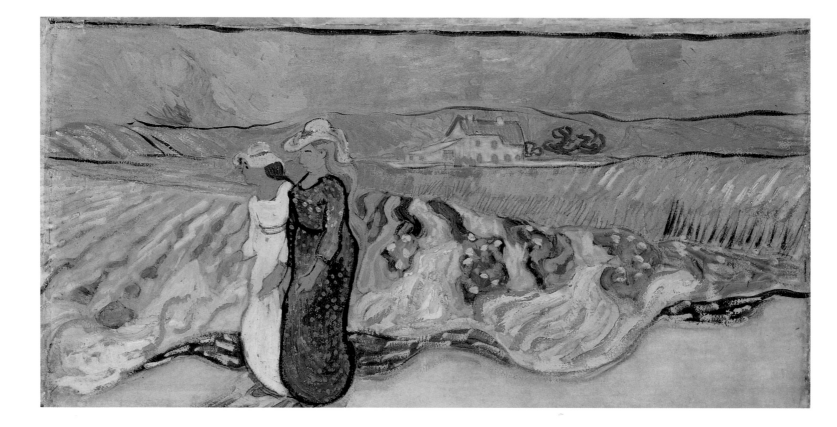

VINCENT VAN GOGH
Dutch, 1853–1890
Women Crossing the Fields, 1890

Oil on paper, 11¹⁵⁄₁₆ x 23½ in.; de la Faille
catalogue 819
Bequest of Marion Koogler McNay
1950.49

VINCENT VAN GOGH

Dutch, 1853–1890

Portrait of Dr. Gachet, 1890

Etching, plate 7¹⁄₁₆ x 5⅞ in., de la Faille
catalogue 1664
Gift of the Friends of the McNay
1980.19

PAUL GAUGUIN

French, 1848–1903

Auti te Pape (The Fresh Water Is in Motion),
1893–94

Woodcut, image 8⅛ x 14¼ in., Guérin catalogue 35,
second state of two
Bequest of Mrs. Jerry Lawson
1994.110

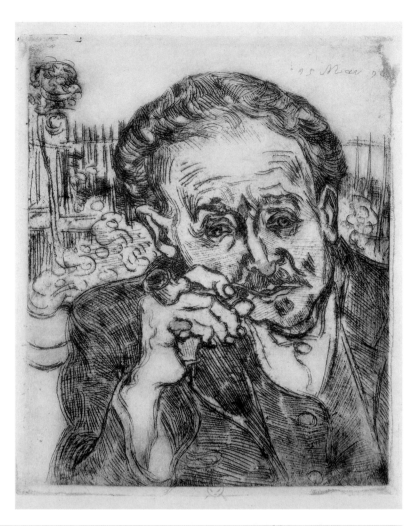

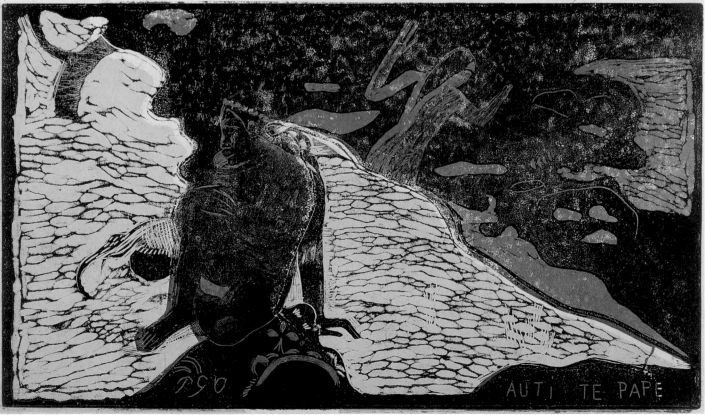

HENRI DE TOULOUSE-LAUTREC
French, 1864–1901
Miss Loie Fuller, 1893

Lithograph, image 14⅜ x 10⅜ in.,
Wittrock catalogue 17
Gift of Robert L. B. Tobin
1974.51

JEAN FORAIN
French, 1852–1931
Au Théâtre, ca. 1895

Lithograph, image 8¼ x 11¾ in.,
Guérin catalogue 8
Gift of Janet and Joe Westheimer
1997.50

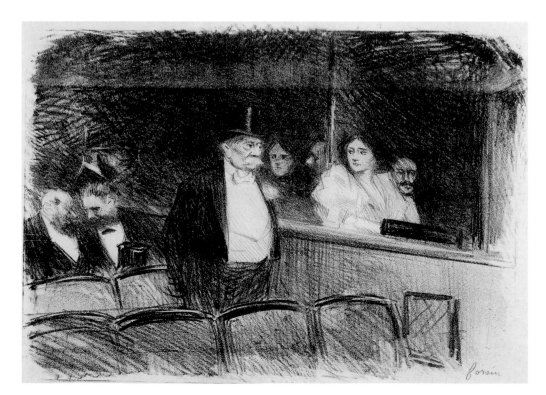

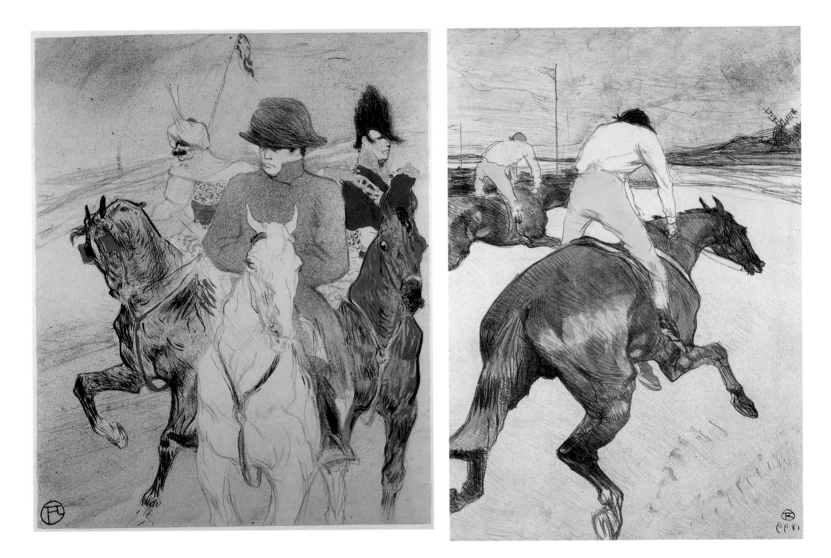

HENRI DE TOULOUSE-LAUTREC
French, 1864–1901
Napoleon, 1895

Lithograph, image 22 1/4 x 17¹¹⁄₁₆ in., Wittrock
catalogue 140
Gift of the Friends of the McNay in memory of
Dr. Wallace E. Moore
1986.31

HENRI DE TOULOUSE-LAUTREC
French, 1864–1901
Le Jockey, 1899

Lithograph, image 20⁵⁄₁₆ x 14¼ in., Wittrock
catalogue 308, second state of two
Museum purchase
1961.3

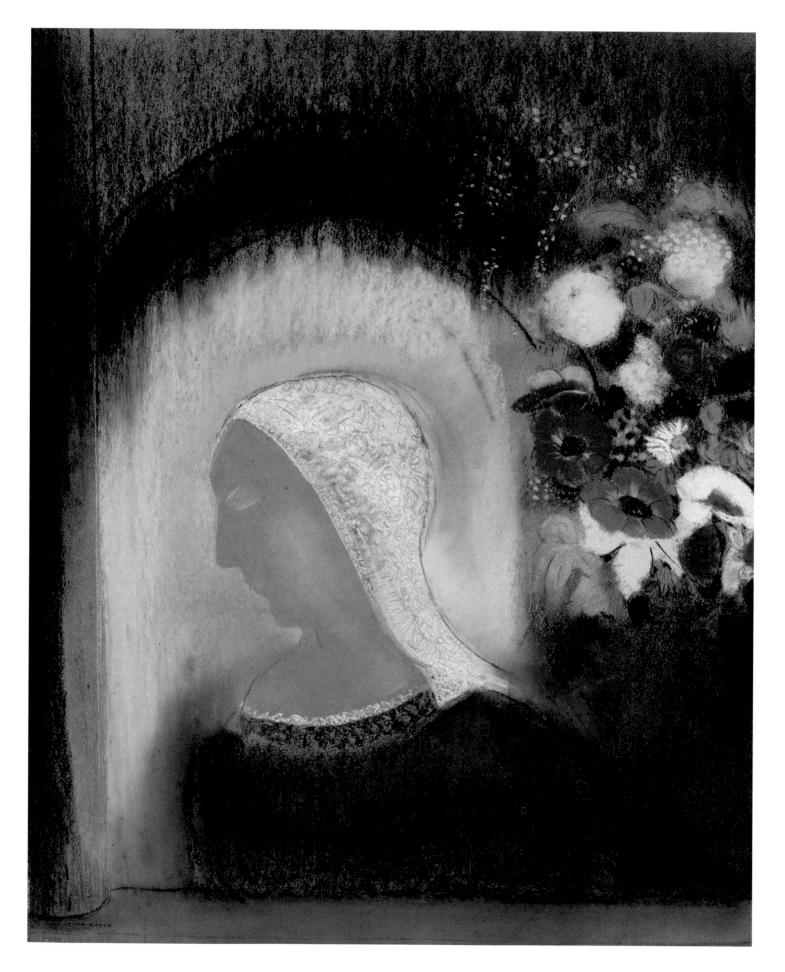

ODILON REDON

French, 1840–1916

Profile and Flowers, 1912

Pastel on paper, 27⅝ x 21¾ in.,
Wildenstein catalogue 317
Bequest of Marion Koogler McNay
1950.117

ODILON REDON

French, 1840–1916

*Le Centaur Visant les Nues (Centaur
Aiming at the Skies),* 1895

Lithograph, sheet 12⅜ x 9⅞ in., Mellerio
catalogue 133
Gift of Robert L. B. Tobin and the Friends
of the McNay
1966.7

HENRI ROUSSEAU

French, 1844–1910

Landscape with Milkmaids, 1906

Oil on canvas, 16¼ x 20¾ in., Certigny
catalogue 234
Bequest of Marion Koogler McNay
1950.131

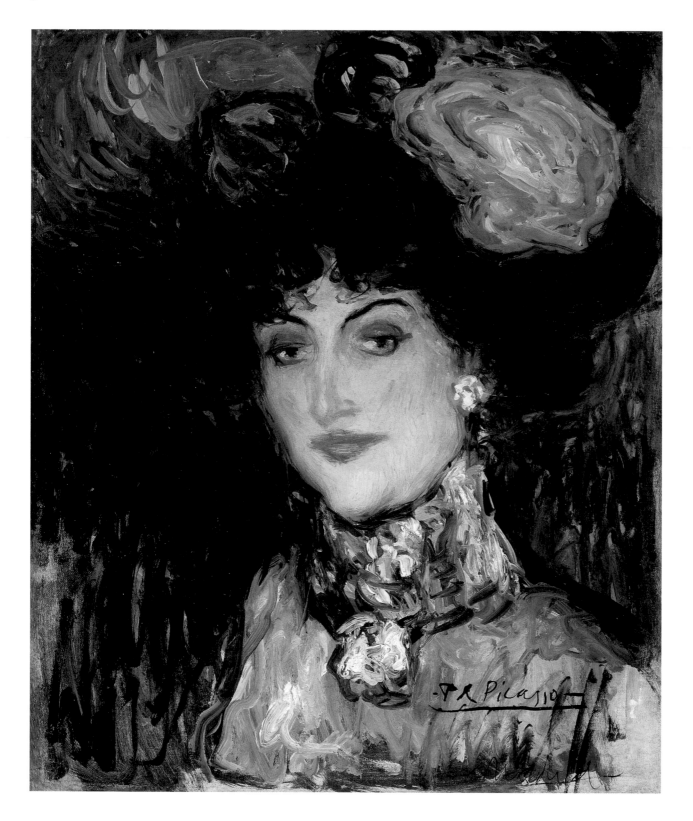

PABLO PICASSO
Spanish, 1881–1973
Woman with a Plumed Hat, 1901

Oil on canvas, 18⅜ x 15⅛ in., Zervos catalogue 39
Bequest of Marion Koogler McNay
1950.113

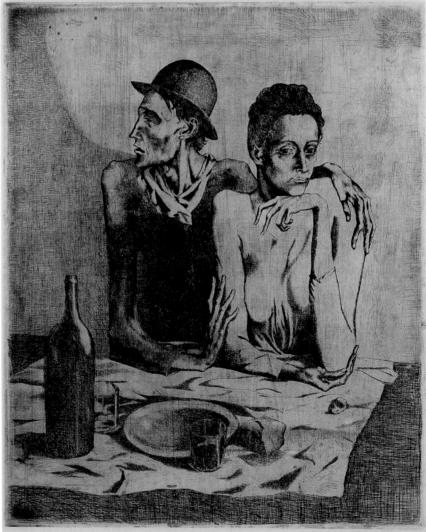

PABLO PICASSO
Spanish, 1881–1973
Sailors, 1903

Watercolor on paper, 12½ x 8⅞ in.,
Zervos catalogue 376
Bequest of Marion Koogler McNay
1950.114

PABLO PICASSO
Spanish, 1881–1973
Le Repas Frugal (The Frugal Meal) from
Les Saltimbanques, 1904

Etching, plate 18³⁄₁₆ x 14⅞ in., Bloch catalogue 1
Bequest of Mrs. Jerry Lawson
1994.152

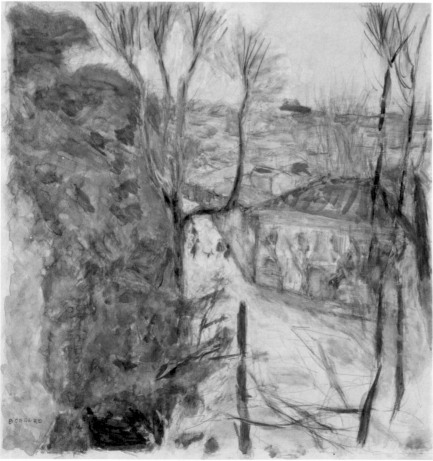

PIERRE BONNARD
French, 1867–1947
Children Playing, 1901

Oil on board mounted on panel, 14 x 22 in.,
Dauberville catalogue 259
Gift of Dr. and Mrs. Frederic G. Oppenheimer
1955.3

PIERRE BONNARD
French, 1867–1947
Autumn Landscape

Watercolor and graphite on paper, 12⅞ x 12¼ in.
Bequest of Marion Koogler McNay
1950.15

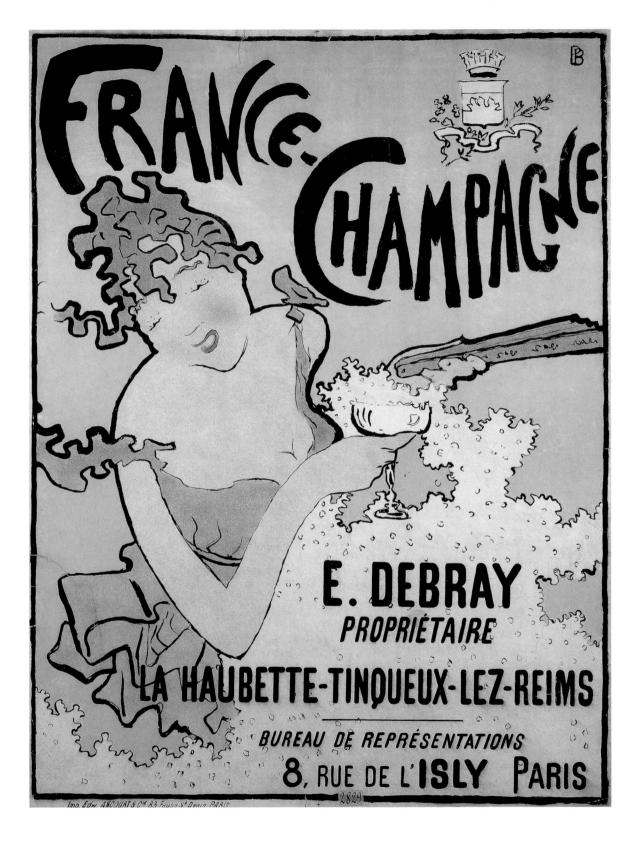

PIERRE BONNARD
French, 1867–1947
France-Champagne, 1889

Lithograph, image 30¾ x 23⅛ in.
Mary and Sylvan Lang Collection
1975.87

GEORGES MINNE
Belgian, 1866–1944
L'Homme à l'Outre (Man with a Watersack),
1899

Bronze, 25⅜ in. high
Museum purchase from the Peggy and
Victor Creighton Fund
2000.75

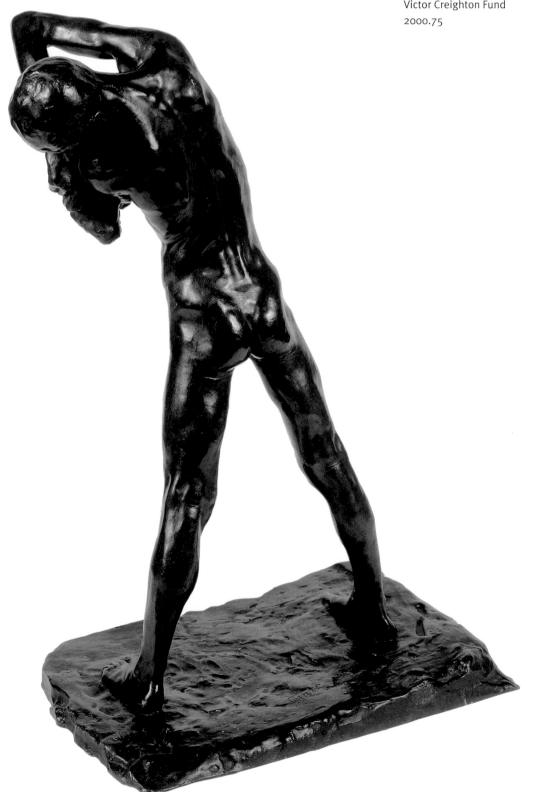

HECTOR GUIMARD
French, 1867–1942
Écritoire-Bibliothèque (Writing Desk–
Bookcase), ca. 1900–1905

Pearwood, 83 x 57 x 26½ in.
Gift of Jeanne and Irving Mathews
1991.93

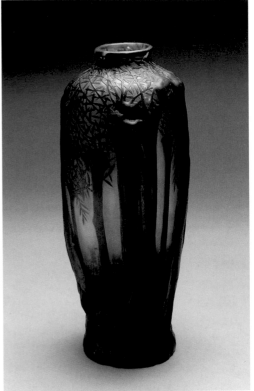

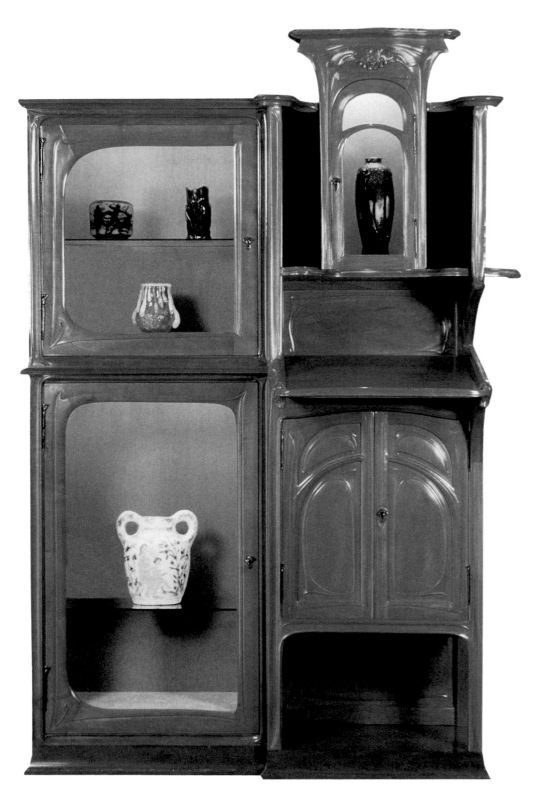

DAUM FRÈRES
Nancy, France
Vase, ca. 1910–15

Mold-blown cameo glass, 11¼ in. high,
4½ in. diameter
Gift of Jeanne and Irving Mathews
1992.20

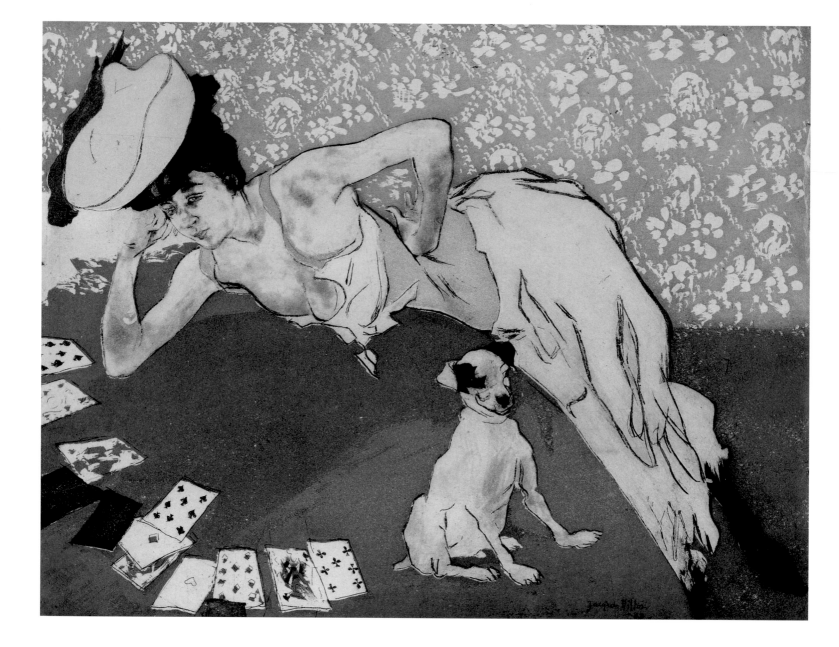

JACQUES VILLON
French, 1875–1963
Les Cartes (The Cards), 1903

Etching and aquatint, plate 13⅝ x 17⅝ in.,
Ginestet et Pouillon catalogue E76
Gift of Robert L. B. Tobin
1963.4

JACQUES VILLON
French, 1875–1963
Comédie de Société (Social Drama), 1903

Etching and aquatint, plate 19⁹⁄₁₆ x 16⁷⁄₁₆ in.,
Ginestet et Pouillon catalogue E75
Gift of Robert L. B. Tobin
1966.5

HENRI CARO-DELVAILLE
French, 1876–1926
L'Amateur, ca. 1900

Lithograph, image 16⅝ x 17¹⁵⁄₁₆ in.
Museum purchase with funds from Alice N. Hanszen
1978.9

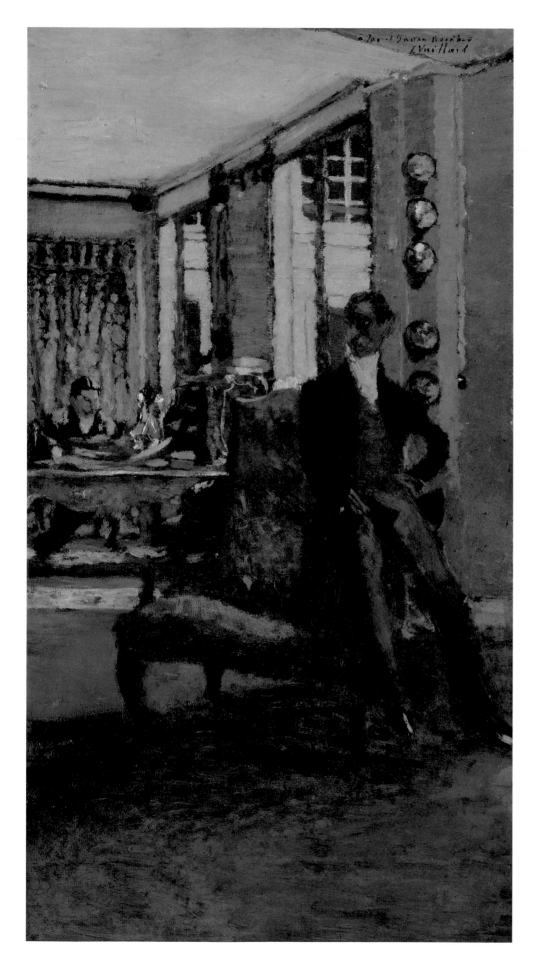

EDOUARD VUILLARD
French, 1869–1940
The Art Dealers (The Bernheim-Jeune Brothers), 1912

Oil on paper mounted on panel, 23 x 12¼ in.
Bequest of Frances Cain
1987.5

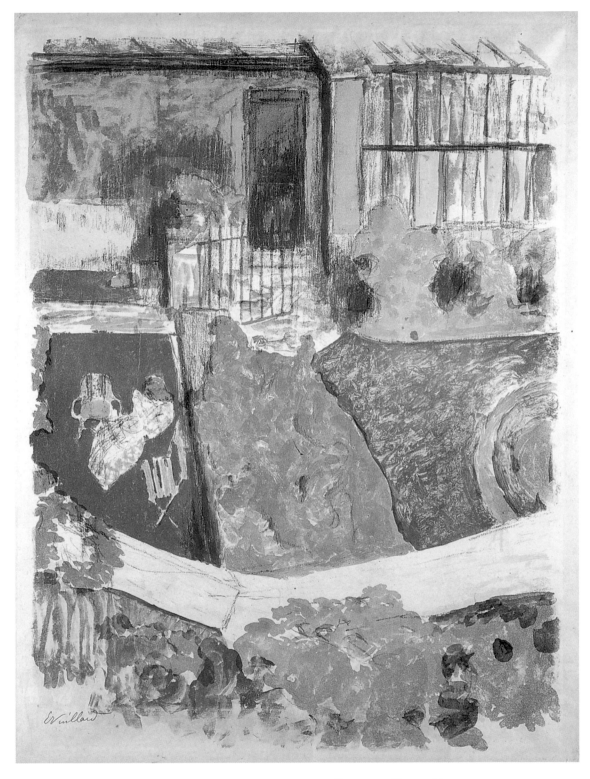

EDOUARD VUILLARD
French, 1868–1940
Le Jardin devant l'Atelier (The Garden in Front of the Studio), **1901**

Lithograph, image 25 x 18¾ in., Roger-Marx catalogue 45
Gift of the Friends of the McNay in memory of Dr. Frederic G. Oppenheimer
1964.2

PIET MONDRIAN
Dutch, 1872–1944
The Tree, ca. 1908

Oil on linen, 43 x 28½ in.; Welsh and
Joosten catalogue A586
Gift of Alice N. Hanszen
1971.1

EDWARD GORDON CRAIG
British, 1872–1966
**Scene design for *The Lady from the Sea*,
1907**

Pastel on board, 19 x 28 in.
Gift of Margaret Batts Tobin
1986.71

THEODORE STEINLEN
Swiss, 1859–1923
Le Chat Noir (The Black Cat), 1896

Lithograph, image 54 x 37½ in.
Gift of the Friends of the McNay
1972.10

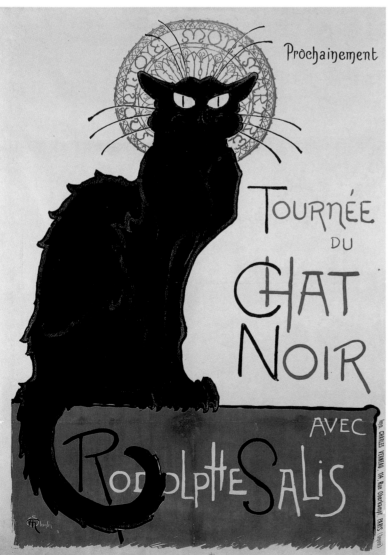

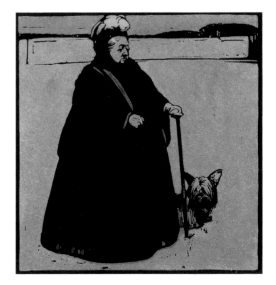

WILLIAM NICHOLSON
British, 1872–1949
Queen Victoria from *Twelve Portraits*, 1899

Woodcut with hand-coloring, image 9⅝ x 8¹⁄₁₆ in.
Gift of the Friends of the McNay
1984.2.1

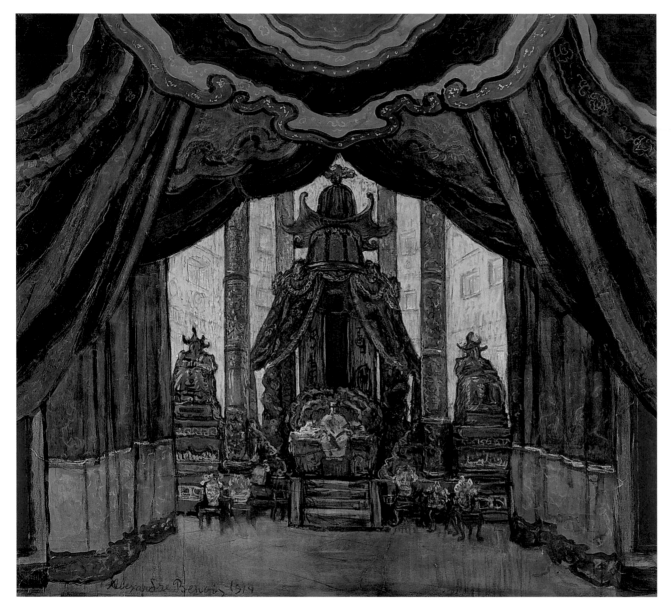

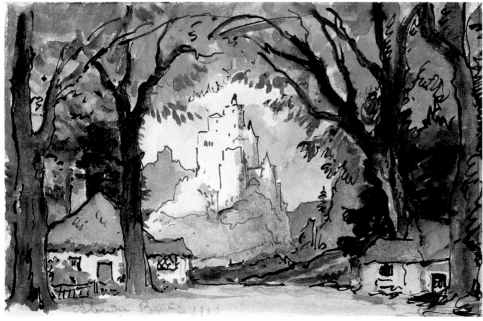

ALEXANDRE BENOIS
Russian, 1870–1960
Scene design for "The King's Bedroom," Act III in *Le Rossignol (The Nightingale)*, 1914

Gouache and pastel on paper mounted on canvas, 38⅝ x 42⁷⁄₁₆ in.
Gift of Robert L. B. Tobin
TL1998.111

ALEXANDRE BENOIS
Russian, 1870–1960
Preliminary scene design for Act I in *Giselle*, 1910

Watercolor, ink, and graphite on paper, 6¾ x 10⅜ in.
Gift of Robert L. B. Tobin
TL1998.103.1

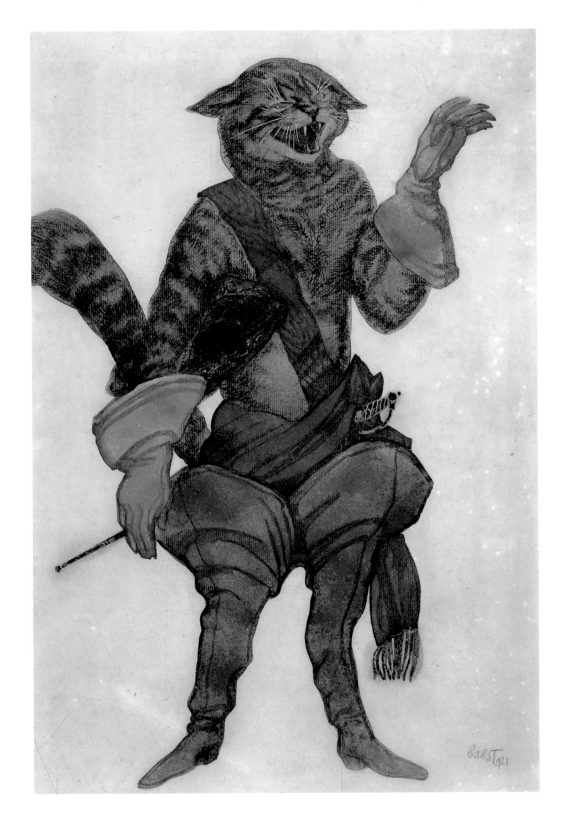

LÉON BAKST
Russian, 1866–1924
Costume design for "Puss in Boots" in
*La Belle au Bois Dormant (The Sleeping
Princess),* **1921**

Watercolor, metallic paint, and graphite on paper
mounted on board, 18¹³⁄₁₆ x 12¾ in.
Gift of Robert L. B. Tobin
TL1998.64

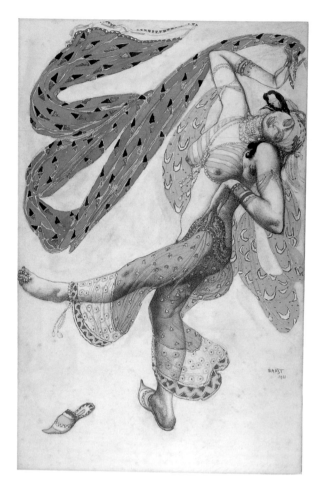

LÉON BAKST

Russian, 1866–1924

Costume design for an odalisque in *Schéhérazade*, **1911**

Gouache, graphite, ink and metallic paint on paper mounted on board, 17¹¹⁄₁₆ x 11¹³⁄₁₆ in.
Gift of Robert L. B. Tobin
TL1999.2

LÉON BAKST

Russian, 1866–1924

Variation of the original scene design for *Schéhérazade*, **after 1910**

Watercolor, metallic paint, and graphite on paper, 29¹⁄₁₆ x 40¾ in.
Gift of Robert L. B. Tobin
TL1998.81

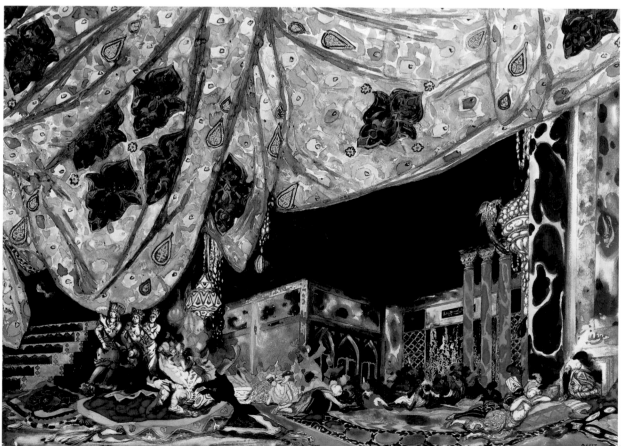

VALENTINE GROSS HUGO
French, 1887–1968
Portrait of Vaslav Nijinsky as La Spectre de la Rose (The Spirit of the Rose), 1913

Graphite on paper, 12³⁄₁₆ x 8⁷⁄₁₆ in.
Promised gift of the Estate of Robert L. B. Tobin

LÉON BAKST
Russian, 1866–1924
Costume design for Vaslav Nijinsky as "Chinese Dancer" in *Les Orientales*, 1917

Watercolor and graphite on paper, 18 x 25³⁄₈ in.
Gift of the Tobin Foundation
TL1998.34

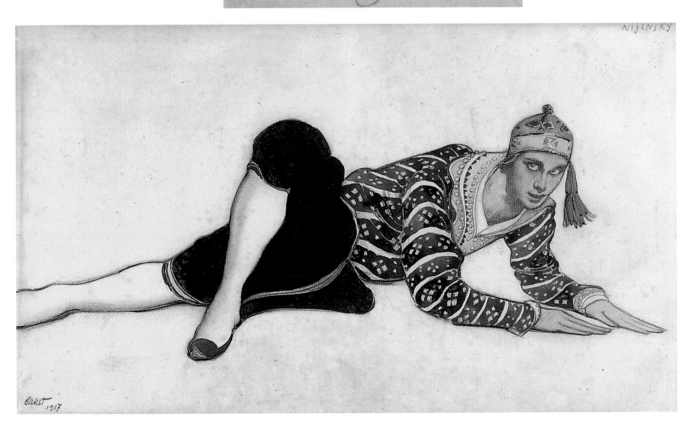

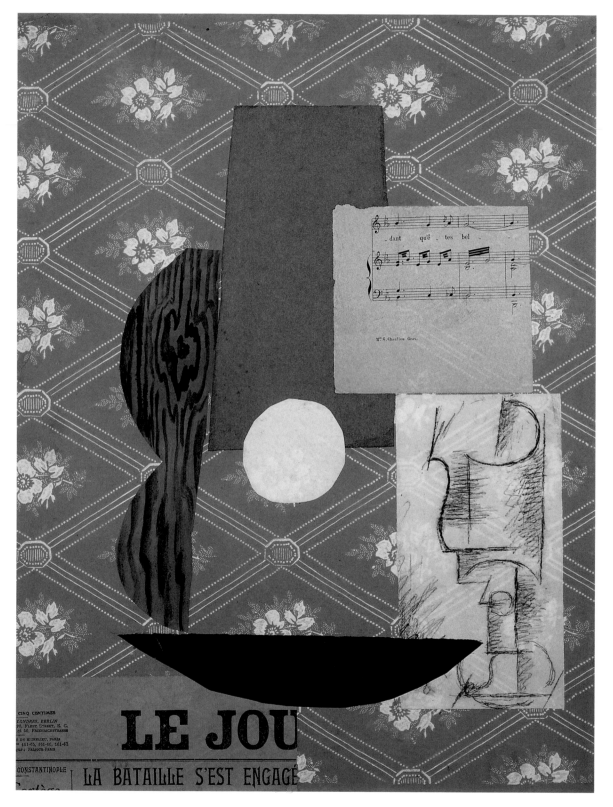

PABLO PICASSO
Spanish, 1881–1973
Guitar and Wine Glass, 1912

Collage and charcoal on board, 18⅞ x 14¾ in.,
Zervos catalogue 423
Bequest of Marion Koogler McNay
1950.112

PABLO PICASSO

Spanish, 1881–1973

Femme Couchée (Seated Woman), 1915

Graphite on paper, 12⅝ x 9¾ in., Zervos
catalogue 842
Mary and Sylvan Lang Collection
1975.46

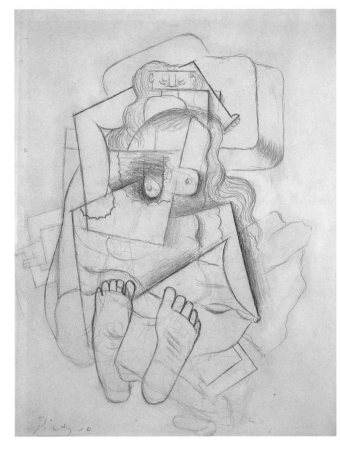

GEORGES BRAQUE

French, 1882–1963

Fox, 1911

Etching and drypoint, plate 21½ x 14¹⁵⁄₁₆ in.,
Vallier catalogue 6
Gift of the Friends of the McNay
1961.13

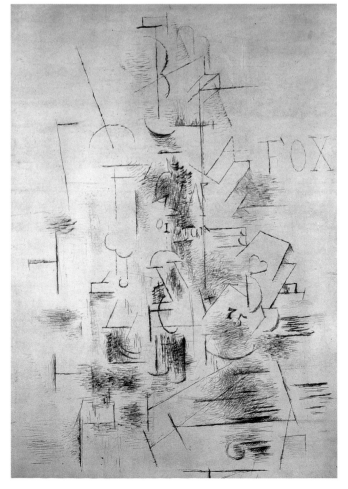

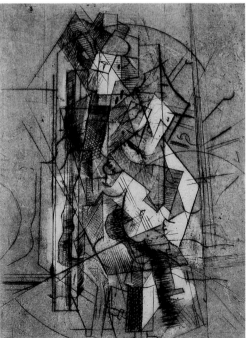

PABLO PICASSO

Spanish, 1881–1973

L'Homme à la Guitare (Man with a Guitar),
1915

Etching, plate 6⅛ x 4½ in., Bloch catalogue 30
Gift of the Friends of the McNay
1968.9

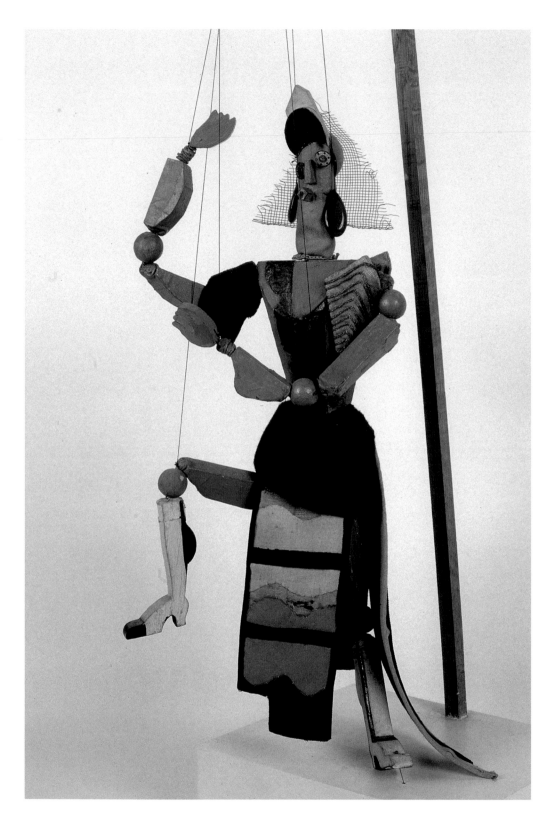

ALEXANDRA EXTER
Russian, 1882–1949
Spanish Dancer Marionette, 1926

Painted wood and found objects, 19 in. high
Gift of Robert L. B. Tobin
1991.5

FERNAND LÉGER
French, 1881–1955
Les Constructeurs, 1920

Lithograph, image 11½ x 9⁵⁄₁₆ in.
Museum purchase
1968.12

LIUBOV POPOVA
Russian, 1889–1924
Preliminary scene design for
The Magnanimous Cuckold, ca. 1920–22

Gouache, ink, and graphite on paper, 6¼ x 10¼ in.
Promised gift of the Estate of Robert L. B. Tobin

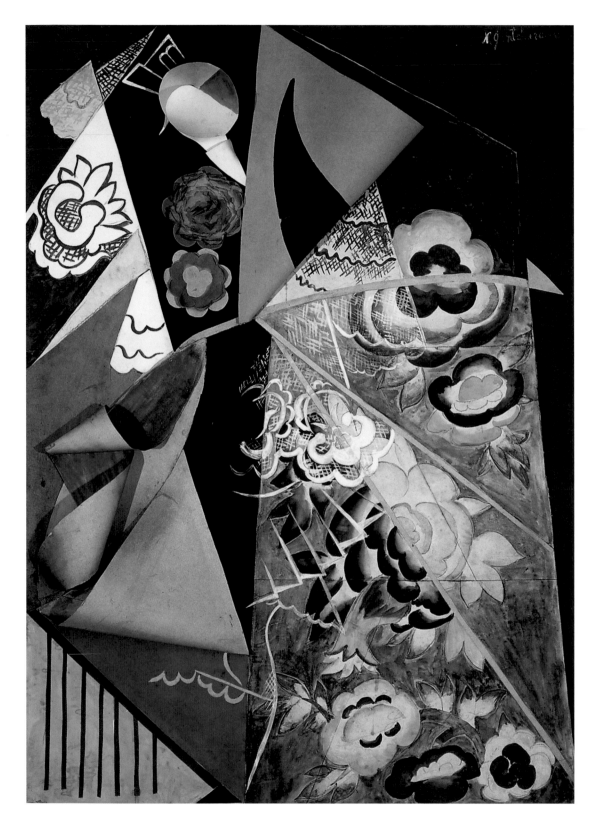

NATALIA GONTCHAROVA
Russian, 1881–1962
Spanish Dancer, 1916

Gouache, collage, watercolor, and graphite
on board, 29¾ x 21 in.
Gift of Robert L. B. Tobin
TL1998.233

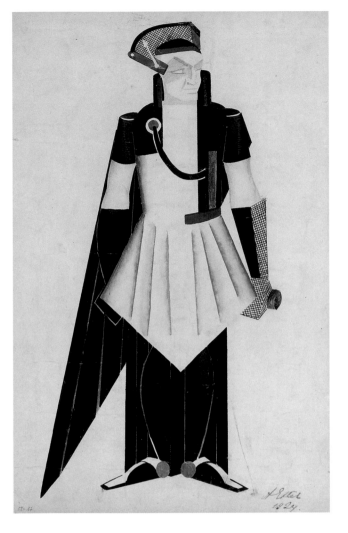

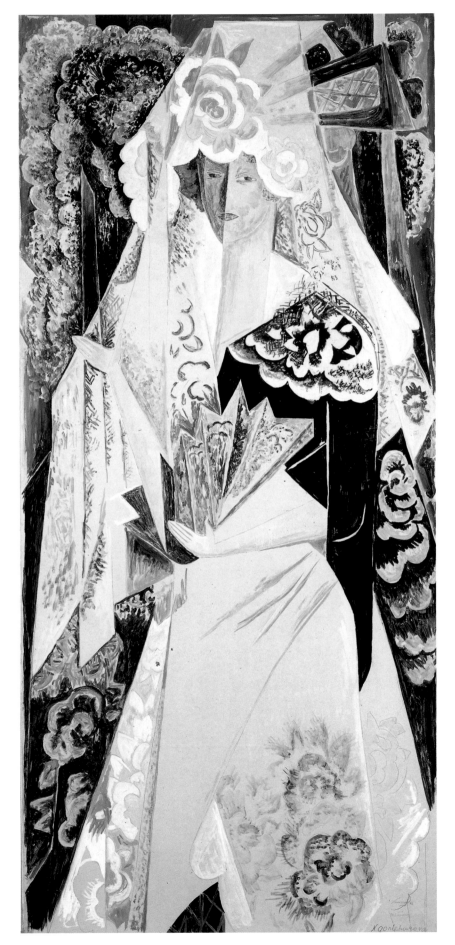

ALEXANDRA EXTER
Russian, 1882–1949
**Costume design for "Chief of Atomic
Power" in** *Aelita*, **1924**

Gouache, ink, and graphite on paper, 19⅛ x 12⅜ in.
Promised gift of the Estate of Robert L. B. Tobin

NATALIA GONTCHAROVA
Russian, 1881–1962
Spanish Dancer, ca. 1916

Oil, crayon, gouache, and graphite on paper,
68¼ x 31 in.
Gift of Robert L. B. Tobin
TL1998.225

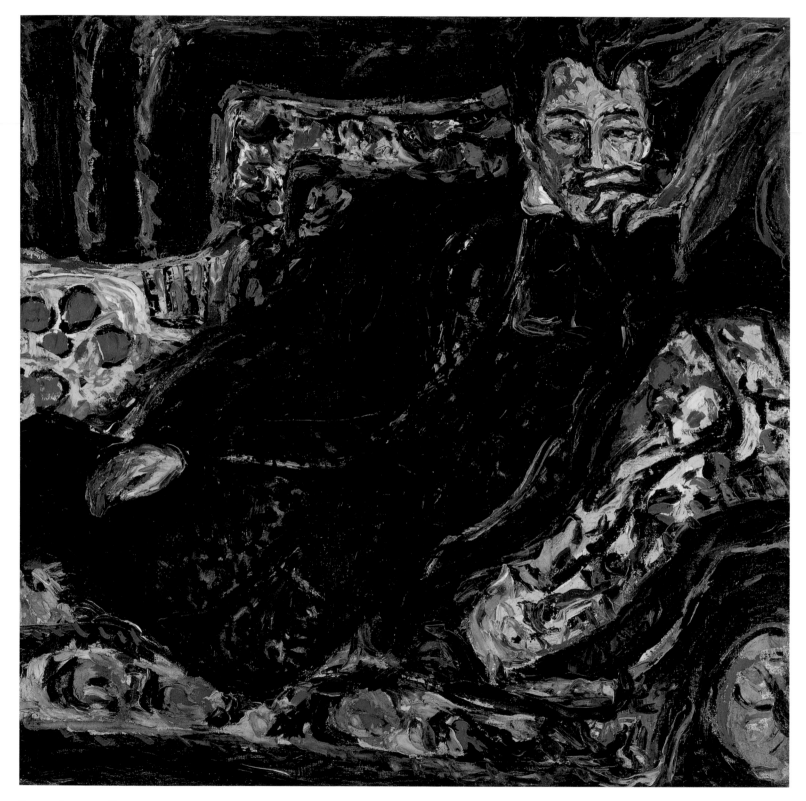

ERNST LUDWIG KIRCHNER
German, 1880–1938
Portrait of Hans Frisch, ca. 1907

Oil on canvas, 44¾ x 44¾ in.
Museum purchase
1963.2

ERNST LUDWIG KIRCHNER
German, 1880–1938
Mann und Sitzende Frau (Man and Seated Woman), 1907

Soft-ground etching, plate 8⅞ x 7¹⁵⁄₁₆ in.,
Dube catalogue 22
Museum purchase in memory of Ruth S. Magurn
and Blanche Magurn Leeper
1992.8

EDVARD MUNCH
Norwegian, 1863–1944
Brothel Scene, 1907

Lithograph, image 16 x 21 in., Woll catalogue 718,
third state of five
Mary and Sylvan Lang Collection
1975.95

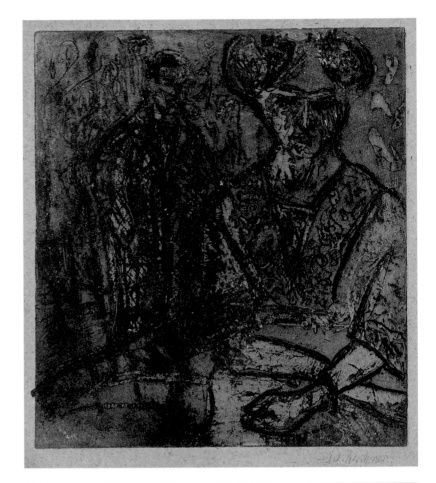

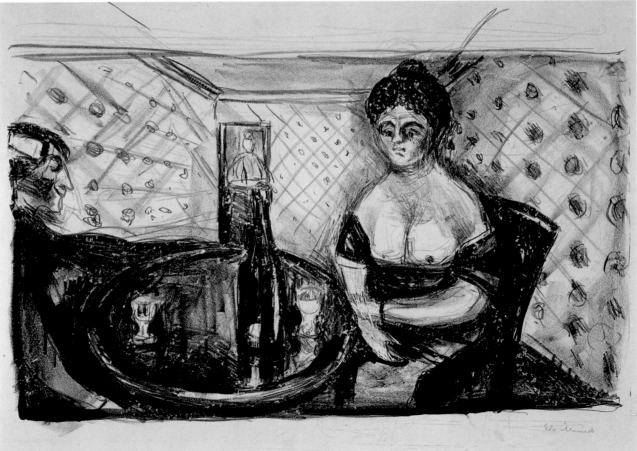

EMIL NOLDE
German, 1867–1956
Steamer, 1910

Etching and aquatint, plate 11¾ x 15¹³⁄₁₆ in.,
Schiefler-Mosel catalogue 135, fourth state of four
Gift of Mrs. Morgan Chaney, by exchange
1997.59

ERNST LUDWIG KIRCHNER
German, 1880–1938
Blankenese, 1910

Lithograph, image 13 x 15⅛ in.,
Dube catalogue 155
Bequest of Ruth S. Magurn
1991.24

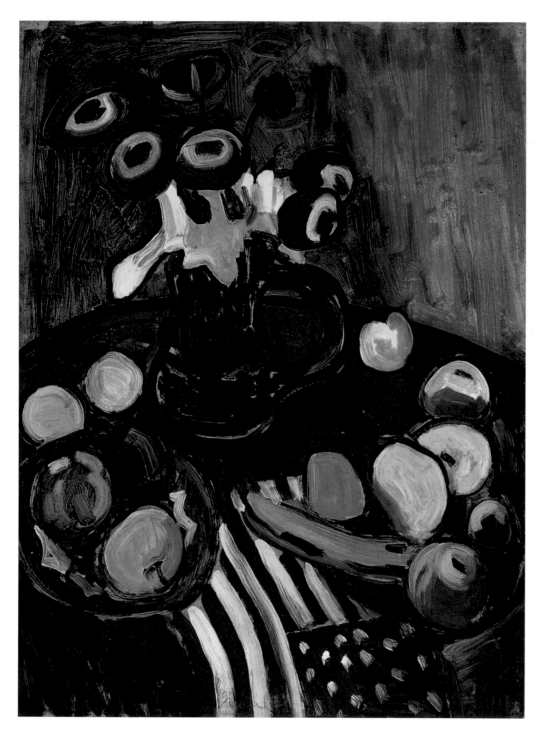

GABRIELE MÜNTER
German, 1877–1962
Still Life, Red, 1909

Oil on board mounted on panel, 20⅞ x 15⅜ in.
Museum purchase with funds from the Ralph A.
Anderson, Jr., Memorial Fund, the Helen and
Everett H. Jones Purchase Fund, and the
Alvin Whitley Fund
1999.1

PAVEL TCHELITCHEV
Russian, 1898–1957
Costume designs for *Coucher de Soleil*
***(The Sunset)*, ca. 1919**

Watercolor, gouache, ink, and graphite on paper,
12 1/16 x 18 3/16 in.
Gift of Robert L. B. Tobin
TL1998.346

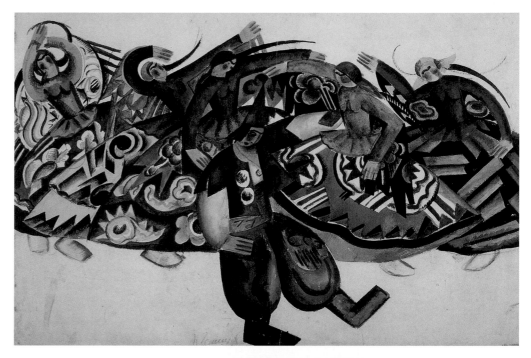

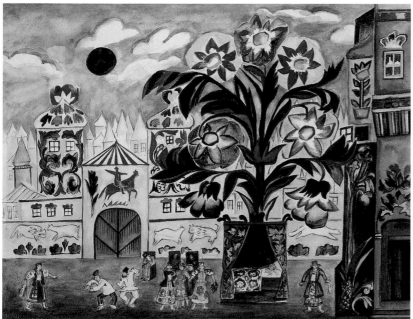

NATALIA GONTCHAROVA
Russian, 1881–1962
Scene design for Act I in *Le Coq d'Or*
***(The Golden Cockerel)*, 1913**

Watercolor, gouache, and graphite on paper,
12 1/4 x 16 in.
Gift of Robert L. B. Tobin
TL1998.173

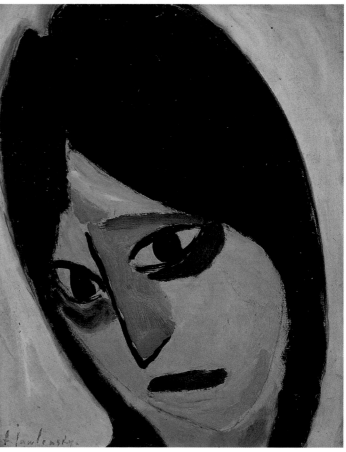

ALEXEY VON JAWLENSKY
Russian, 1864–1941
***Niobe*, 1917**

Encaustic on board, 15 5/8 x 12 1/8 in.
Mary and Sylvan Lang Collection
1975.36

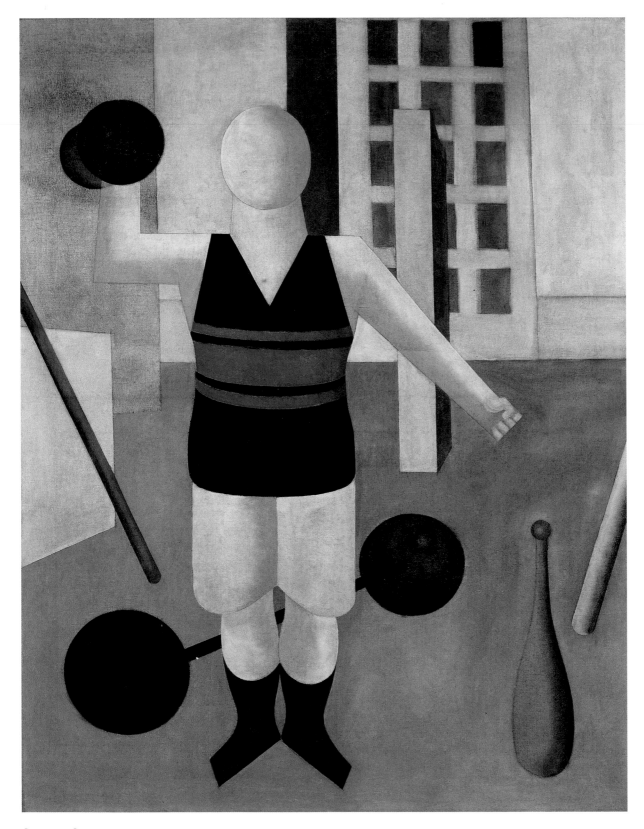

GEORGE GROSZ
American, born Germany, 1893–1959
Der Turner (The Gymnast), ca. 1922

Oil on canvas, 41 x 31½ in.
Gift of Robert L. B. Tobin
1974.26

GEORGE GROSZ
American, born Germany, 1893–1959
Encounter in the Street, 1927

Watercolor, ink, and graphite on paper,
23⅝ x 17¹⁵⁄₁₆ in.
Gift of Robert L. B. Tobin
1974.50

GEORGE GROSZ
American, born Germany, 1893–1959
**Costume designs for "The Bicyclist, the
Rifleman, and Herr Rat" in** *Kanzlist Krehler
(Office Clerk Krehler)*, 1922

Watercolor and ink on paper, 9¹¹⁄₁₆ x 15¹¹⁄₁₆ in.
Promised gift of the Estate of Robert L. B. Tobin

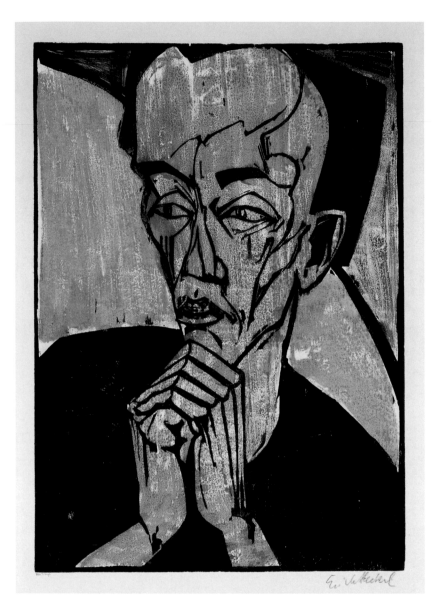

ERICH HECKEL
German, 1883–1970
Portrait of a Man, 1919

Woodcut, image 18³⁄₁₆ x 12¾ in., Dube
catalogue 318, third state of three
Gift of the Friends of the McNay
1962.7

MAX BECKMANN
German, 1884–1950
Self-Portrait with Bowler, 1921

Drypoint, plate 12½ x 9½ in., Gallwitz
catalogue 153
Gift of the Friends of the McNay
1966.4

LYONEL FEININGER
American, 1871–1956
Cathedral, 1919

Woodcut, image 7¹⁄₁₆ x 4¾ in.,
Prasse catalogue 143
Museum purchase
1968.2

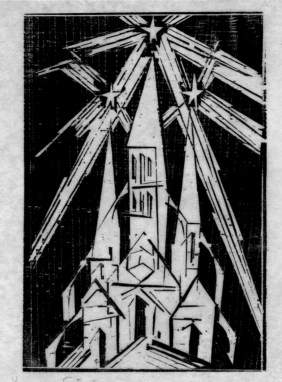

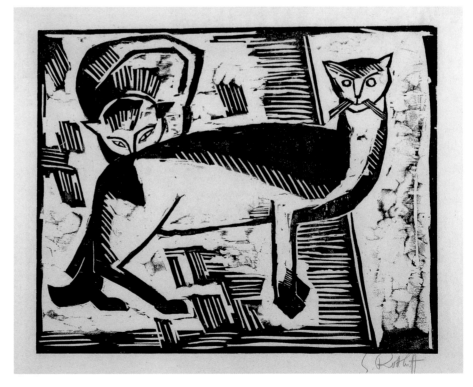

KARL SCHMIDT-ROTTLUFF
German, 1884–1976
Zwei Katzen (Two Cats), 1915

Woodcut, image 15⅝ x 19⁹⁄₁₆ in.,
Schapire catalogue 169
Gift of Robert L. B. Tobin
1963.5

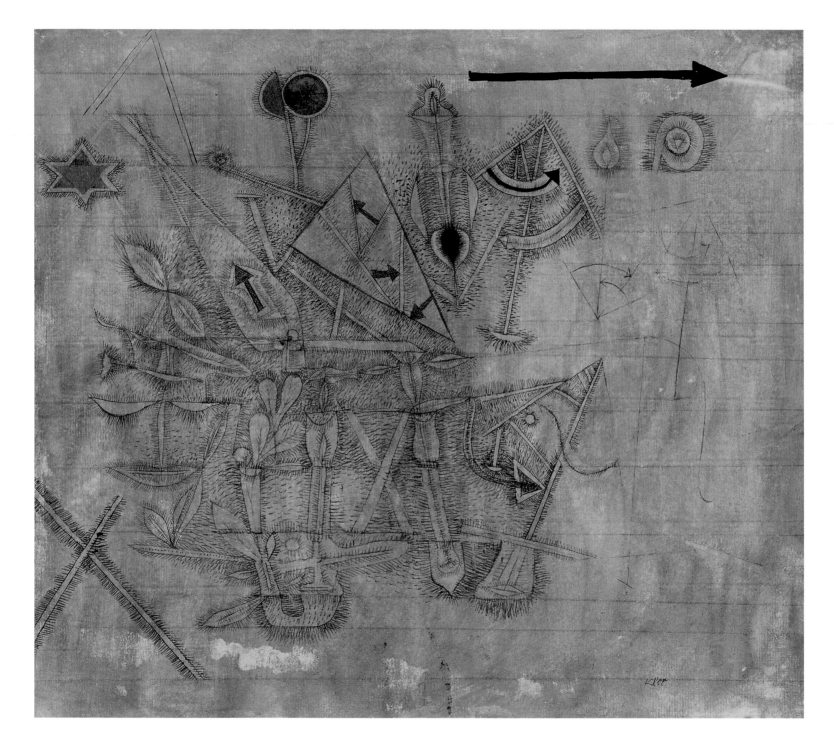

PAUL KLEE
Swiss, 1879–1940
Pflanzliches im Aufbau (Plantlife in the Making), 1924

Watercolor and ink on paper, 11⅛ x 12⁵⁄₁₆ in.,
Helfenstein and Rümelin catalogue 3445
Mary and Sylvan Lang Collection
1975.38

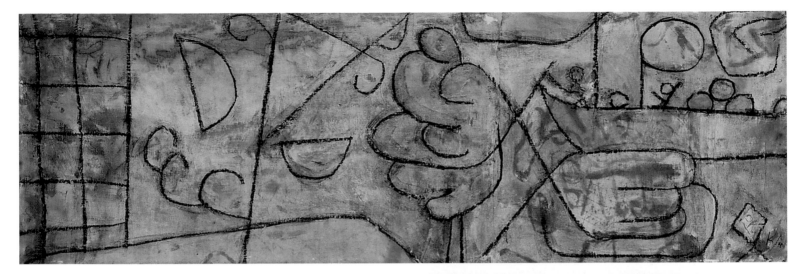

PAUL KLEE
Swiss, 1879–1940
On the River

Watercolor and crayon on handkerchief
mounted on board, 8⅜ x 25⅝ in.
Bequest of Marion Koogler McNay
1950.77

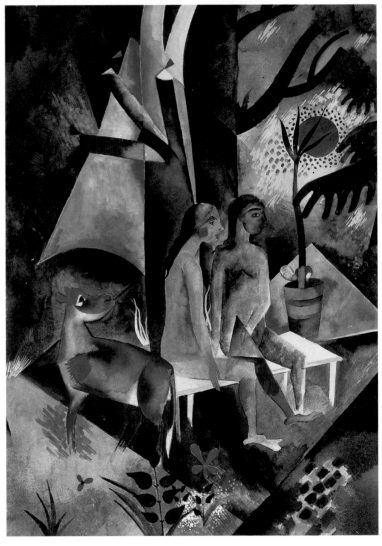

HEINRICH CAMPENDONK
German, 1889–1957
Shepherdesses, ca. 1922–27

Watercolor on paper, 18¾ x 13⅜ in.
Bequest of Marion Koogler McNay
1950.20

JOSEF ALBERS
American, born Germany, 1888–1976
Segments, 1934

Linocut, image 9⁷⁄₁₆ x 11⅛ in.
Gift of the Friends of the McNay in
memory of John Palmer Leeper
1996.22

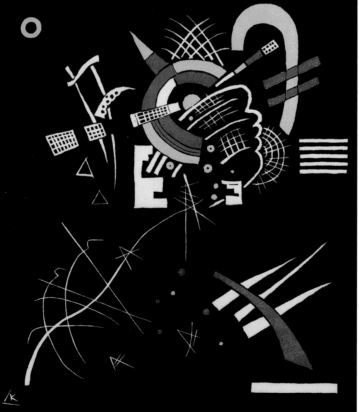

WASSILY KANDINSKY
Russian, 1866–1944
Kleine Welten VII (Small Worlds VII), 1922

Lithograph, image 10⅝ x 9⅛ in.,
Roethel catalogue 164
Gift of Robert L. B. Tobin
1963.3

LYONEL FEININGER
American, 1871–1956
Summer Clouds, 1938

Watercolor and ink on paper, 12⅞ x 18⅛ in.
Bequest of Marion Koogler McNay
1950.41

LÁSZLÓ MOHOLY-NAGY
Hungarian, 1895–1956
Konstruktionen III, 1923

Lithograph, image 23¾ x 11 in.
Gift of the Friends of the McNay
2000.85

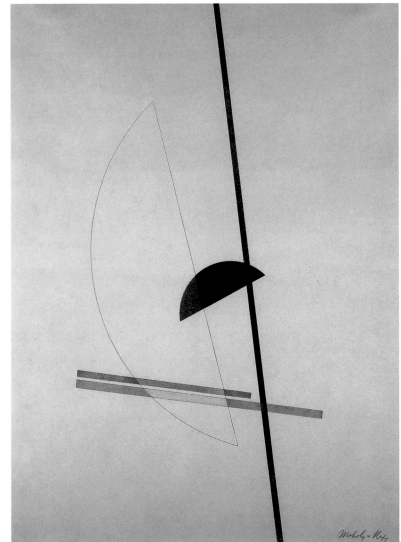

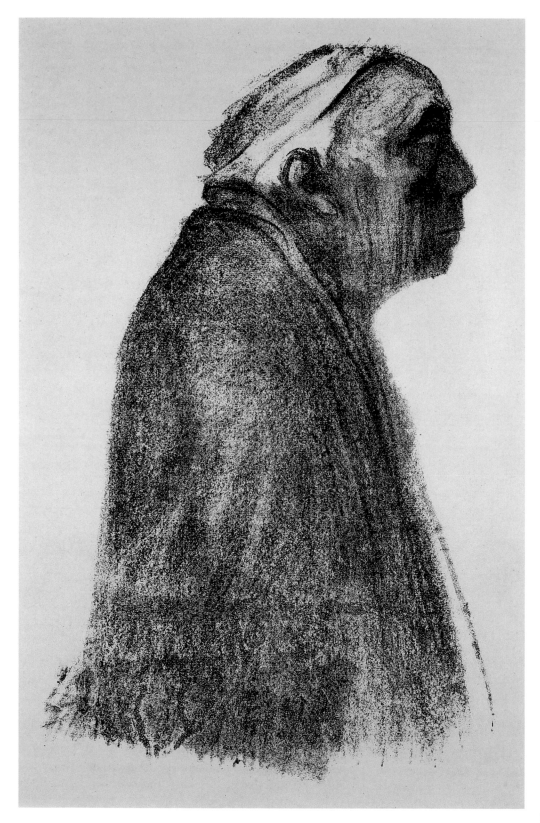

KÄTHE KOLLWITZ
German, 1867–1945
Self-Portrait, 1938

Lithograph, image 24¹³⁄₁₆ x 18⅞ in., Klipstein
catalogue 265, third state of three
Gift of Gilbert M. Denman, Jr.
1976.45

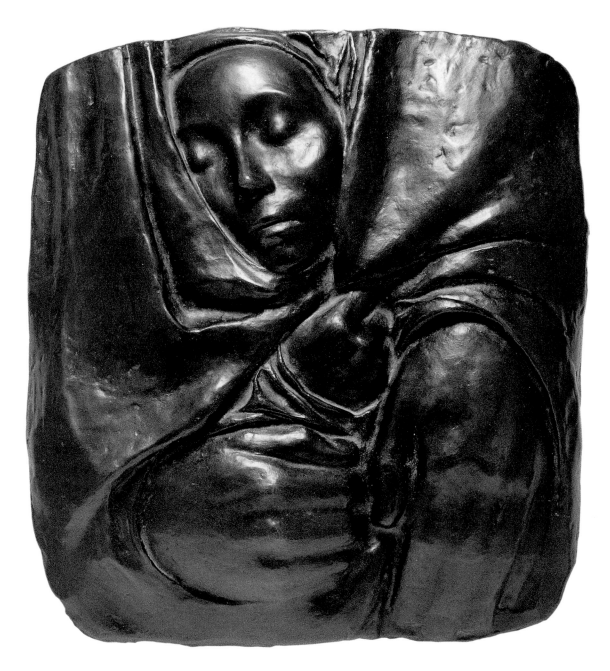

KÄTHE KOLLWITZ
German, 1867–1945
Im Gottes Hand (Rest in the Peace of God's Hands), 1935–36

Bronze, 14 x 13 in.
Mary and Sylvan Lang Collection
1975.64

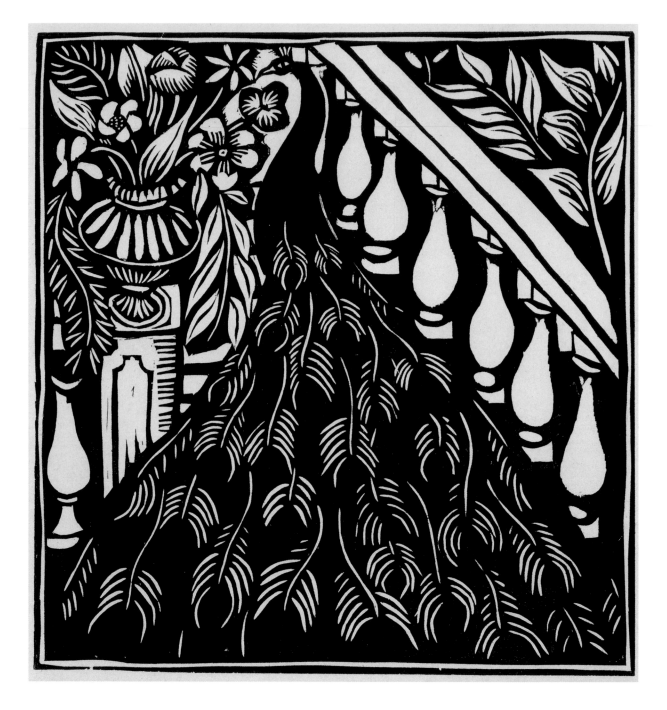

RAOUL DUFY
French, 1877–1953
Le Paon (The Peacock) from *Bestiare
(The Bestiary)*, 1910–11

Woodcut, image 8¹⁄₁₆ x 7½ in.
Gift of the Semmes Foundation
1980.7.27

RAOUL DUFY

French, 1877–1953

Seated Woman—Rosalie, 1929

Oil on canvas, 21⅞ x 18¼ in., Laffaille
catalogue 1801
Bequest of Marion Koogler McNay
1950.39

RAOUL DUFY

French, 1877–1953

La Baigneuse (The Bather), 1918

Lithograph with hand-coloring,
image 20¾ x 14½ in.
Gift of Joe Milam
1980.36

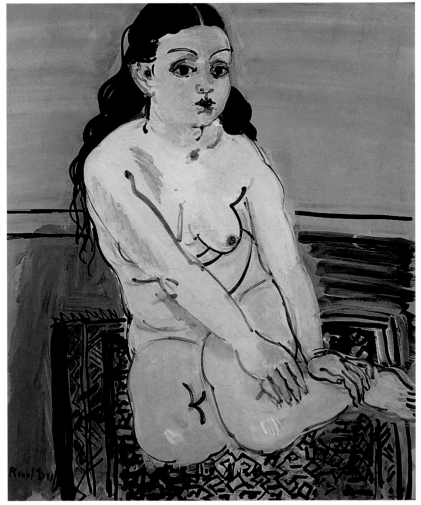

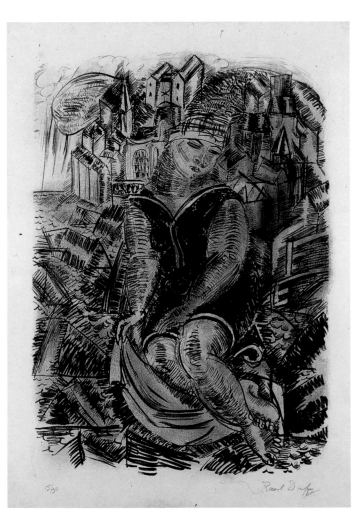

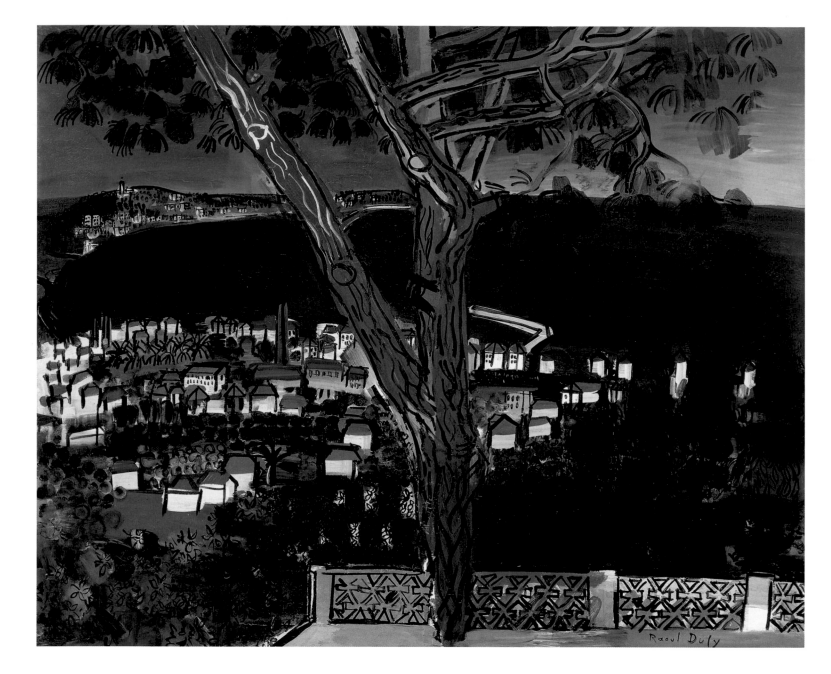

RAOUL DUFY
French, 1877–1953
Golfe Juan, 1927

Oil on canvas mounted on panel,
32³/₁₆ x 39⅝ in., Laffaille catalogue 480
Bequest of Marion Koogler McNay
1950.38

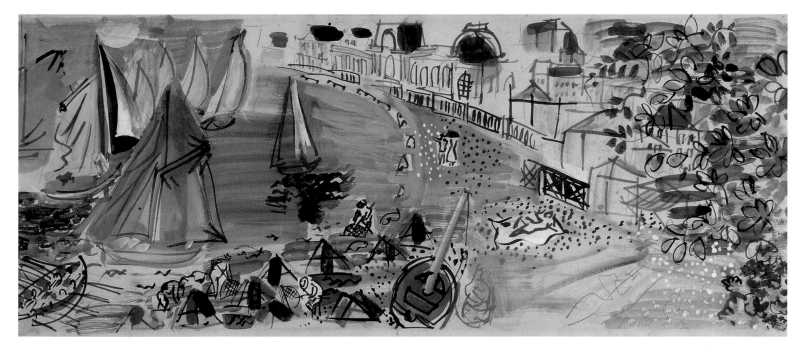

RAOUL DUFY
French, 1877–1953
Beach at Trouville, 1935

Watercolor, crayon and graphite on paper,
10⅜ x 25½ in., Guillon-Laffaille catalogue 1907
Mary and Sylvan Lang Collection
1975.29

MAURICE VLAMINCK
French, 1876–1958
Houses in Martigues, ca. 1913

Woodcut, image 9⅞ x 13¼ in., Bern catalogue 19
Bequest of Mrs. Jerry Lawson
1994.182

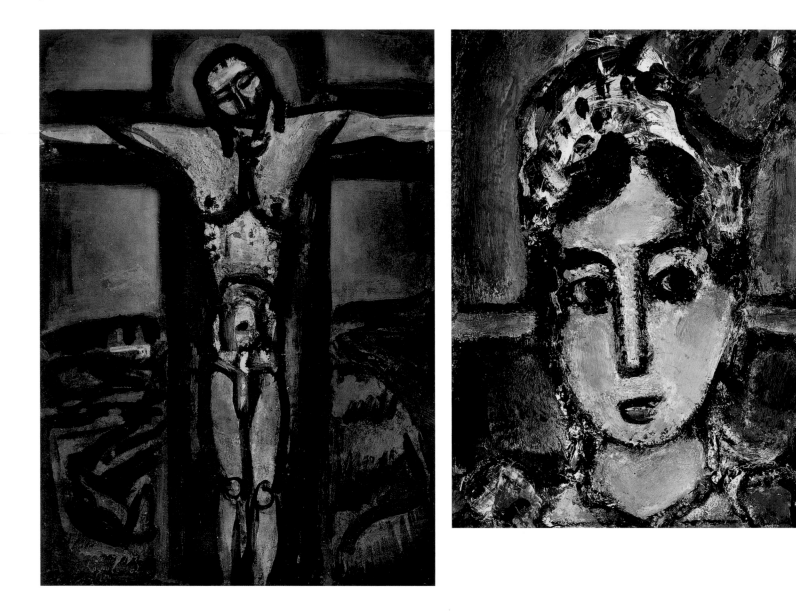

GEORGES ROUAULT
French, 1871–1958
Crucifixion from *Misèrère*, 1922–27

Etching, plate 23 x 16⁷⁄₁₆ in.
Gift of Gilbert M. Denman, Jr., in honor of the
Right Reverend and Mrs. Everett H. Jones
1976.46.20

GEORGES ROUAULT
French, 1871–1958
The Dancer, 1937

Oil on canvas, 14⁵⁄₈ x 10 in., Dorival
catalogue 1872
Bequest of Marion Koogler McNay
1950.129

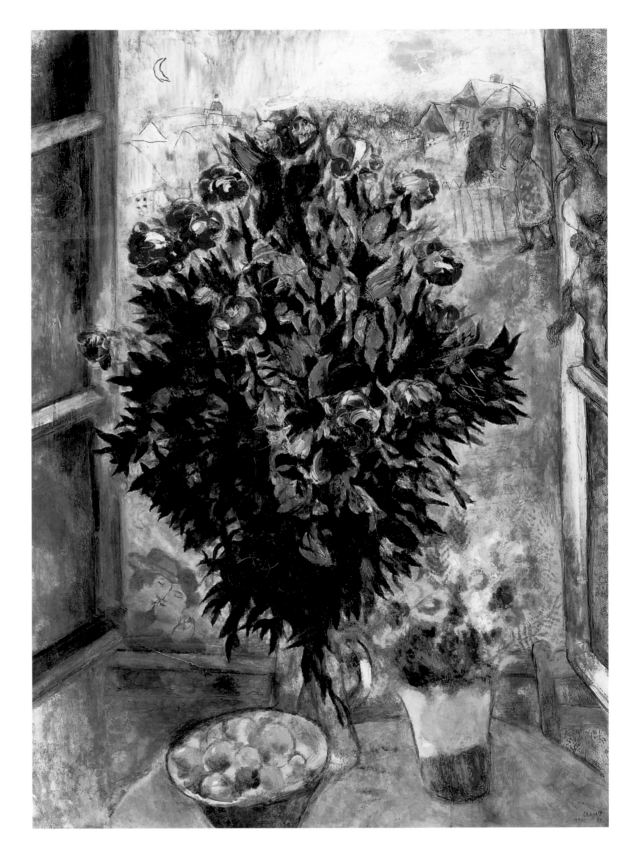

MARC CHAGALL
French, born Russia, 1887–1985
Dream Village, 1929

Oil on canvas, 39½ x 29⅛ in.
Bequest of Marion Koogler McNay
1950.24

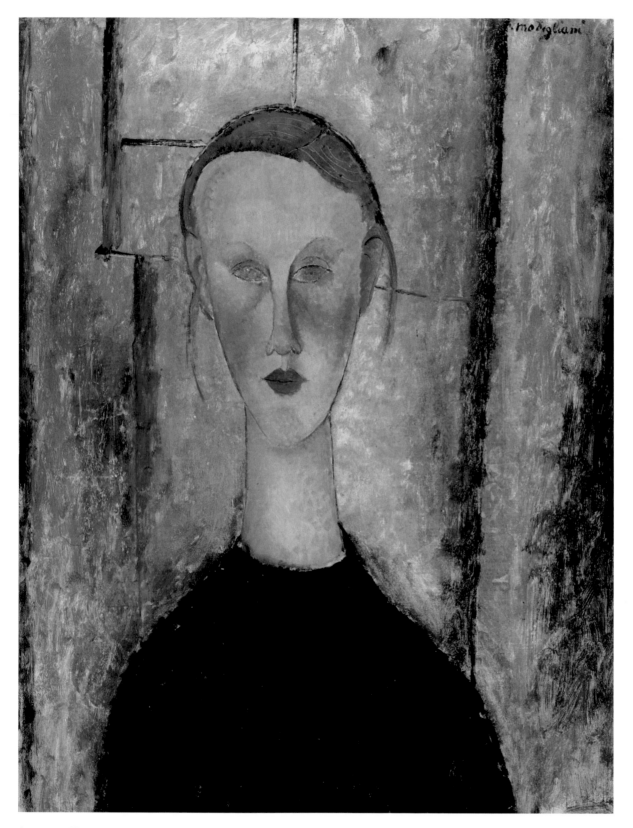

AMEDEO MODIGLIANI

Italian, 1884–1920

Girl with Blue Eyes, 1918

Oil on canvas, 24 x 18¼ in., Patani catalogue 240
Bequest of Marion Koogler McNay
1950.99

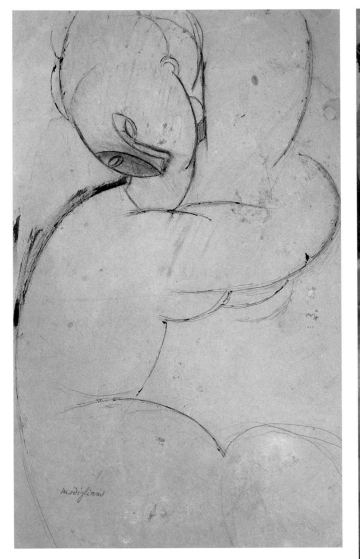

AMEDEO MODIGLIANI
Italian, 1884–1920
Caryatid, 1913

Ink, graphite, and pastel on paper,
16¾ x 10¼ in., Patani catalogue 178
Bequest of Marion Koogler McNay
1950.100

MARIE LAURENCIN
French, 1885–1956
In the Forest, 1916

Oil on canvas, 39⅜ x 26⅜ in.,
Marchesseau catalogue 126
Bequest of Marion Koogler McNay
1950.81

MAURICE UTRILLO
French, 1883–1955
Saint-Ouen, ca. 1912

Oil on canvas, 23⅝ x 31⅞ in.,
Petrides catalogue 302
Gift of Mrs. Donald Alexander
1961.22

CHAIM SOUTINE
French, born Russia, 1894–1943
The Cellist (Portrait of M. Serevitsch),
ca. 1916

Oil on canvas, 31⅞ x 17¾ in., Tuchman
catalogue v. 2, 4
Bequest of Marion Koogler McNay
1950.142

JACOB EPSTEIN
American, 1880–1959
Helene, 1919

Bronze, 24 in. high, Buckle catalogue 157
Gift of the Friends of the McNay
1991.3

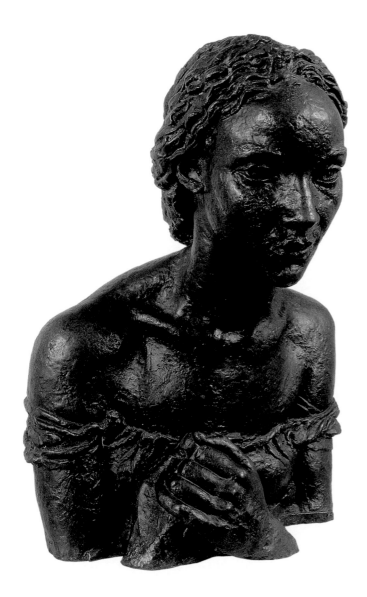

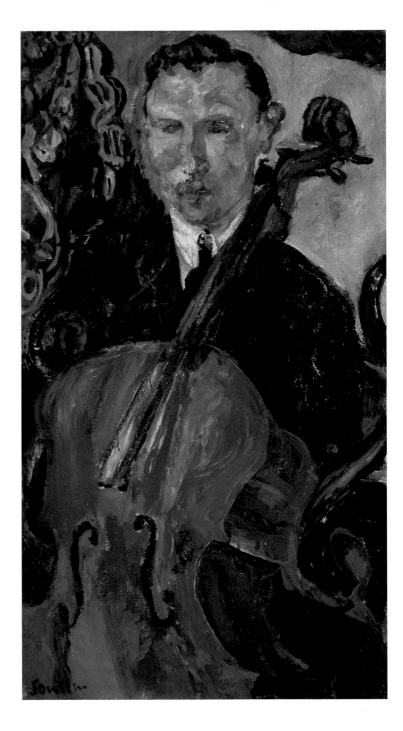

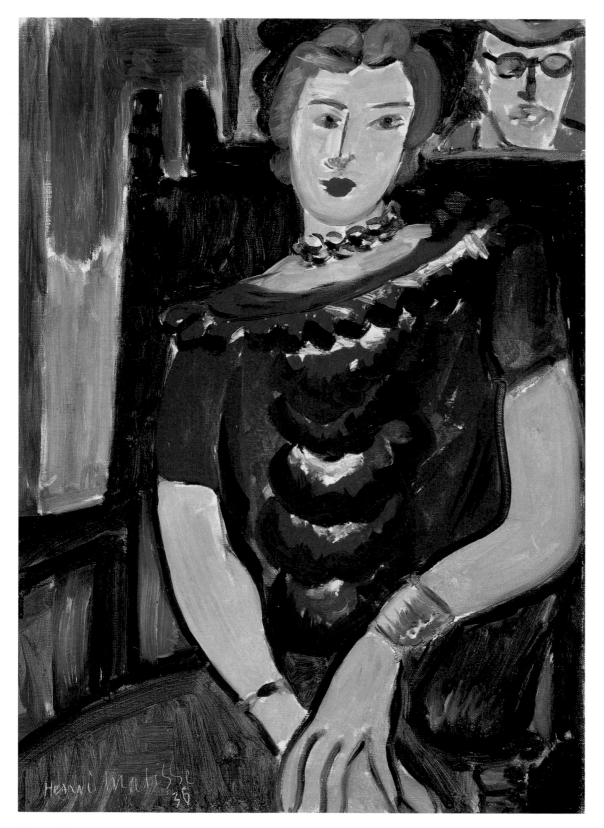

HENRI MATISSE
French, 1869–1954
The Red Blouse, 1936

Oil on canvas, 18⅜ x 13⅛ in.
Bequest of Marion Koogler McNay
1950.98

HENRI MATISSE
French, 1869–1954
Nu au Coussin Bleu (Nude on a Blue Cushion), 1924

Lithograph, image 24⁷⁄₁₆ x 18⁵⁄₈ in.,
Duthuit catalogue 442
Mary and Sylvan Lang Collection
1975.92

HENRI MATISSE
French, 1869–1954
Petit Torse (Small Torso), 1929

Bronze, 4 in. high, Duthuit catalogue 74
Mary and Sylvan Lang Collection
1975.66

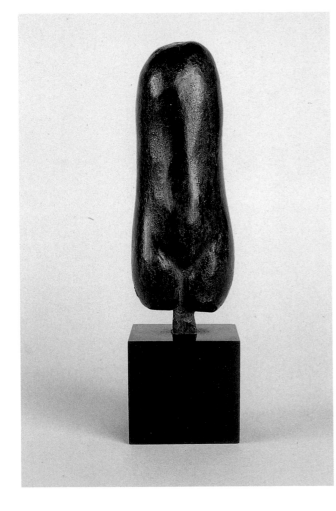

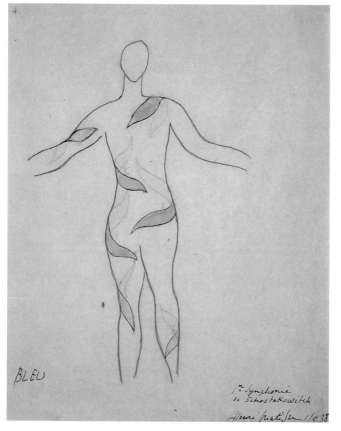

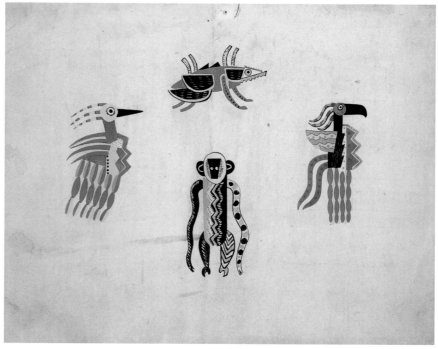

HENRI MATISSE

French, 1869–1954

Costume design for "Bleu" (Blue) in
***Rouge et Noir (Red and Black),* 1939**

Ink, graphite, and watercolor on paper,
10½ x 8³⁄₁₆ in.
Promised gift of the Estate of Robert L. B. Tobin

FERNAND LÉGER

French, 1881–1955

Costume designs for animals in *Création du*
***Monde (Creation of the World),* ca. 1923**

Gouache and ink on paper, 8¹¹⁄₁₆ x 10¹⁵⁄₁₆ in.
Promised gift of the Estate of Robert L. B. Tobin

PABLO PICASSO

Spanish, 1881–1973

Maquette for *Le Tricorne (The Three-Cornered Hat)*, 1919

Watercolor and graphite on board,
6¼ x 10½ x 5½ in.
Promised gift of the Estate of Robert L. B. Tobin

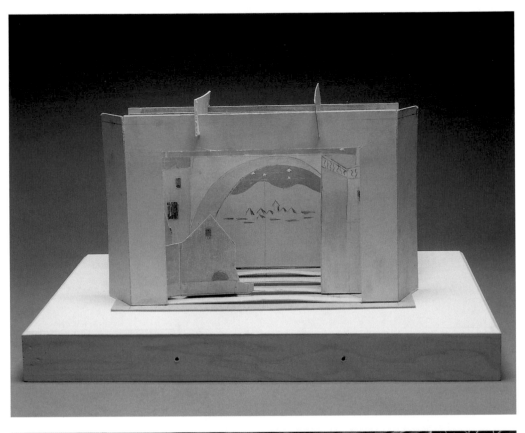

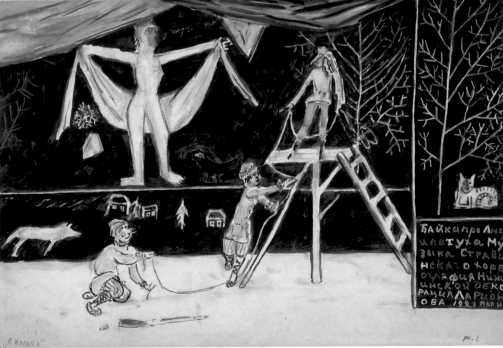

MIKHAIL LARIONOV

Russian, 1895–1964

**Scene design for *Le Renard (The Fox)*,
ca. 1921**

Watercolor, gouache, and graphite on paper,
13¹¹⁄₁₆ x 20⅛ in.
Gift of Robert L. B. Tobin
TL1998.264

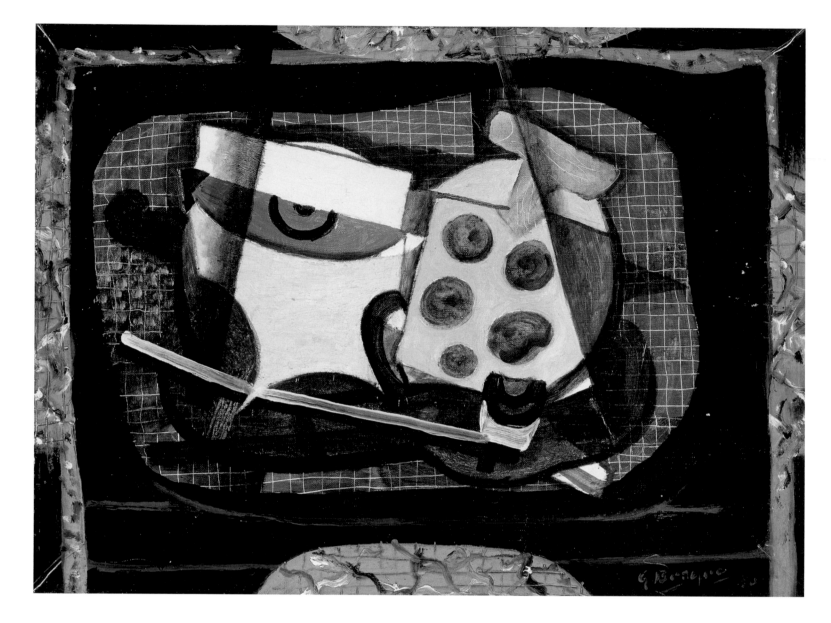

GEORGES BRAQUE
French, 1882–1963
Still Life with Pipe, 1930

Oil on canvas, 9⅝ x 13 in., Maeght catalogue, p. 54
Mary and Sylvan Lang Collection
1975.23

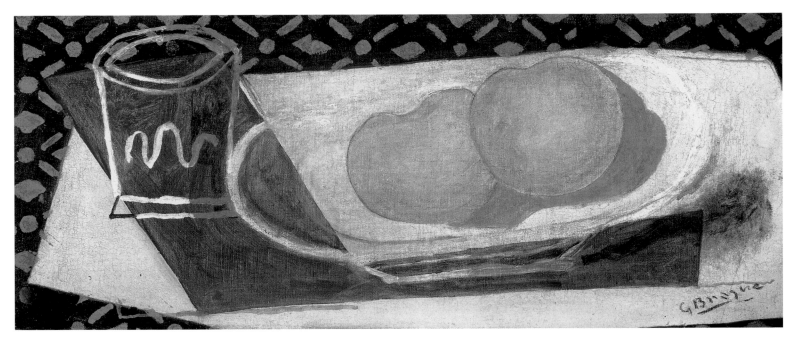

GEORGES BRAQUE

French, 1882–1963

Glass, Two Apples, 1935

Oil on canvas, 7⅞ x 18½ in., Maeght
catalogue, p. 118
Bequest of Marion Koogler McNay
1950.19

GEORGES BRAQUE

French, 1882–1963

Sheet from *Hesiod's Theogonie*, ca. 1932

Etching, plate 14½ x 11¹³⁄₁₆ in., Vallier catalogue 20g
Gift of Mrs. Jerry Lawson
1985.35.5

ALBERT GLEIZES
French, 1881–1953

Aladdin from *Les Quatres Personnages Légendaires du Ciel (The Four Legendary Figures of the Sky)*, 1939–40

Oil on canvas, 121⅝ x 73⅜ in., Varichon catalogue 1601
Gift of Robert L. B. Tobin
1973.17.2

ROBERT DELAUNAY
American, 1885–1941
L'Etoile (The Star), 1926

Lithograph, image 8¼ x 8¼ in.
Gift of the Friends of the McNay
1997.55

PABLO PICASSO
Spanish, 1881–1973
Woman with Crossed Arms, 1946–47

Bronze, 7¹⁵⁄₁₆ in. high, Spies catalogue 312
Mary and Sylvan Lang Collection
1975.71

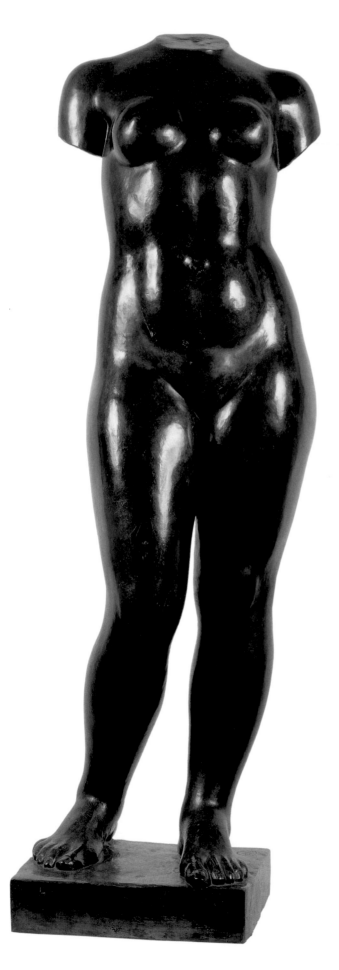

ARISTIDE MAILLOL
French, 1861–1944
La Nymphe, 1930

Bronze, 53¼ in. high
Gift of Emily Wells Brown in memory of
H. Lutcher Brown and F. Lutcher Brown
1975.17

PABLO PICASSO
Spanish, 1881–1973
La Source (The Spring), 1921

Drypoint and engraving, plate 6¹⁵⁄₁₆ x 9¼ in.,
Bloch catalogue 45
Gift of Gilbert M. Denman, Jr.
1974.40

MARCEL GROMAIRE
French, 1892–1971
Côte Basque, 1929

Watercolor and ink on paper, 12⅜ x 16⅝ in.
Bequest of Marion Koogler McNay
1950.57

JULES PASCIN
American, born Bulgaria, 1885–1930
Two Girls in an Armchair, ca. 1927

Oil on canvas, 37 x 32¼ in.
Bequest of Marion Koogler McNay
1950.109

MAURICE VLAMINCK
French, 1876–1958
Portrait of the Artist's Daughter, ca. 1920

Oil on canvas, 16¼ x 13⅛ in.
Bequest of Stella C. Herff
1992.27

JULES PASCIN
American, born Bulgaria, 1885–1930
Boat's Crew from *Caribbean Sketchbook,*
ca. 1920

Watercolor and graphite on paper, 6¾ x 8¼ in.
Bequest of Marion Koogler McNay
1950.531

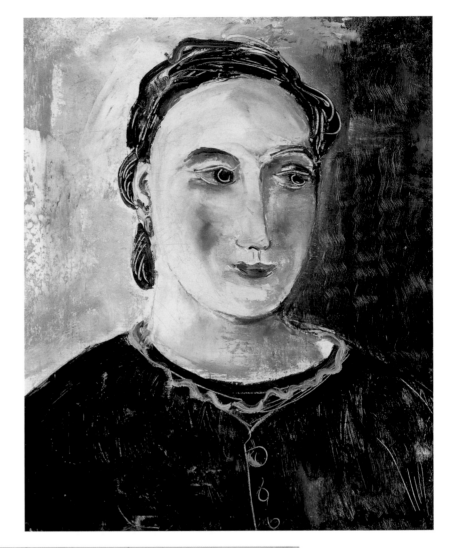

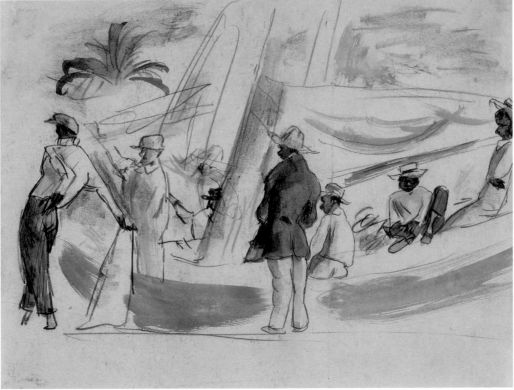

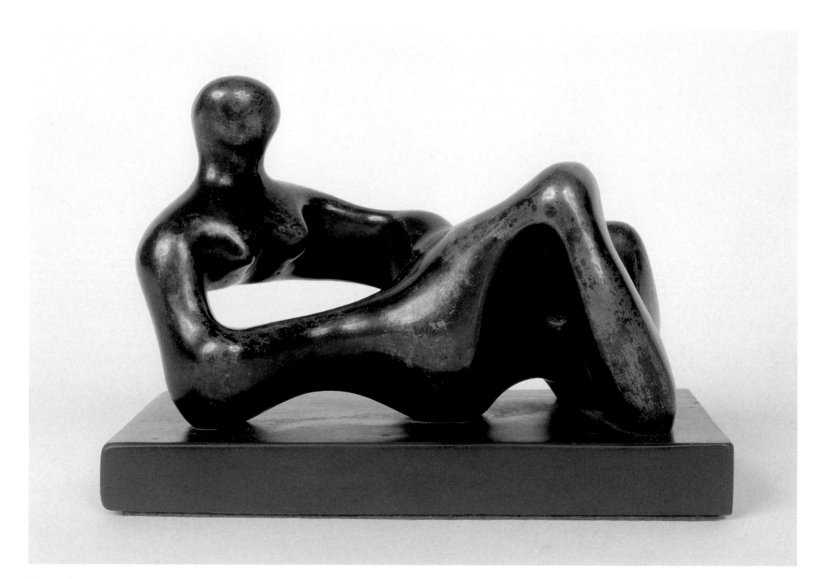

HENRY MOORE
British, 1898–1986
Maquette for Recumbent Figure, 1938

Bronze, 3⅜ in. high, Sylvester catalogue 184
Mary and Sylvan Lang Collection
1975.67

HENRY MOORE
British, 1898–1986
Ideas for Sculpture, 1950

Watercolor, crayon and graphite on paper,
22½ x 15½ in.
Gift of Robert L. B. Tobin
1991.6

HENRY MOORE
British, 1898–1986
Mother and Child in a Ladderback Chair,
1952

Bronze, 16 in. high, Bowness catalogue 313
Mary and Sylvan Lang Collection
1975.68

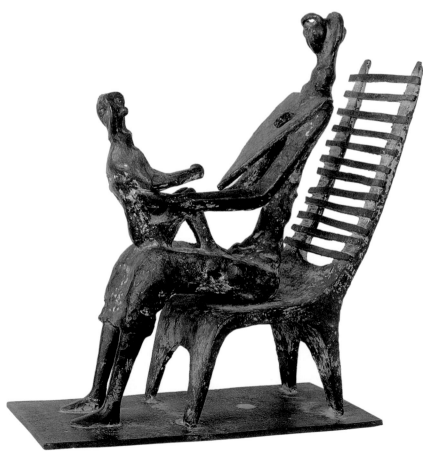

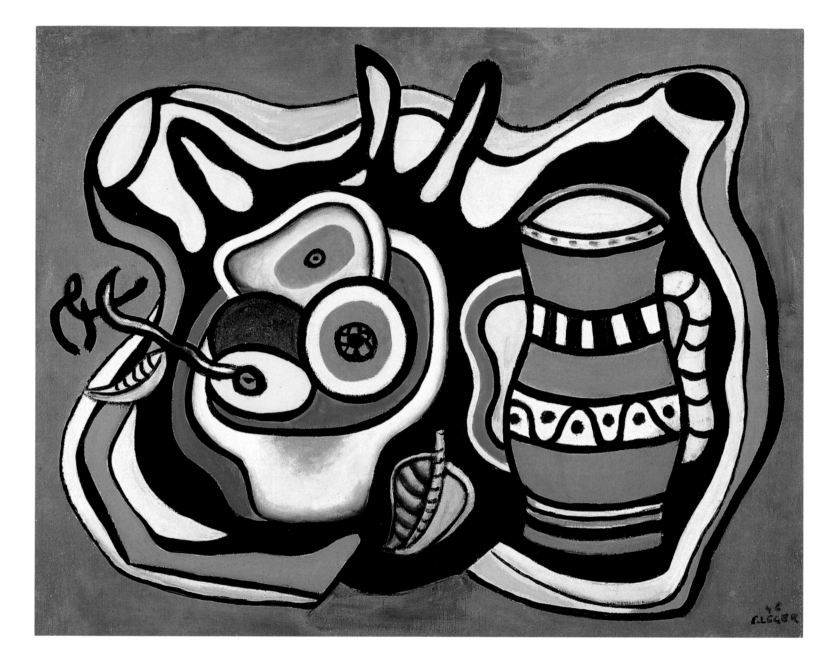

FERNAND LÉGER
French, 1881–1955
Le Vase Orange (The Orange Vase), 1946

Oil on canvas, 28¾ x 36¼ in.
Gift of Mary and Sylvan Lang
1972.43

FERNAND LÉGER
French, 1881–1955
Le Papillon Blanc (The White Butterfly),
1946

Oil on canvas, 15 x 18⅛ in.
Gift of Alice C. Simkins on the occasion of
the opening of the Tobin Wing
1984.5

HENRI MATISSE
French, 1869–1954
L'Enterrement de Pierrot (Burial of Pierrot)
from *Jazz,* 1947

Pochoir, image 16⅝ x 25½ in., Duthuit
catalogue 22B
Gift of Margaret Bosshardt Pace and family
1978.15.10

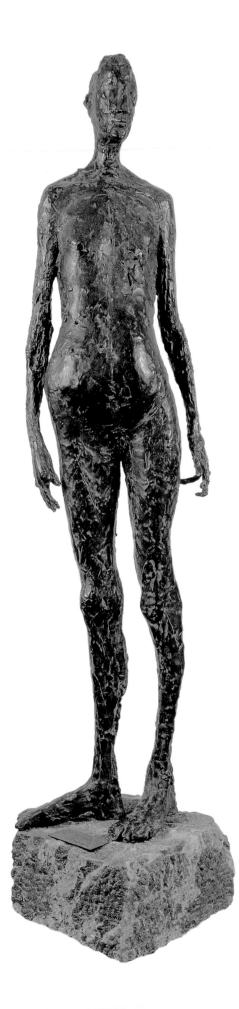

GERMAINE RICHIER
French, 1904–1959
The Leaf, 1948

Bronze, 55 in. high
Gift of Emily Wells Brown
1959.5

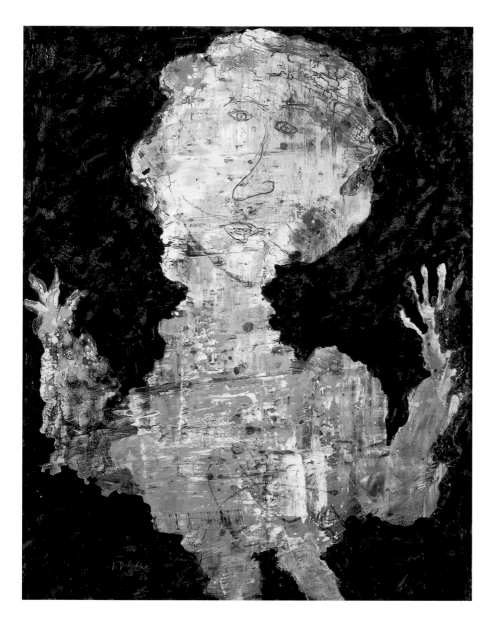

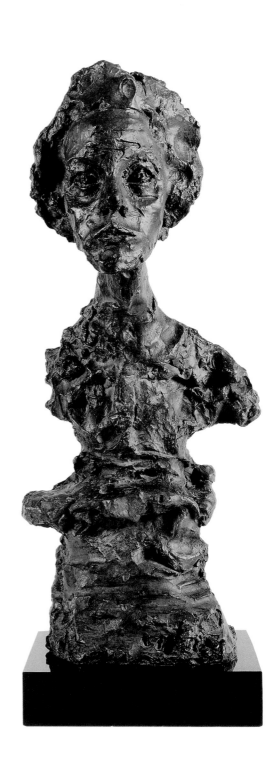

JEAN DUBUFFET
French, 1901–1985

Faiseur de Grâces (Bestower of Blessings),
1954

Oil and lacquer on canvas, 36⅛ x 29 in.,
Loreau catalogue X, 62
Mary and Sylvan Lang Collection
1975.28

ALBERTO GIACOMETTI
Swiss, 1901–1966

Bust of Annette IV, **1962**

Bronze, 22⅞ in. high
Mary and Sylvan Lang Collection
1975.63

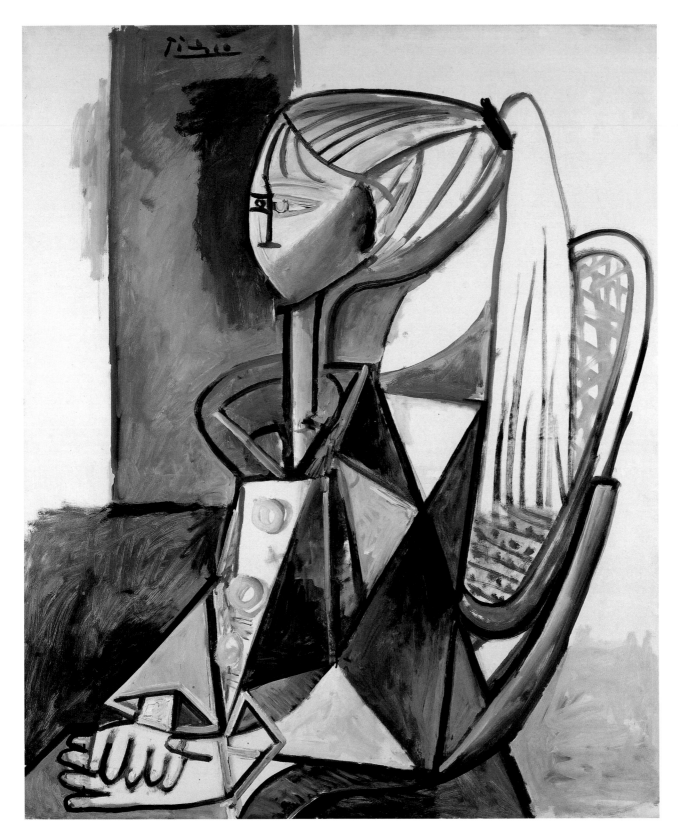

PABLO PICASSO
Spanish, 1881–1973
Portrait of Sylvette, 1954

Oil on canvas, 39 x 32 in., Zervos catalogue 287
Gift of the Estate of Tom Slick
1973.36

PABLO PICASSO

Spanish, 1881–1973

Danse Nocturne avec un Hibou (Nocturnal Dance with an Owl), 1959

Linocut, image 20¾ x 24¾ in., Baer catalogue 1256, second state of two
Gift of the Friends of the McNay
1990.66

ANTONI CLAVÉ

French, born Spain, born 1913

Curtain design for *Carmen*, ca. 1949

Gouache, watercolor, and ink on paper,
21½ x 26 in.
Promised gift of the Estate of Robert L. B. Tobin

BEN NICHOLSON
British, 1894–1982
Jan 3-52 (Cromlech) , 1952

Oil on canvas, 81¾ x 66⅝ in.
Gift of the Estate of Tom Slick
1973.26

BEN NICHOLSON
British, 1894–1982
Thoralby, 1954

Graphite and wash on paper, 15 x 22 in.
Gift of Betty Jameson in memory of
Bess Ransdell Jameson
1970.9

STANLEY WILLIAM HAYTER
British, 1901–1988
Falling Figure, 1947

Engraving and soft-ground etching,
plate 17⅞ x 15 in.
Gift of the Friends of the McNay
1994.189

JOHN PIPER
British, 1903–1992
Scene design for *Gloriana*, 1953

Watercolor and gouache on paper,
10¼ x 15⁹⁄₁₆ in.
Gift of Robert Hilton Simmons, Sr., in memory of
John Palmer Leeper
TL1996.11

BARBARA HEPWORTH
British, 1903–1975
Cantate Domino, 1958

Bronze, 80 in. high
Gift of the Estate of Tom Slick
1973.31

BARBARA HEPWORTH
British, 1903–1975
Reclining Figure (Landscape Rosewall), 1957

Bronze, 15 13/16 in. high
Gift of the Estate of Tom Slick
1973.30

BARBARA HEPWORTH
British, 1903–1975
Winged Figure II, 1957

Bronze with plaster and wire, 67 7/8 in. high
Gift of the Estate of Tom Slick
1973.32

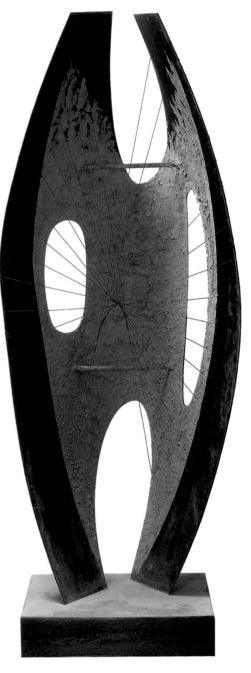

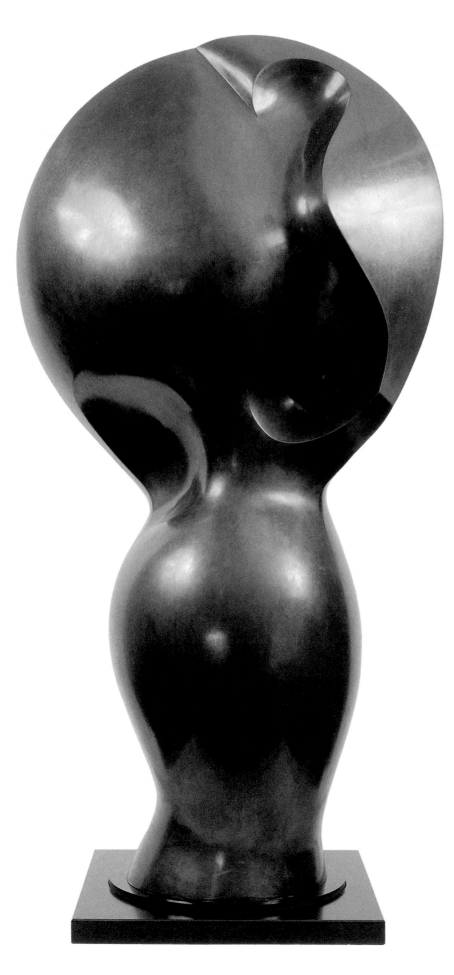

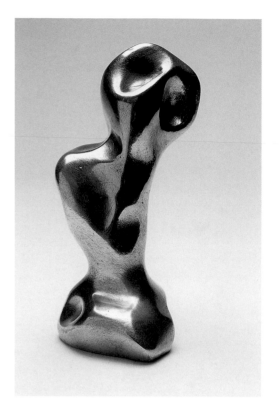

JEAN ARP
German, 1887–1966
Ombre d'Orient (Shade of the East), 1961

Bronze, 5⅝ in. high
Gift of Jeanne and Irving Mathews
1982.97

JEAN ARP
German, 1887–1966
La Saint de Lisières (Saint of the Forest Edge), 1963

Bronze, 28¼ in. high
Gift of Emily Wells Brown in honor of
Blanche Magurn Leeper
1983.49

REGINALD BUTLER
British, 1913–1981
Doll, 1955

Bronze, 19 in. high
Mary and Sylvan Lang Collection
1975.59

REGINALD BUTLER
British, 1913–1981
Seated Nude (Legs Together), 1960

Bronze, 5½ in. high
Gift of Jeanne and Irving Mathews
1980.42

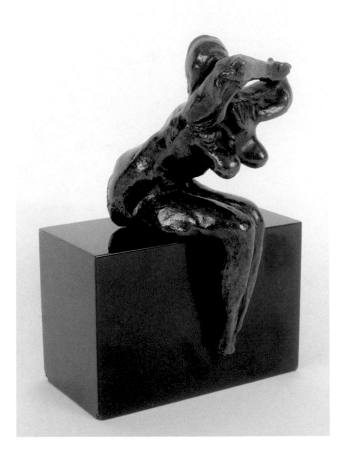

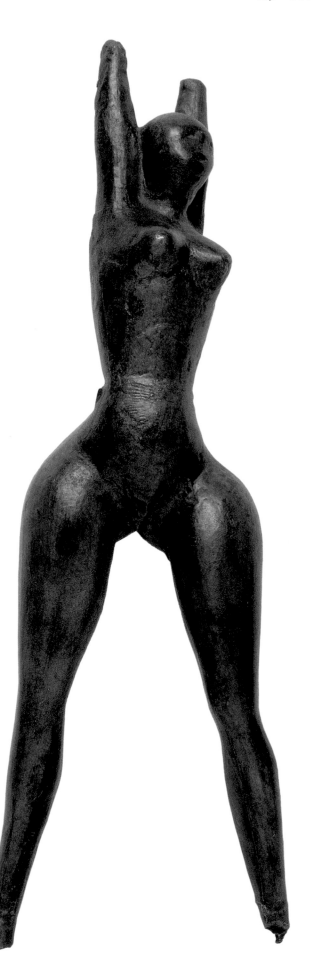

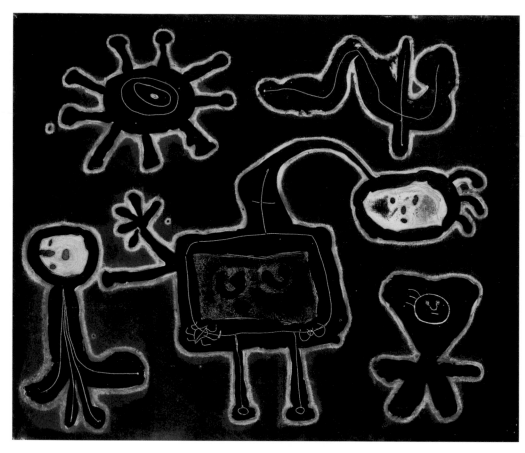

JOAN MIRÓ
Spanish, 1893–1973
Serie I, 1952–53

Etching, plate 15 x 17¹⁵⁄₁₆ in.
Mary and Sylvan Lang Collection
1975.93

JEAN COCTEAU
French, 1889–1963
Portrait of Jean Marais, 1938

Graphite on paper, 12⅛ x 9½ in.
Promised gift of the Estate of Robert L. B. Tobin

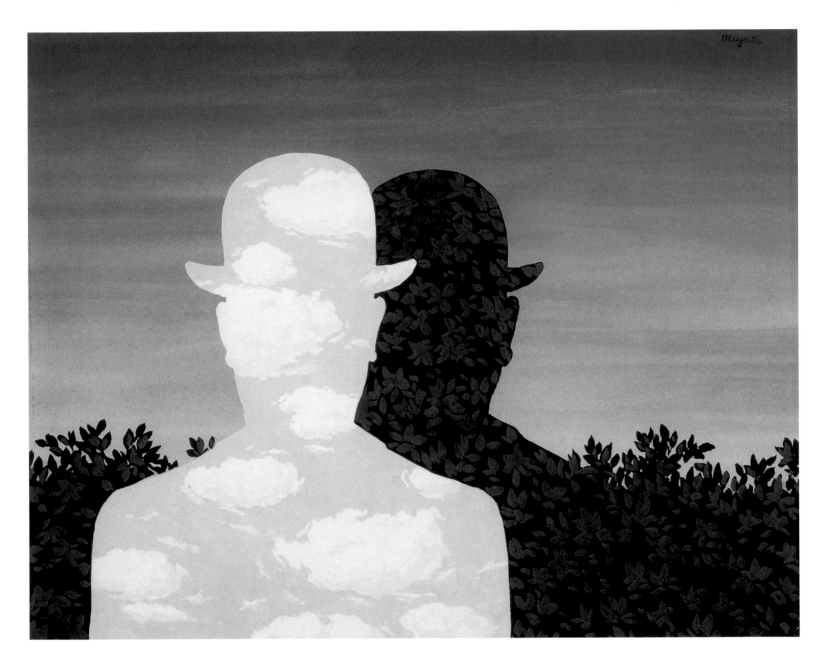

RENÉ MAGRITTE
Belgian, 1898–1967
Two Men with Derbies, 1965

Gouache on paper, 10 x 12½ in.
Museum purchase with funds from
the Tobin Foundation
1994.2

ANTONI TÁPIES
Spanish, born 1923
Grey Borders, 1958

Cement on panel, 35⅟₁₆ x 45⁹⁄₁₆ in.
Gift of the Estate of Tom Slick
1973.25

FRANCISCO FARRERAS
Spanish, born 1927
Untitled (Spanish Landscape), 1975

Collage on paper, 19 x 24½ in.
Gift of the Wenger Anderson Family Collection
1997.48

HOWARD HODGKIN
British, born 1932
Early Evening at the Museum of Modern Art, 1979

Etching with hand-coloring, image 29½ x 38¹¹⁄₁₆ in.
Museum purchase
1983.11

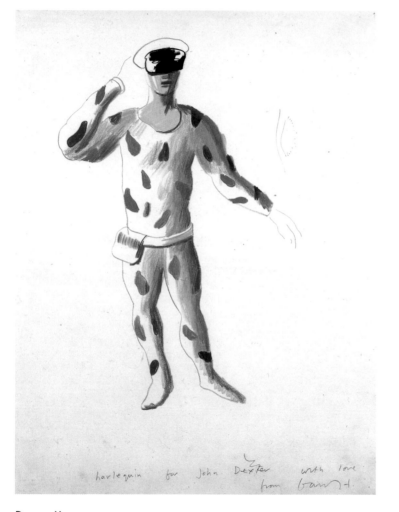

DAVID HOCKNEY
British, born 1937
Costume design for the harlequin in *Parade*, 1980

Colored pencil on paper, 18¹³⁄₁₆ x 14¹⁄₁₆ in.
Gift of Robert L. B. Tobin
1994.10

DAVID HOCKNEY
British, born 1937
The Old Guitarist from *Blue Guitar*, 1977

Etching, plate 16⅞ x 13¾ in.
Gift of Robert L. B. Tobin
1978.3.2

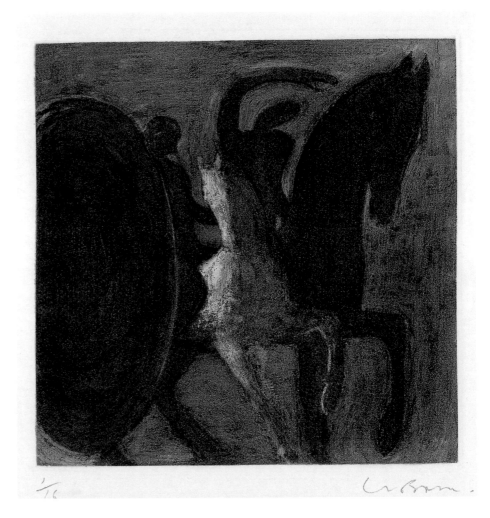

CHRISTOPHER LEBRUN
British, born 1951
Rider and Shadow, 1996

Etching and aquatint, plate 5 ¹⁵⁄₁₆ x 5 ¹⁵⁄₁₆ in.
Gift of the artist
1996.8.10

WINSLOW HOMER
American, 1836–1910
Girl on a Garden Seat (Woman Seated on a Bench), 1878

Watercolor on paper, 6⅜ x 8¼ in.
Mary and Sylvan Lang Collection
1975.34

WINSLOW HOMER
American, 1836–1910
Study for *Inside the Bar, Tynemouth,* 1882

Watercolor and graphite on paper, 5⅞ x 13⅜ in.
Bequest of Mrs. Jerry Lawson
1994.124

WINSLOW HOMER

American, 1836–1910

Eight Bells, 1887

Etching, plate 19 x 24½ in., Goodrich catalogue 94
Gift of the Friends of the McNay
1977.8

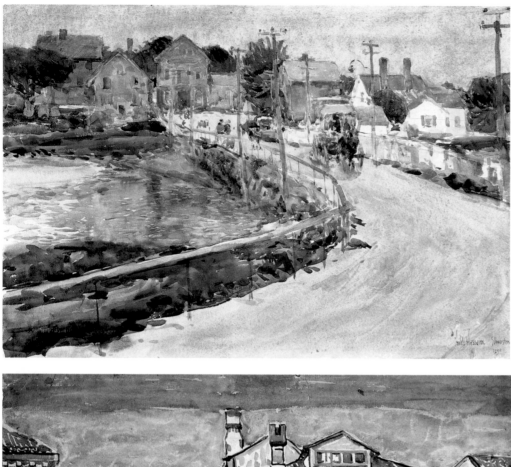

CHILDE HASSAM
American, 1859–1935
At Gloucester, 1890

Watercolor on board, 14⅛ x 20 in.
Bequest of Marion Koogler McNay
1950.61

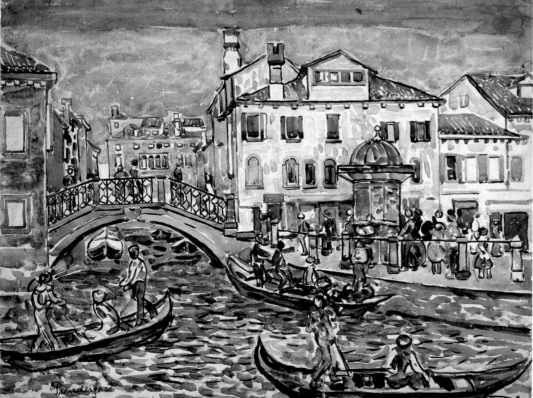

MAURICE PRENDERGAST
American, 1859–1924
Venice, 1910–12

Watercolor and graphite on paper, 17⅛ x 23⅛ in.,
Williams College catalogue 1019
Bequest of Marion Koogler McNay
1950.116

JAMES WHISTLER
American, 1834–1903
Early Morning, 1878

Lithograph, image 6½ x 10¼ in.,
Way catalogue 7
Museum purchase
1959.4

MAURICE PRENDERGAST
American, 1859–1924
Roma—Flower Stall, ca. 1898–99

Monotype, plate 9⁵⁄₁₆ x 7½ in.,
Williams College catalogue 1700
Gift of the Friends of the McNay
1976.5

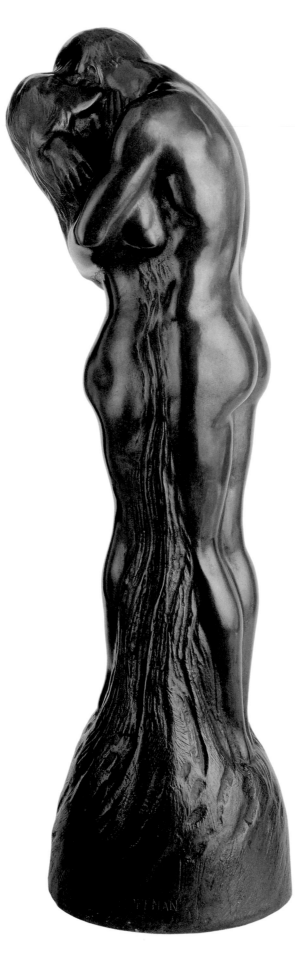

MALVINA HOFFMAN
American, 1885–1966
Column of Life, 1917

Bronze, 26¼ in. high
Museum purchase in memory of John Palmer
Leeper with funds from Marian Harwell, by
exchange, and the members of the McNay
1996.37

JOHN LaFARGE
American, 1835–1910
Vaiala in Upolo, Samoa, 1890

Watercolor on paper, 11¼ x 12 in.
Gift of Alice N. Hanszen
1977.10

JOHN SINGER SARGENT
American, born Italy, 1856–1925
Study of a Young Man (Seated), 1895

Lithograph, image 11⅝ x 8⁹⁄₁₆ in., Dodgson
catalogue 1
Gift of the Friends of the McNay
1989.39

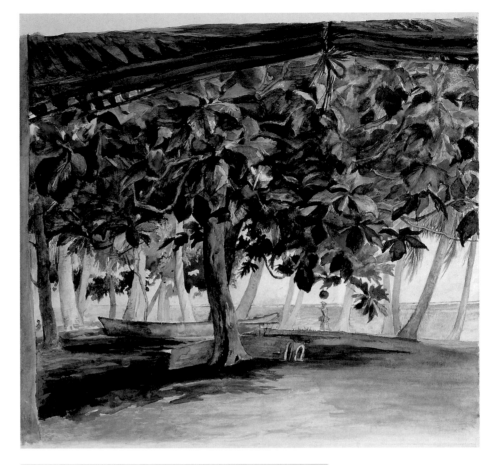

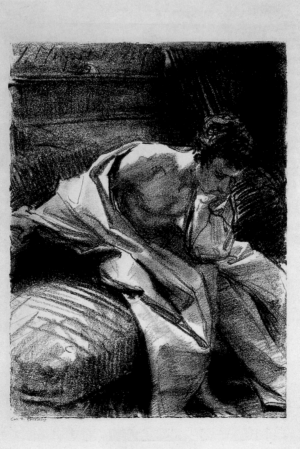

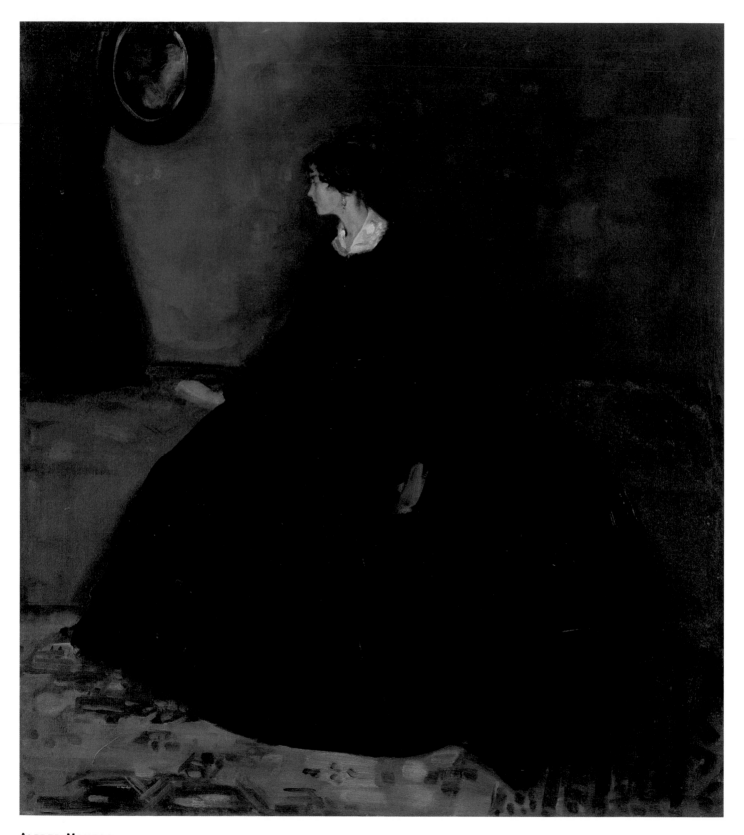

ALFRED MAURER
American, 1868–1932
Lady in Black, ca. 1900

Oil on canvas, 36 x 22 in.
Museum purchase
1959.3

JOSÉ ARPA Y PAREA
American, born Spain, 1858–1952
On the Riverbank, ca. 1910

Oil on canvas, 24 x 29 in.
Gift of Robert L. B. Tobin
1999.85

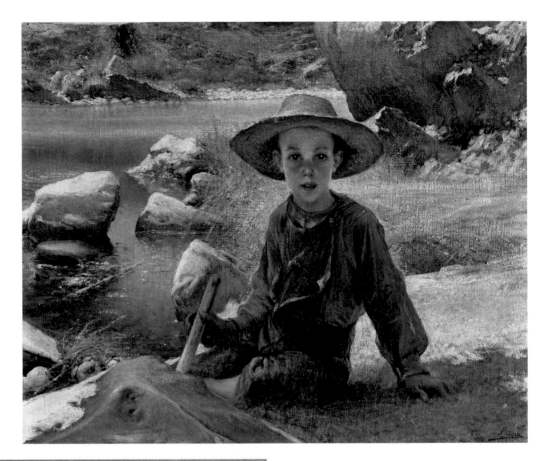

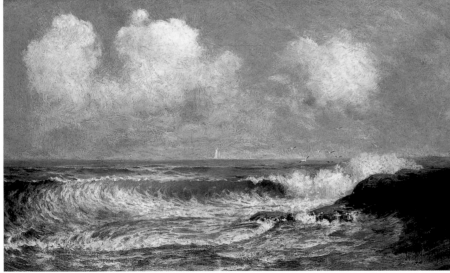

JULIAN ONDERDONK
American, 1882–1922
Seascape, ca. 1901

Oil on canvas, 9 x 15 1/16 in.
Gift of Alice C. Simkins in memory of
William Stewart Simkins
1974.2

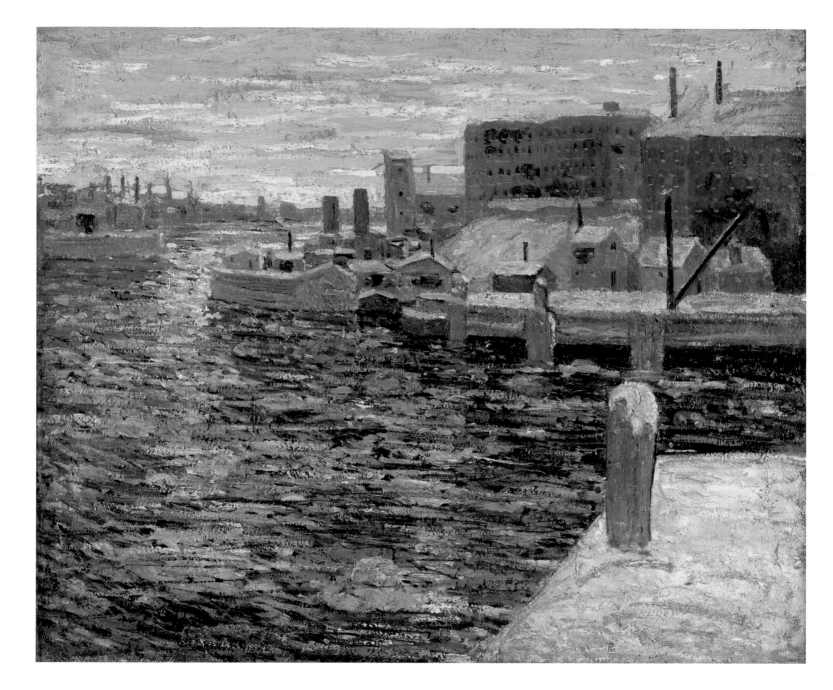

ERNEST LAWSON
Canadian, 1873–1939
Harbor in Winter, ca. 1908

Oil on canvas, 24¼ x 29½ in.
Bequest of Gloria and Dan Oppenheimer
1998.10

JOHN MARIN
American, 1870–1953
Brooklyn Bridge, 1911

Etching, plate 11⁷⁄₁₆ x 9 in., Zigrosser catalogue 104
Gift of the Friends of the McNay
1974.4

ARTHUR B. DAVIES
American, 1862–1928
Listening to the Water Ousel, ca. 1915

Oil on canvas mounted on panel, 13 x 11 in.
Bequest of Mrs. Jerry Lawson
1994.107

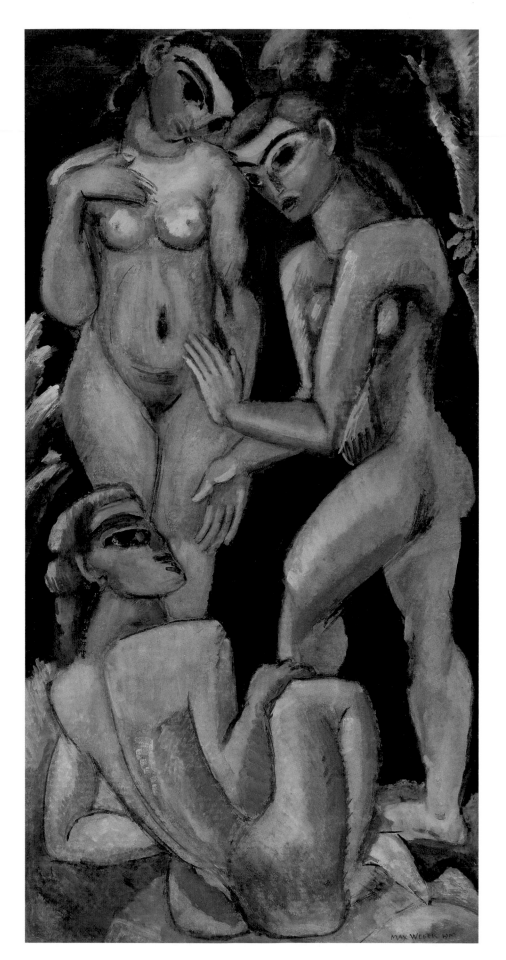

MAX WEBER
American, born Russia, 1881–1961
Surprise, 1910

Gouache on board, 47½ x 24½ in.
Gift of Alice N. Hanszen
1973.19

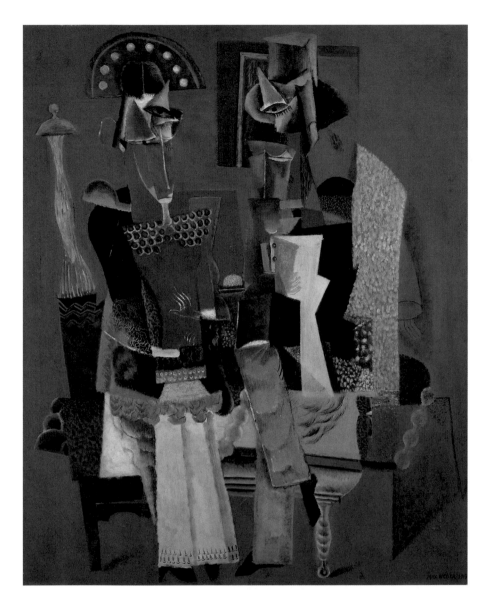

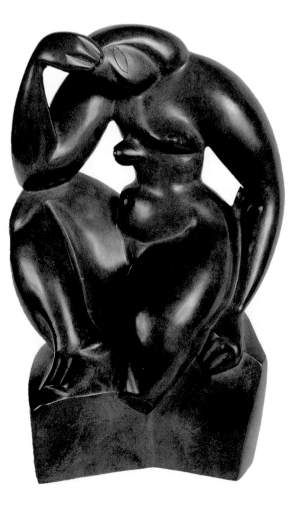

MAX WEBER
American, born Russia, 1881–1961
Conversation, 1919

Oil on canvas, 42 x 32 in.
Museum purchase
1961.1

ALEXANDER ARCHIPENKO
American, born Russia, 1887–1964
Seated Figure, 1912, cast 1967–70

Bronze, 16 in. high
Mary and Sylvan Lang Collection
1975.58

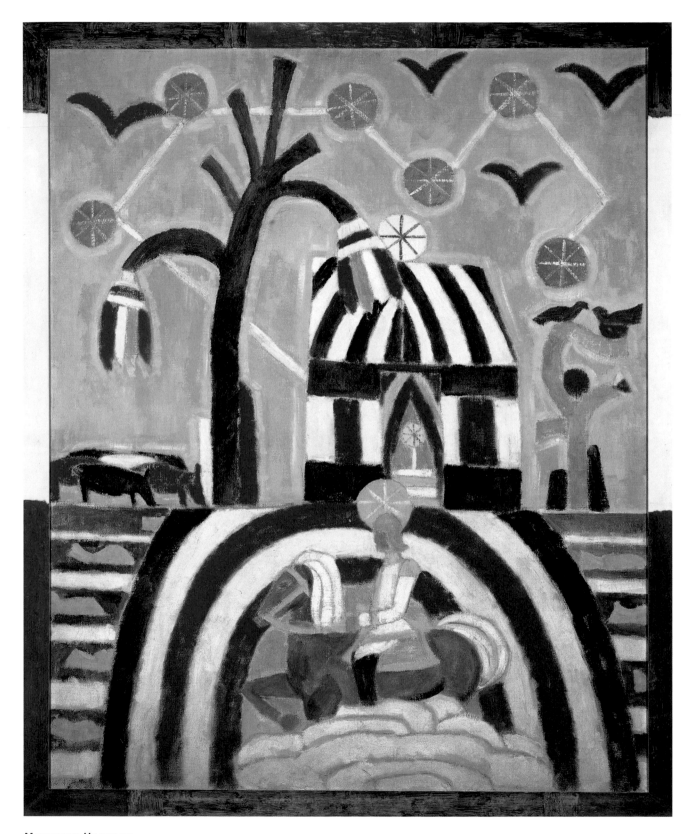

MARSDEN HARTLEY
American, 1877–1943
Portrait Arrangement, 1914

Oil on canvas, 39⅜ x 32 in.
Museum purchase
1959.2

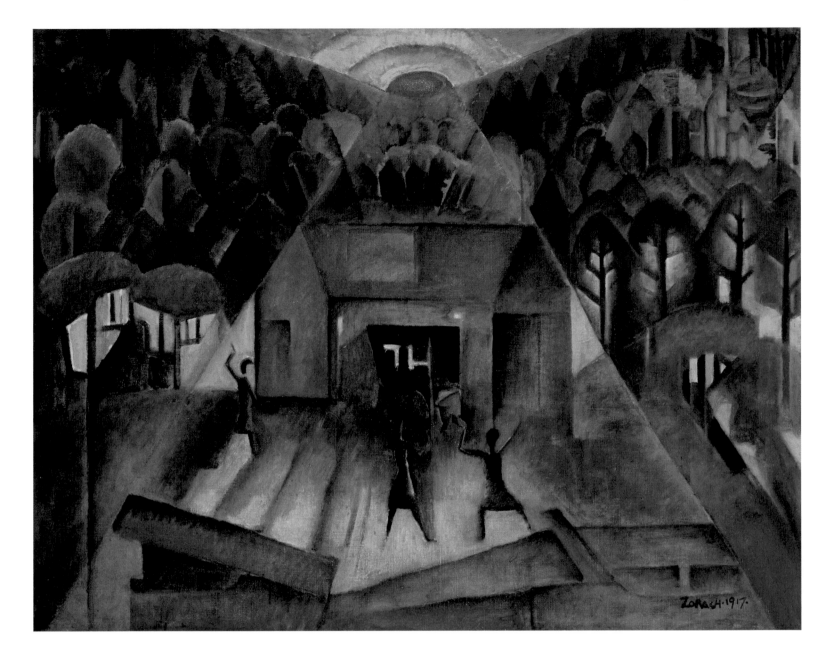

WILLIAM ZORACH
American, born Russia, 1887–1966
Milking Time (Echo Farm,
New Hampshire), **1917**

Oil on canvas, 28 x 36 in.
Gift of Robert L. B. Tobin
1999.107

WILLIAM GLACKENS
American, 1870–1938
Summer House at Hartford, ca. 1917

Oil on canvas, 26 x 32 in.
Gift of Mrs. Otto Koehler
1981.22

EVERETT SHINN
American, 1876–1953
Toy Theatre, 1919

Mixed media, 42⅝ x 40 x 27¼ in.
Gift of Robert L. B. Tobin
TL1993.4.1

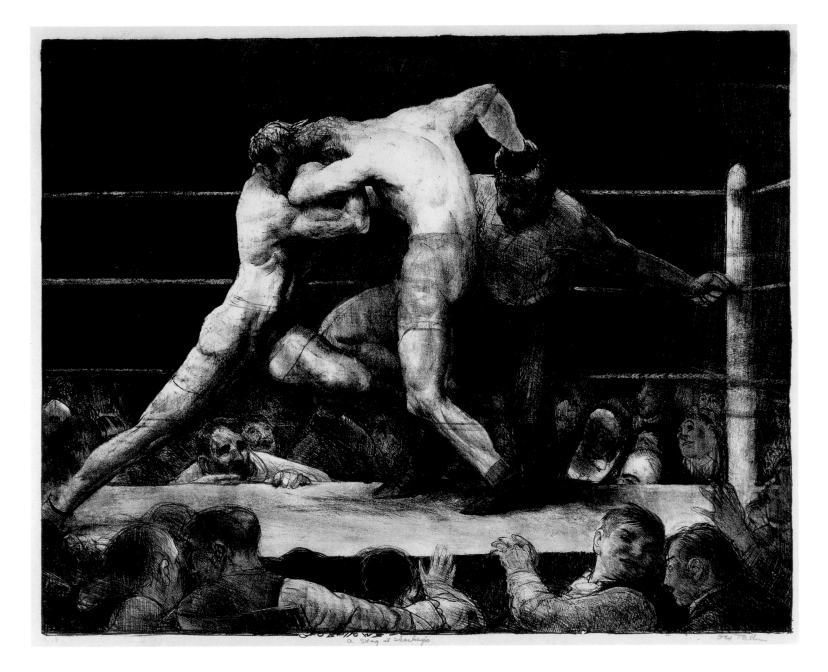

GEORGE BELLOWS
American, 1882–1925
A Stag at Sharkey's, 1917

Lithograph, image 18⅝ x 23¾ in.,
Mason catalogue 46
Gift of the Friends of the McNay
1982.49

GEORGIA O'KEEFFE
American, 1887–1986
Evening Star No. V, 1917

Watercolor on paper, 8⅝ x 11⅝ in.,
Lynes catalogue 203
Bequest of Helen Miller Jones
1989.36

CHARLES BURCHFIELD
American, 1893–1967
Nasturtiums and Barn, 1917

Watercolor, charcoal, gouache, crayon,
ink, and graphite on paper, 22 x 18 in.
Gift of Alice N. Hanszen
1974.54

GEORGIA O'KEEFFE
American, 1887–1986
Leaf Motif #2, 1924

Oil on canvas, 35 x 18 in., Lynes catalogue 467
Mary and Sylvan Lang Collection
1975.45

JAMES DAUGHERTY
American, 1889–1974
Study for *Moses,* ca. 1920

Charcoal and chalk on paper, 18 x 18 in.
Gift of Robert L. B. Tobin in honor of
Linda M. Hardberger
1999.121

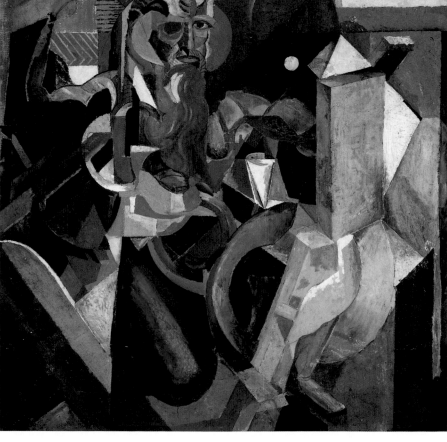

James Daugherty
American, 1889–1974
Recto (above): *Untitled,* 1922
Verso (left): *Moses,* 1920

Oil on double-sided canvas, 75 x 75 in.
Gift of Robert L. B. Tobin
1999.87

MARSDEN HARTLEY
American, 1877–1943
Landscape with Arroyo, ca. 1922

Oil on canvas, 23 x 41¼ in.
Museum purchase with funds from the
Tobin Foundation
1994.5

MARSDEN HARTLEY
American, 1877–1943
Apples in a Basket, 1923

Lithograph, image 14¾ x 19⅝ in.
Museum purchase in memory of
Alexander J. Oppenheimer
1998.24

CHARLES DEMUTH
American, 1883–1935
From the Kitchen Garden, 1925

Watercolor and graphite on paper, 18¼ x 12 in.
Bequest of Marion Koogler McNay
1950.33

PAUL MANSHIP
American, 1885–1966
Atalanta, 1921

Bronze, 28½ in. high
Gift of Alice N. Hanszen
1974.55

MARY BONNER
American, 1885–1935
Fighting Bulls, 1929

Aquatint, plate 10⁷⁄₁₆ x 29⅛ in.
Gift of Robert L. B. Tobin
1999.12

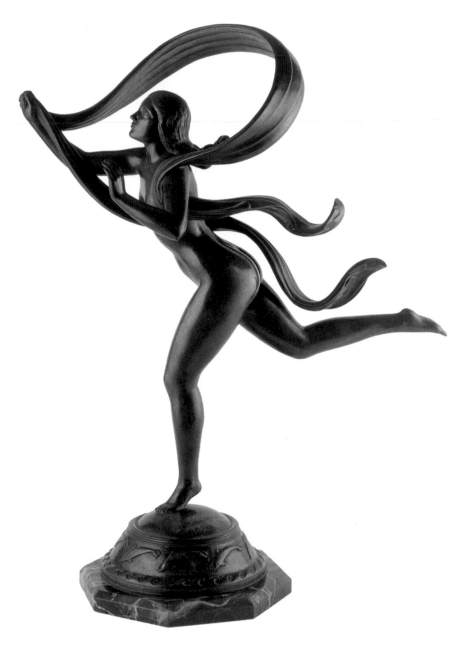

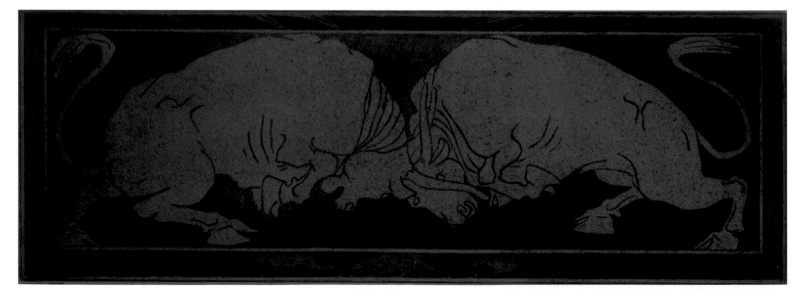

EMIL BISTTRAM
American, born Hungary, 1895–1976
Knight of the Evening, 1928

Watercolor on paper, 13⅞ x 20 in.
Bequest of Marion Koogler McNay
1950.14

JOHN STEUART CURRY
American, 1897–1946
Mare and Foal in Storm, 1930

Watercolor on paper, 15⅛ x 22⅛ in.
Bequest of Marion Koogler McNay
1950.28

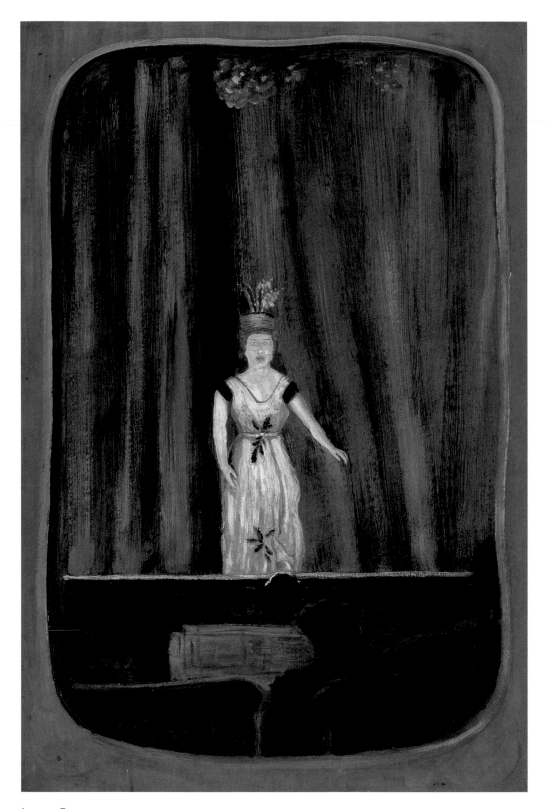

LOUIS EILSHEMIUS
American, 1864–1942
The Opera Singer, ca. 1910–20

Oil on panel, 30¾ x 20¾ in.
Gift of Robert L. B. Tobin
1999.89

ALFRED MAURER
American, 1868–1932
Still Life with Watermelons and Shrimp (Abstract), 1930

Oil on panel, 18 x 21½ in.
Gift of the Friends of the McNay
1960.4

WALT KUHN
American, 1877–1949
Apple Basket, 1933

Oil on canvas, 29½ x 39½ in.
Gift of Alice N. Hanszen
1976.38

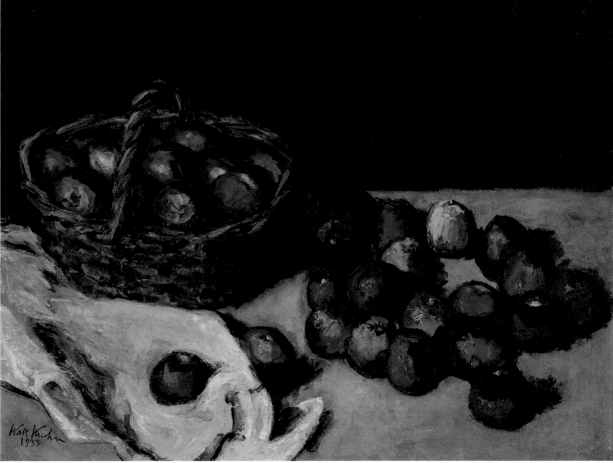

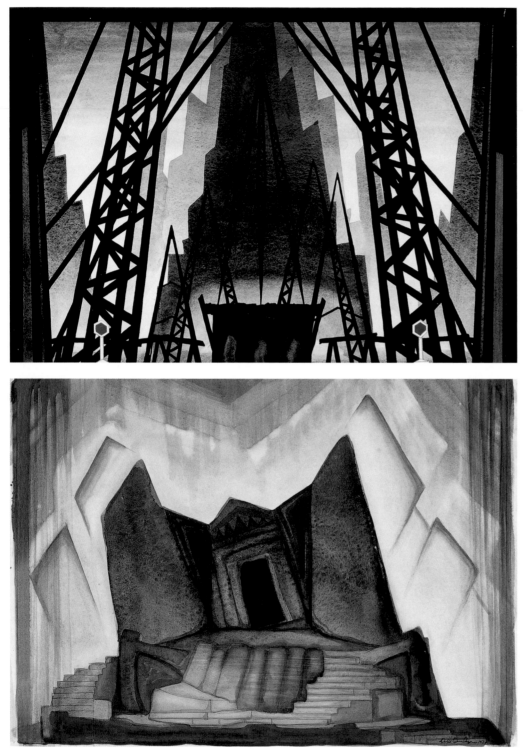

ROBERT EDMOND JONES
American, 1887–1954
**Scene design for "Steel Girders," Scene 6
in** *Skyscrapers*, **1926**

Watercolor, ink, and collage on paper,
19⁵⁄₁₆ x 26½ in.
Gift of Robert L. B. Tobin
TL1999.116.1

DONALD OENSLAGER
American, 1909–1975
Scene design for Act III in *Tristan und
Isolde*, **1934**

Watercolor and graphite on paper, 19⅞ x 26⅞ in.
Gift of Robert L. B. Tobin
TL1999.218

CHARLES SHEELER
American, 1883–1965
Yachts, 1924

Lithograph, image 8 x 10¼ in.,
Driscoll catalogue 25
Gift of the Friends of the McNay
1972.8

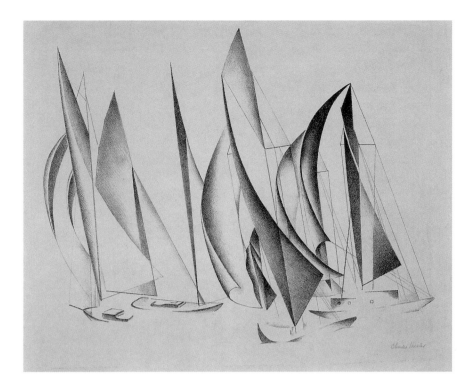

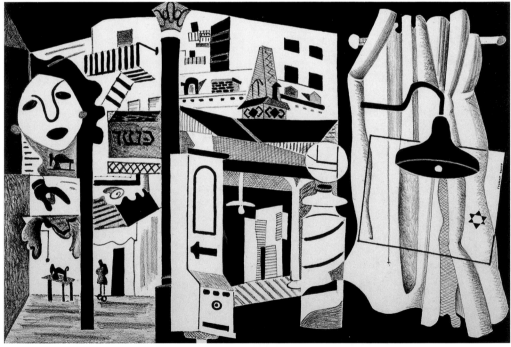

STUART DAVIS
American, 1894–1964
Sixth Avenue El, 1934

Lithograph, image 12 x 18 in.,
Cole and Myers catalogue 15
Gift of the Friends of the McNay
1974.45

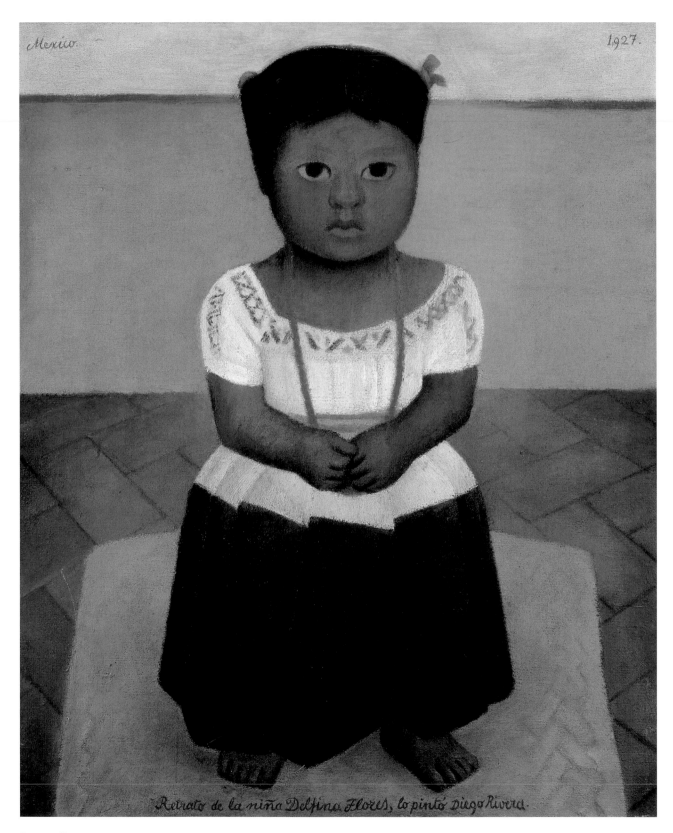

Mexico. 1927.

Retrato de la niña Delfina Flores, lo pintó Diego Rivera.

DIEGO RIVERA
Mexican, 1886–1957
Delfina Flores, 1927

Oil on canvas, 32¼ x 26 in.
Bequest of Marion Koogler McNay
1950.124

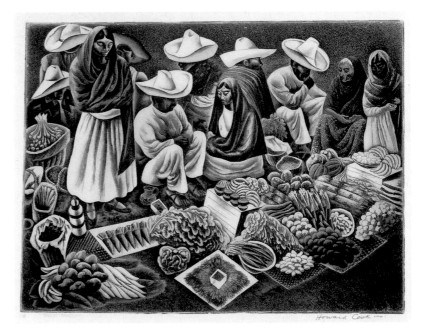

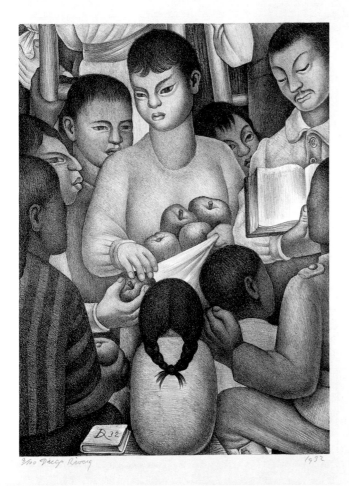

DIEGO RIVERA
Mexican, 1886–1957
Fruits of the Earth, 1932

Lithograph, image 16⁹⁄₁₆ x 11⅞ in.,
Williams catalogue 6
Gift of the Friends of the McNay
1998.16

HOWARD COOK
American, 1901–1980
Taxco Market, 1933

Etching and aquatint, plate 8¹⁵⁄₁₆ x 11¹⁵⁄₁₆ in.
Bequest of Marion Koogler McNay
1950.454

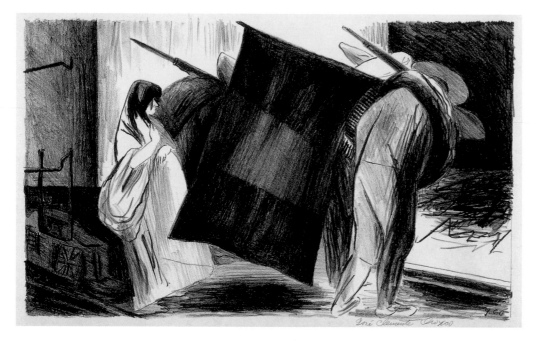

JOSÉ CLEMENTE OROZCO
Mexican, 1883–1949
La Bandera (The Flag), 1928

Lithograph, image 10⁵⁄₁₆ x 17 in.,
Hopkins catalogue 7
Museum purchase with funds from the Cullen
Foundation, the Friends of the McNay, Charles Butt,
Margaret Pace Willson, and Jane and Arthur Stieren
2000.48

DAVID ALFARO SIQUEIROS
Mexican, 1896–1974
Portrait of William Spratling, 1939

Lithograph, image 20¼ x 14⅞ in.,
Williams catalogue 6
Gift of Mr. and Mrs. Harry C. Burkhalter
1962.10

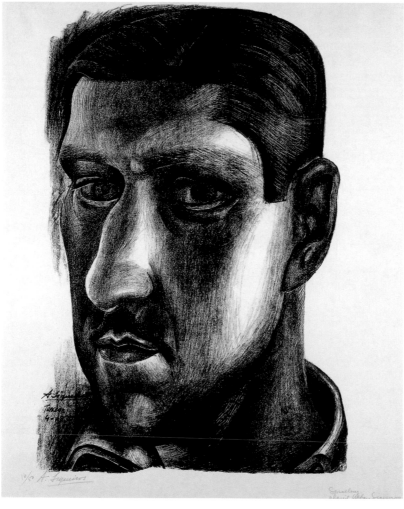

RUFINO TAMAYO

Mexican, 1899–1991

The Woodchopper, 1928

Woodcut, image 10⅛ x 10 in., Williams catalogue 2
Museum purchase with funds from the Cullen
Foundation, the Friends of the McNay, Charles Butt,
Margaret Pace Willson, and Jane and Arthur Stieren
2000.69

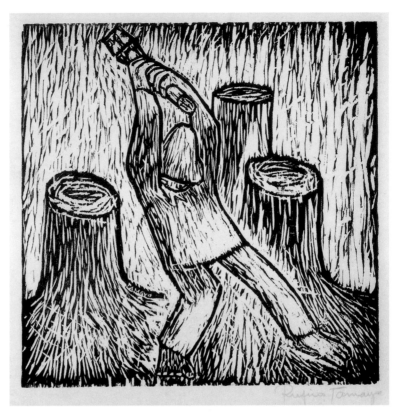

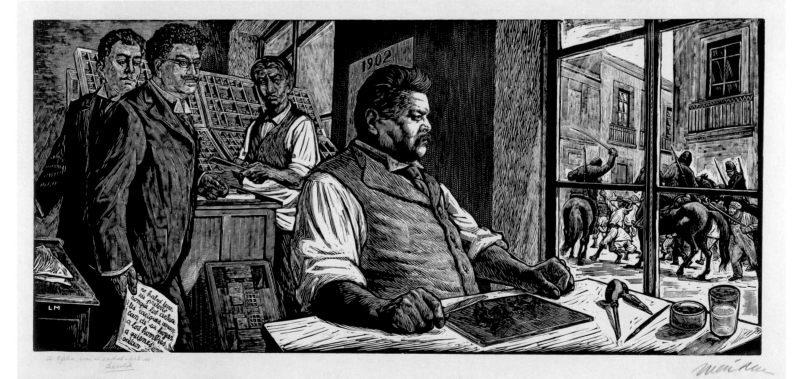

LEOPOLDO MÉNDEZ

Mexican, 1902–1969

Posada en Su Taller (Posada in His Studio), 1956

Linocut, image 14 x 31 in.
Gift of John Palmer Leeper, by exchange
1998.2

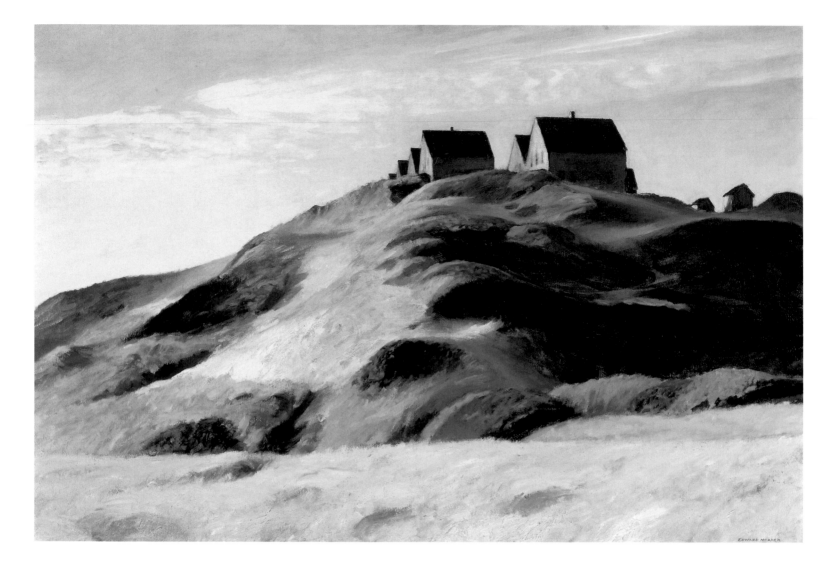

EDWARD HOPPER
American, 1882–1967
Corn Hill (Truro, Cape Cod), 1930

Oil on canvas, 28½ x 42½ in.,
Levin catalogue o-272
Mary and Sylvan Lang Collection
1975.35

EDWARD HOPPER
American, 1882–1967
Night Shadows, 1921

Etching, plate 7 x 8¼ in., Zigrosser catalogue 11
Gift of the Friends of the McNay
1974.5

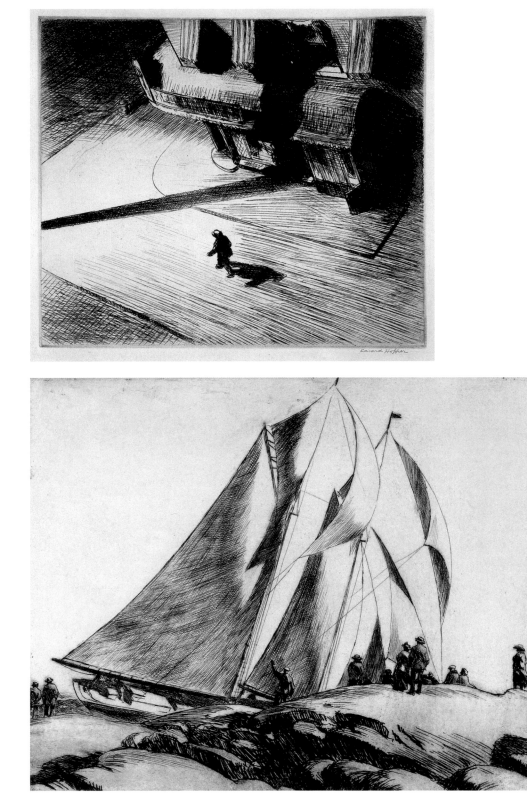

EDWARD HOPPER
American, 1882–1967
The Henry Ford, 1923

Etching, plate 11¾ x 14¾ in., Zigrosser catalogue 22
Gift of the Friends of the McNay
1985.10

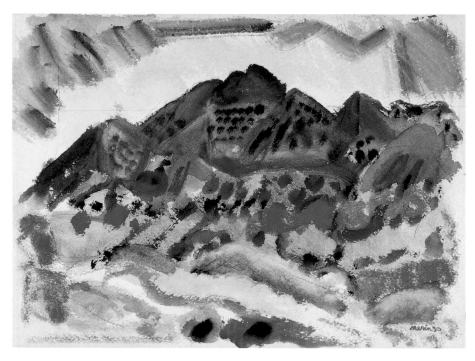

JOHN MARIN
American, 1870–1953
Taos, 1930

Watercolor and graphite on paper, 12¾ x 17¼ in.
Bequest of Marion Koogler McNay
1950.96

JOHN MARIN
American, 1870–1953
Movement, Boat, Sea, Sky, Maine, 1944

Oil on canvas, 22 x 28⅛ in.
Bequest of Helen Miller Jones
1986.9

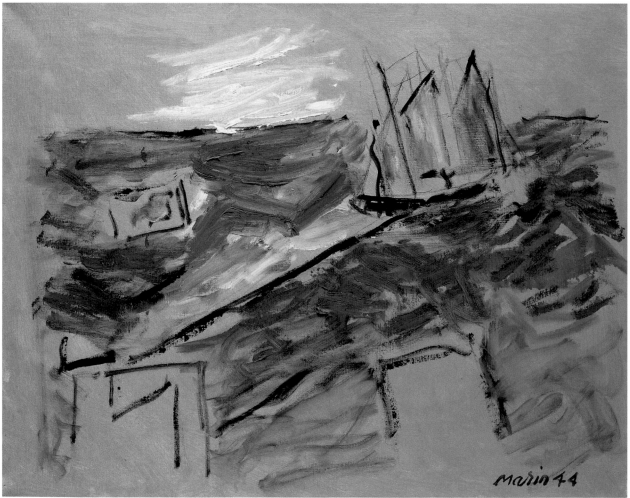

JOHN MARIN
American, 1870–1953
Pertaining to New Jersey, 1950

Oil on canvas, 14 x 17 in.
Mary and Sylvan Lang Collection
1975.42

GEORGIA O'KEEFFE
American, 1887–1986
From the Plains I, 1953

Oil on canvas, 47¹¹⁄₁₆ x 83⅝ in.,
Lynes catalogue 1262
Gift of the Estate of Tom Slick
1973.22

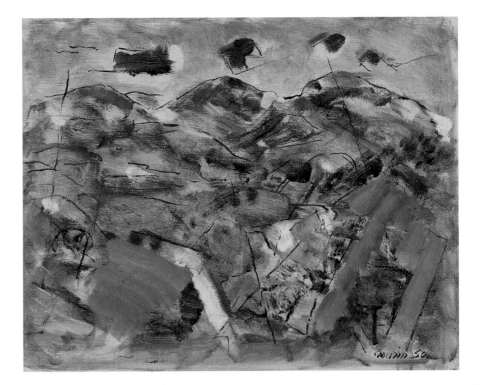

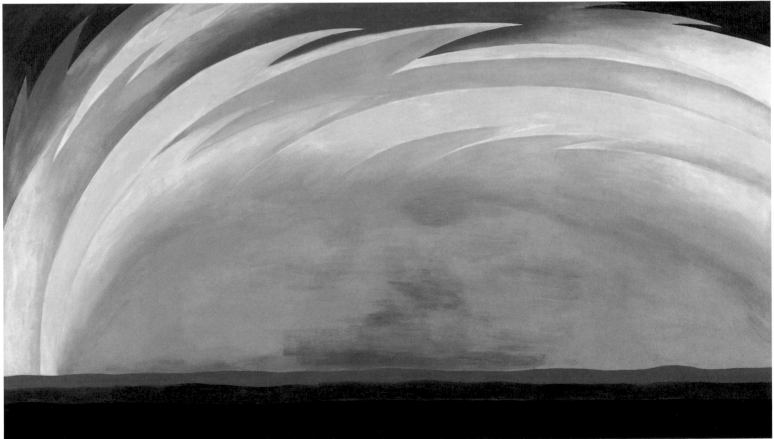

ARTHUR DOVE
American, 1880–1946
Dawn III, 1932

Oil on canvas, 22 x 22 in., Morgan catalogue 32.8
Mary and Sylvan Lang Collection
1975.27

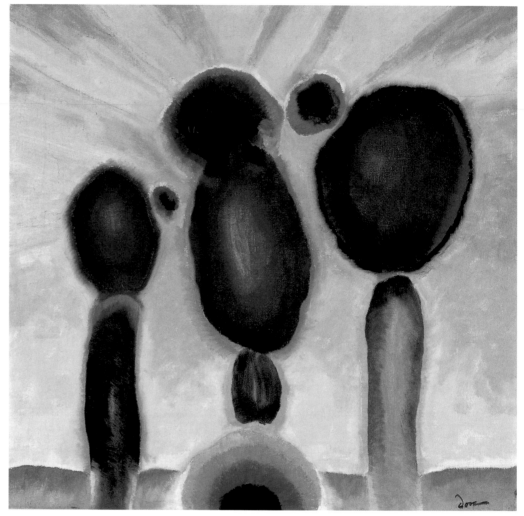

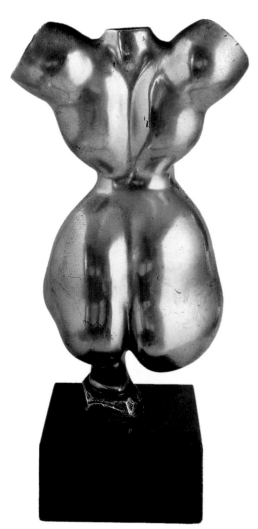

GASTON LACHAISE
American, born France, 1882–1935
Torso, 1931

Bronze with a gold patina, 13⅝ in. high
Bequest of Mrs. Jerry Lawson
1994.137

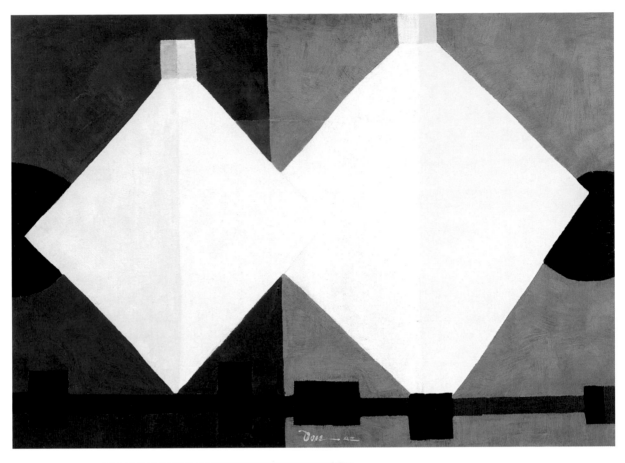

ARTHUR DOVE
American, 1880–1946
The Brothers, 1942

Tempera and wax emulsion on canvas, 20 x 28 in.,
Morgan catalogue 42.3
Gift of Robert L. B. Tobin through the Friends of
the McNay
1962.3

ARTHUR DOVE
American, 1880–1946
Study for *The Brothers*, 1942

Watercolor on paper, 3¹⁄₁₆ x 4 in.
Gift of Robert L. B. Tobin through the Friends of
the McNay
1962.4.8

ARTHUR DOVE
American, 1880–1946
Study for *The Brothers*, 1942

Watercolor on paper, 5³⁄₁₆ x 7 in.
Gift of Robert L. B. Tobin through the Friends of
the McNay
1962.4.9

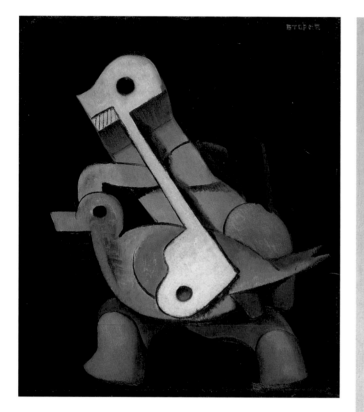

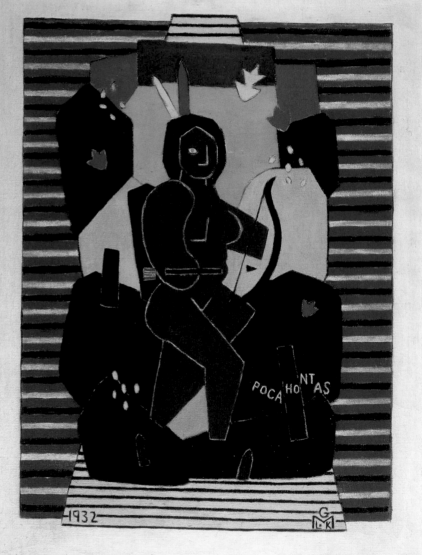

JOHN STORRS
American, 1885–1956
Death and the Duck, 1932

Oil on canvas, 14 x 12 in.
Gift of Robert L. B. Tobin
1999.105

GEORGE L. K. MORRIS
American, 1905–1975
Pocahontas, 1932

Oil on canvas, 25½ x 19¼ in.
Gift of Robert L. B. Tobin
1999.102

GEORGE L. K. MORRIS
American, 1905–1975
House to House Fighting, 1943

Oil on canvas, 26 x 32 in.
Mary and Sylvan Lang Collection
1975.43

GEORGE L. K. MORRIS
American, 1905–1975
Study for *House to House Fighting,* 1943

Charcoal on paper, 18 x 22 in.
Mary and Sylvan Lang Collection
1975.44

CHARLES SHAW
American, 1893–1974
Polygon, 1938

Stained wood, 17 ⅝ x 18 in.
Museum purchase with the Helen and Everett H. Jones Purchase Fund
1997.47

FLORENCE MILLER PIERCE
American, born 1918
Rising Red, 1942

Oil on canvas, 36 x 36 in.
Museum purchase with the Ralph A. Anderson, Jr., Memorial Fund and the Helen and Everett H. Jones Purchase Fund
1999.21

ALEXANDER CALDER
American, 1898–1976
Standing Mobile, ca. 1940

Steel wire and painted aluminum, 35 in. high
Mary and Sylvan Lang Collection
1975.60

BURGOYNE DILLER
American, 1906–1965
Untitled, 1937

Gouache on paper, 10 x 8 in.
Gift of Emma-Stina and Kenneth W. Prescott
2000.77

GRANT WOOD
American, 1891–1942
A Sultry Night, 1938–39

Lithograph, image 9¹⁄₁₆ x 11¾ in., Cole catalogue 6
Gift of the Gallery of the McNay
1987.173

GRANT WOOD
American, 1891–1941
Shrine Quartet, 1939

Lithograph, image 8 x 11¹⁵⁄₁₆ in., Cole catalogue 11
Gift of the Friends of the McNay
1993.31

JAMES ALLEN
American, 1894–1964
The Flats, 1937

Lithograph, image 11⁷⁄₁₆ x 14¾ in., Ryan catalogue 11
Gift of John Palmer Leeper, by exchange
1997.36

SOINTU SYRJALA
American, 1905–1979
**Drop design for "Sing Me a Song of Social
Significance" in** *Pins and Needles,* **1938**

Watercolor, gouache, and ink on paper,
13⁹⁄₁₆ x 20¼ in.
Gift of Robert L. B. Tobin
TL1999.328.1

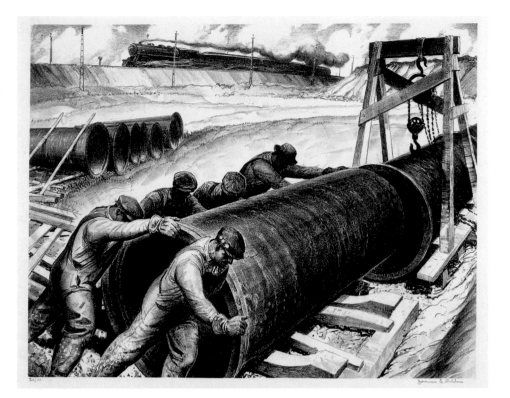

EUGENE BERMAN
American, born Russia, 1899–1972
Cassandra, 1942–43

Oil on canvas, 50⅛ x 39⅛ in.
Gift of Robert L. B. Tobin
1982.79

EUGENE BERMAN
American, born Russia, 1899–1972
**Backdrop design for Act II, Scene 5
(Finale), in *Don Giovanni*, 1957**

Watercolor, ink, and graphite on paper, 10¼ x 15 in.
Promised gift of the Estate of Robert L. B. Tobin

KURT SELIGMANN

American, born Switzerland, 1900–1961

The Childhood of Oedipus from *The Myth of Oedipus*, 1944

Engraving, plate 17¹³⁄₁₆ x 11¹³⁄₁₆ in.
Bequest of Mrs. Jerry Lawson
1994.179.2

EUGENE BERMAN

American, born Russia, 1899–1972

Drop design for "Storm Projection," Act I in *Otello*, 1963

Watercolor, gouache, and ink on paper,
11¼ x 20 in.
Promised gift of the Estate of Robert L. B. Tobin

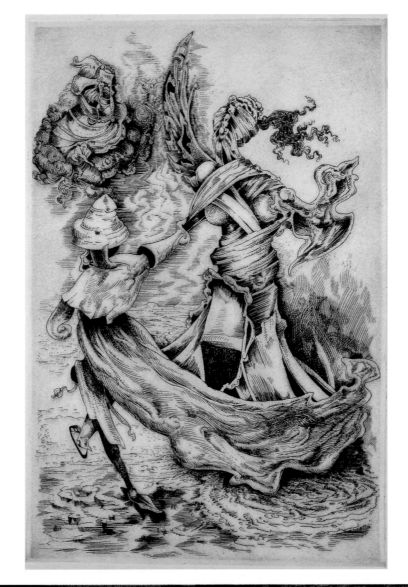

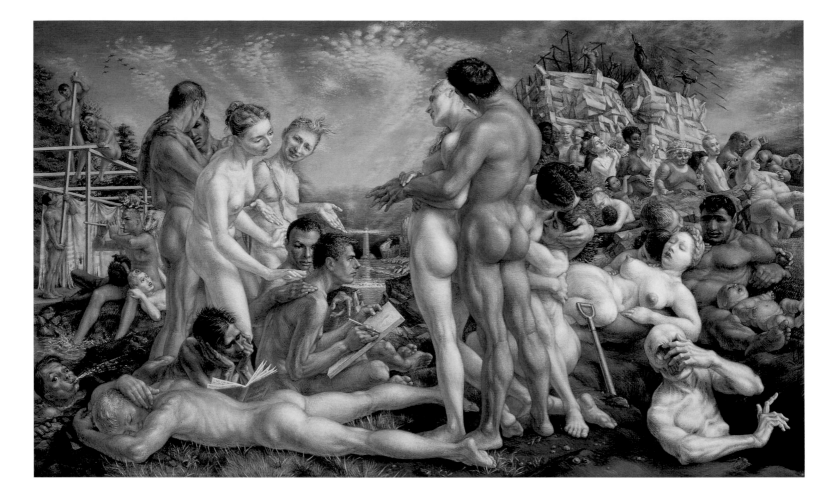

PAUL CADMUS
American, 1904–1999
What I Believe, 1947–48

Tempera on panel, 16¼ x 27 in.
Gift of Robert L. B. Tobin
1999.86

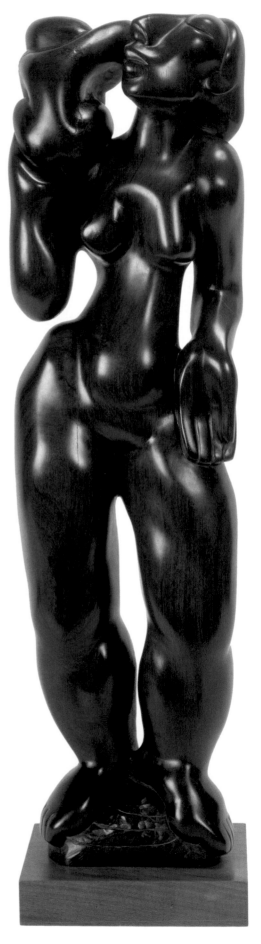

RAOUL PÈNE DU BOIS
American, 1914–1985
Scene design for Dean Acheson's office in *Call Me Madam*, **1950**

Watercolor and ink on paper, 14⅜ x 25½ in.
Gift of Robert L. B. Tobin
TL1999.225

CHARLES UMLAUF
American, 1911–1994
Mother and Child, **1943**

Rosewood, 31½ in. high
Mary and Sylvan Lang Collection
1975.74

KELLY FEARING
American, born 1918
Boy Flying Kite, Fish Watching, 1947–48

Oil on canvas, 12 x 16 in.
Gift of Amy Freeman Lee in honor of Blanche
and John Leeper
1990.15

LEONORA CARRINGTON
Mexican, born Britain, 1917
Bird in Mouth

Graphite on paper, 13⅜ x 10½ in.
Gift of Amy Freeman Lee in honor of Blanche
and John Leeper
1990.7

BILL REILY
American, born 1930
Song of the Arabian Nightingale, 1957

Collage on panel, 23¹¹⁄₁₆ x 16³⁄₁₆ in.
Gift of Mary and Sylvan Lang
1959.1

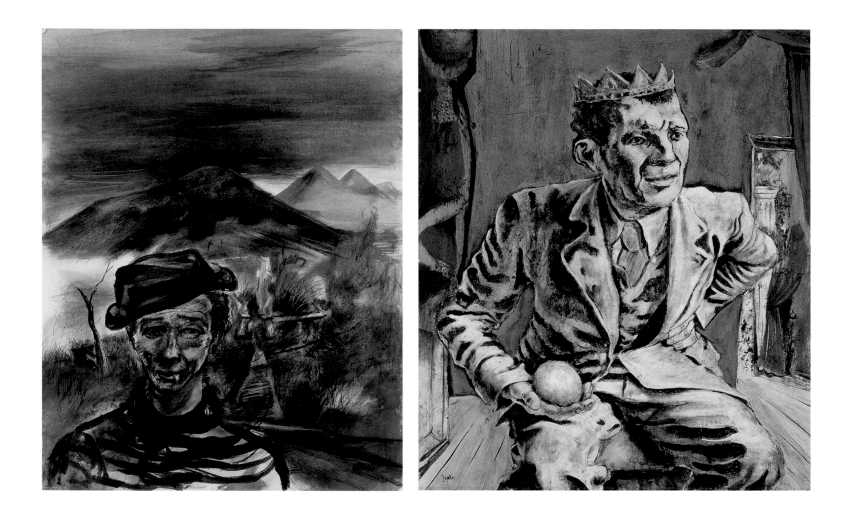

YASUO KUNIYOSHI
American, born Japan, 1893–1953
Pie in the Sky, 1945

Ink and wash on paper, 28 x 22 in.
Mary and Sylvan Lang Collection
1975.40

KARL ZERBE
American, born Germany, 1903–1972
Penny-Gaff, 1945

Encaustic on canvas, 33¾ x 29 in.
Gift of Mary and Sylvan Lang
1958.3

MAX WEBER
American, born Russia, 1881–1961
Refreshments, 1947

Oil on canvas, 24 x 32 in.
Mary and Sylvan Lang Collection
1975.57

JO MIELZINER
American, born France, 1901–1976
Scene design for McLevy's window in
A Tree Grows in Brooklyn, 1951

Watercolor, ink, and graphite on board, 13½ x 24 in.
Gift of Robert L. B. Tobin
TL1999.202

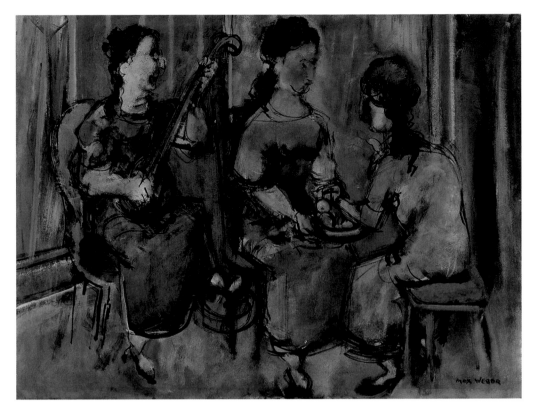

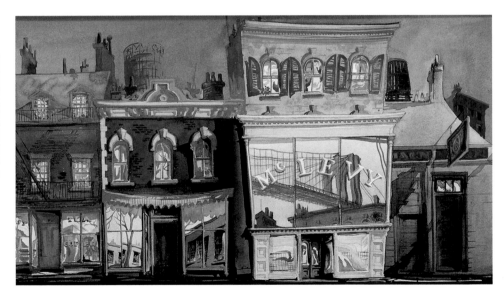

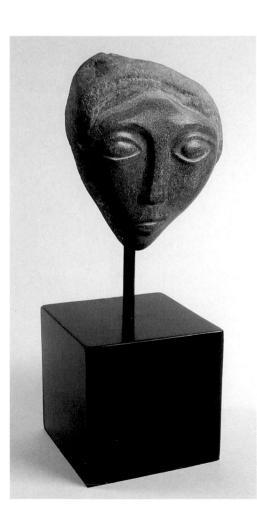

WILLIAM ZORACH
American, born Russia, 1887–1966
Head, 1952

Granite, 7⅝ in. high
Mary and Sylvan Lang Collection
1975.77

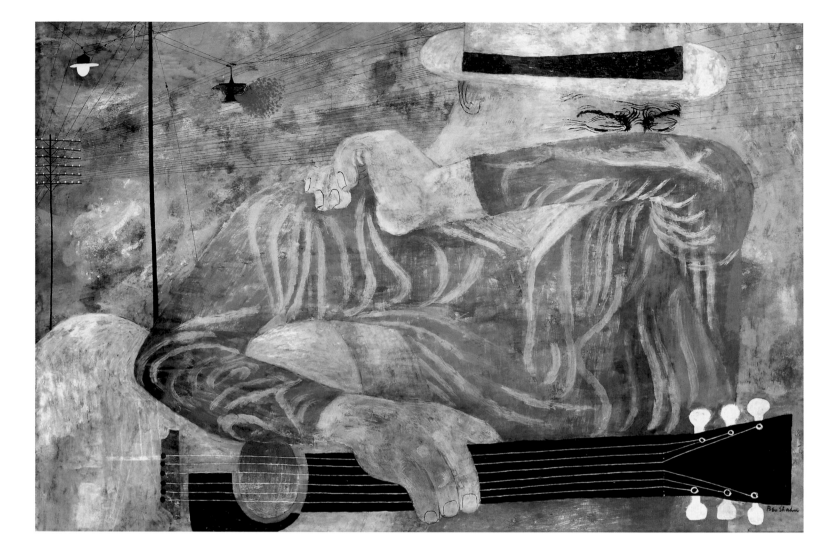

BEN SHAHN
American, born Lithuania, 1898–1969
Sing Sorrow, 1946

Tempera on panel, 26 x 39 in.
Mary and Sylvan Lang Collection
1975.49

OLIVER SMITH
American, 1918–1994
Scene design for "Under the El" in
West Side Story, ca. 1957

Watercolor and graphite on paper, 15¾ x 23 in.
Gift of Robert L. B. Tobin
TL1999.314

CHARLES SHEELER
American, 1883–1965
Barn Decoration, 1959

Oil on canvas, 27³⁄₁₆ x 38³⁄₁₆ in.
Mary and Sylvan Lang Collection
1975.52

RALSTON CRAWFORD
American, born Germany, 1906–1978
Grey Street, 1940

Screenprint, image 12 x 15 in., Flint catalogue 2
Gift of the Friends of the McNay
1989.29

MARK TOBEY
American, 1890–1976
Edge of the Map, 1954

Tempera on paper, 16¹¹⁄₁₆ x 10⁵⁄₁₆ in.
Mary and Sylvan Lang Collection
1975.54

JOHN MCLAUGHLIN
American, 1898–1976
Untitled, 1949

Oil on panel, 23½ x 26½ in.
Museum purchase with the Helen and
Everett H. Jones Purchase Fund
2000.12

MILTON AVERY
American, 1893–1965
Portrait of March, the Artist's Daughter,
1950

Oil on panel, 15½ x 11⅝ in.
Gift of Mrs. Donald W. Saunders
1977.13

WILLIAM BAZIOTES
American, 1912–1963
White Bird, **1950**

Oil and charcoal on canvas, 30 x 24 in.
Mary and Sylvan Lang Collection
1975.20

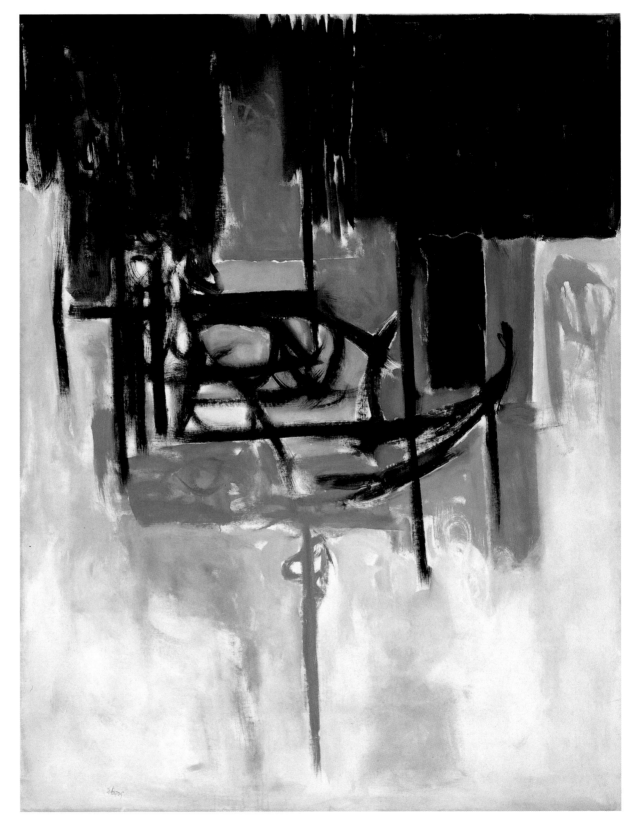

THEODOROS STAMOS
American, born Greece, 1922–1997
Red Sea Terrace No. 2, 1952

Oil on canvas, 92 x 70¼ in.
Museum purchase
1960.1

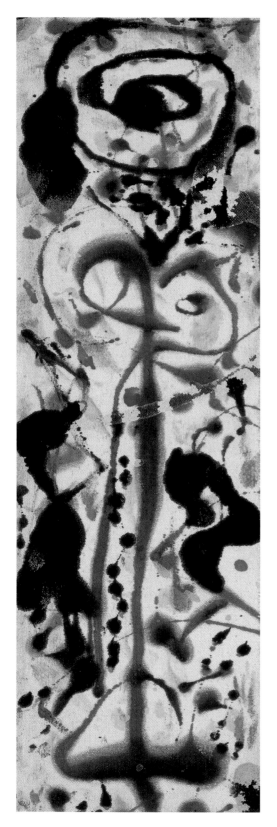

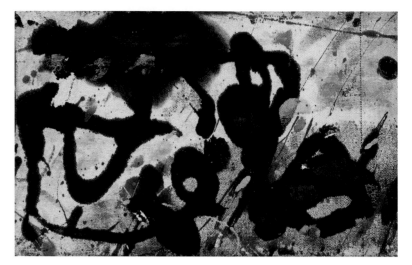

JACKSON POLLOCK
American, 1912–1956
No. 2-A, 1952

Oil on canvas mounted on panel, 7¼ x 11¼ in.
Mary and Sylvan Lang Collection
1975.47

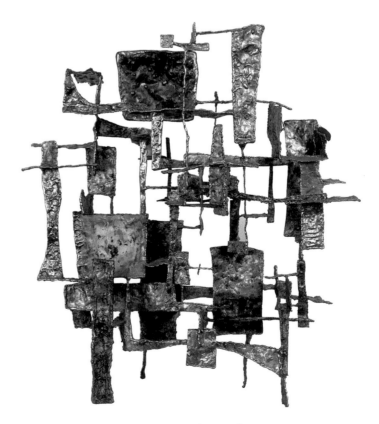

JACKSON POLLOCK
American, 1912–1956
No. 2-B, 1952

Oil on canvas mounted on panel, 23 x 7¼ in.
Mary and Sylvan Lang Collection
1975.48

IBRAM LASSAW
American, born Egypt, 1913
Assemblage, 1958

Bronze, nickel, copper, and silver, 31½ in. high
Gift of Evelyn Halff Ruben
1982.63

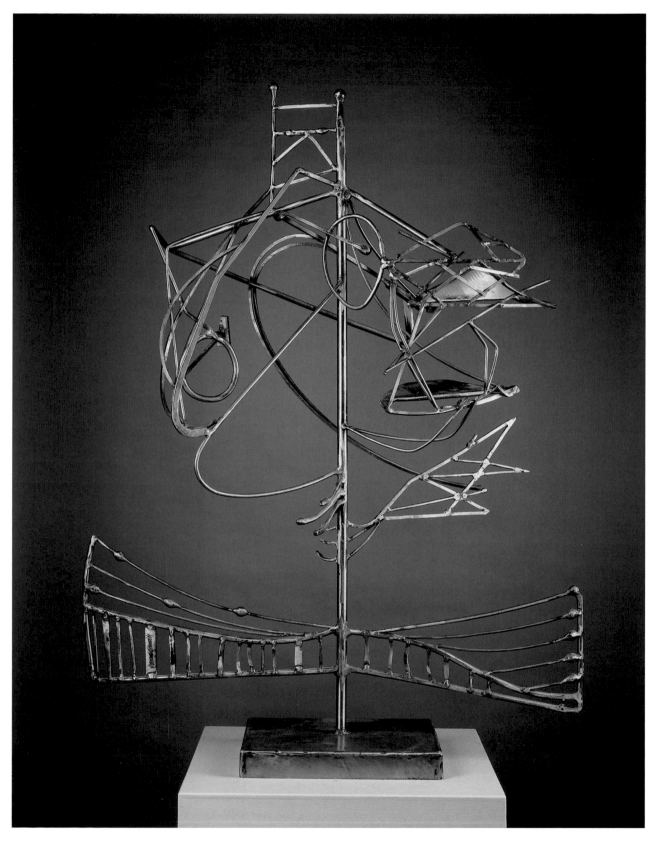

DAVID SMITH
American, 1906–1965
Stainless Network I, 1951

Stainless steel, 38⅛ in. high, Krauss catalogue 261
Bequest of Evelyn Halff Ruben

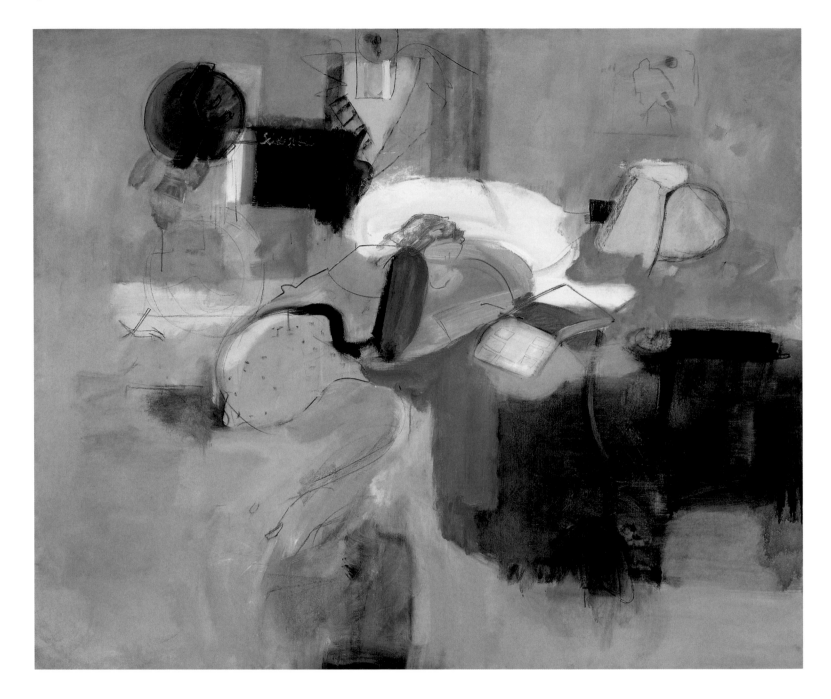

LARRY RIVERS
American, born 1923
Blocks: Yellow, Orange, ca. 1958

Oil on canvas, 60 x 72 in.
Gift of the Estate of Tom Slick
1973.23

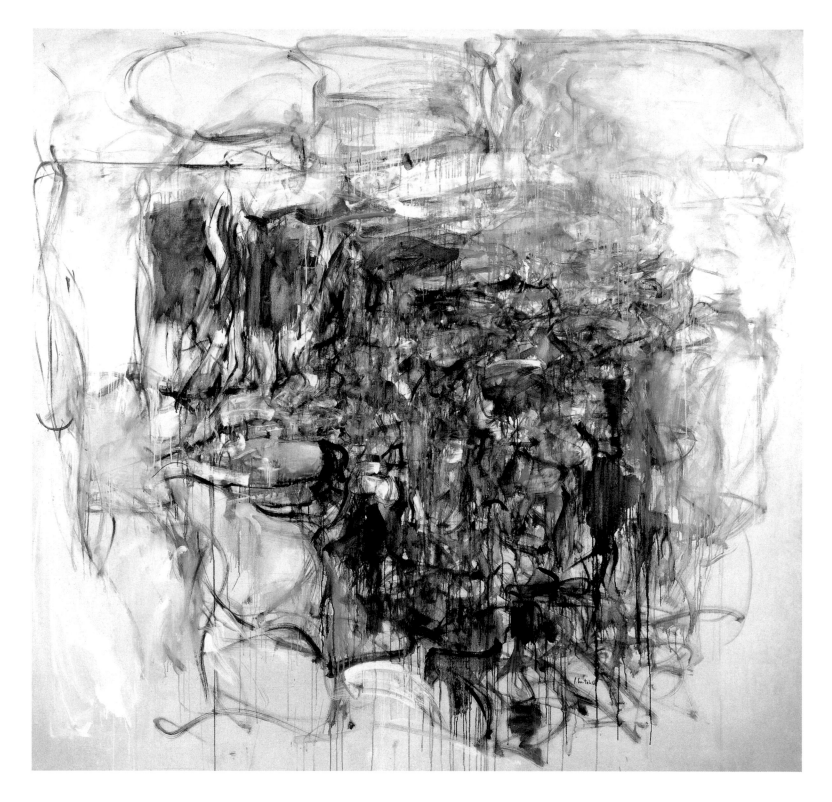

JOAN MITCHELL
American, 1926–1992
Hudson River Day Line, 1955

Oil on canvas, 83 x 79 in.
Museum purchase with funds from the
Tobin Foundation
1994.7

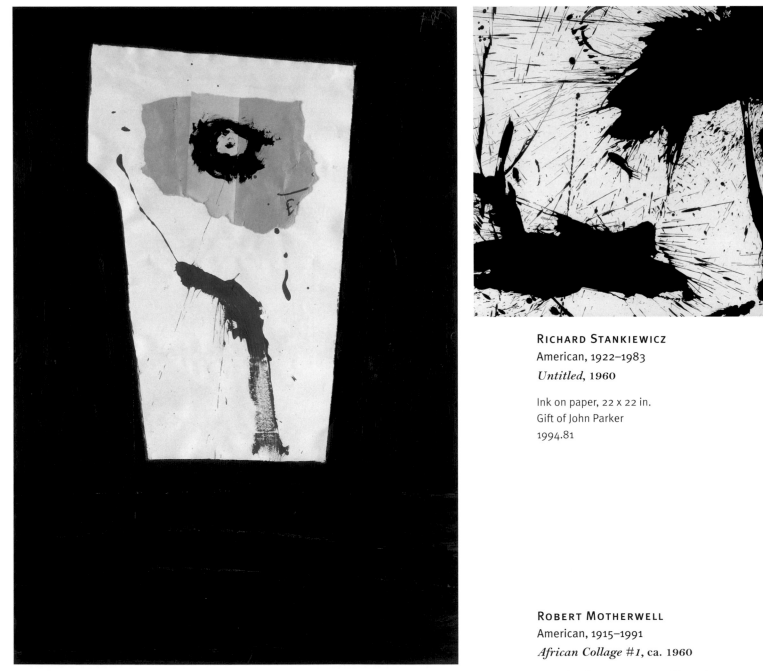

RICHARD STANKIEWICZ
American, 1922–1983
Untitled, 1960

Ink on paper, 22 x 22 in.
Gift of John Parker
1994.81

ROBERT MOTHERWELL
American, 1915–1991
African Collage #1, ca. 1960

Oil and collage on paper, 39½ x 27 in.
Museum purchase with the Helen and Everett H.
Jones Purchase Fund and Gift of the Dedalus
Foundation
1996.12

RICHARD STANKIEWICZ
American, 1922–1983
Untitled, 1960

Welded metal, 39½ in. high
Gift of the Friends of the McNay and
Robert L. B. Tobin
1992.16

JIM LOVE
American, born 1927
Choir Director, 1959

Iron, 15 in. high
Mary and Sylvan Lang Collection
1975.65

ISAMU NOGUCHI
American, 1904–1988
The Mirror, 1958

Painted aluminum, 63½ in. high
Gift of the Estate of Tom Slick
1973.35

RICHARD STANKIEWICZ
American, 1922–1983
Untitled, 1964

Intaglio on polyester, plate 34 x 14¾ in.
Museum purchase
2000.45

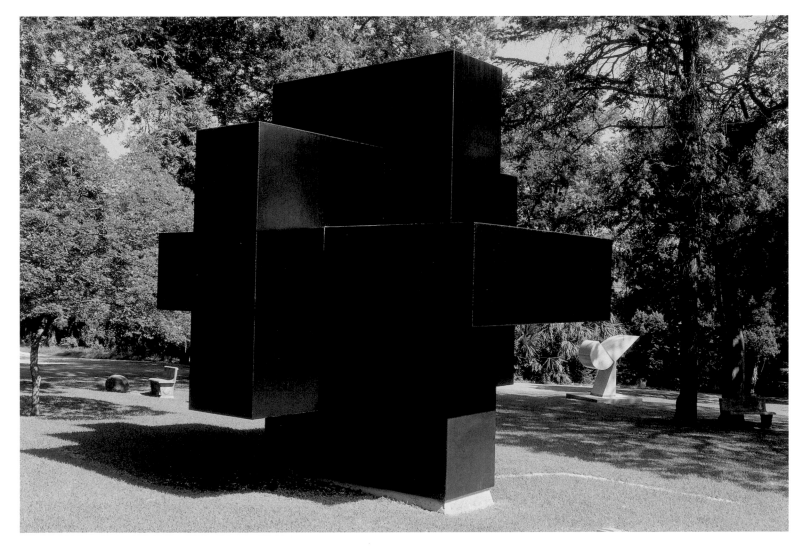

TONY SMITH
American, 1912–1980
Asteriskos, 1968

Painted steel, 197½ in. high
Gift of the Catto Foundation in honor of
William Pettus Hobby
1970.18

SUE FULLER
American, born 1914
String Composition #T-220, 1965

Synthetic fibers, 42 x 42 in.
Gift of Emerson Crocker
1965.9

JACK YOUNGERMAN
American, born 1926
Delta, 1965

Acrylic on canvas, 50 x 64⅝ in.
Gift of Paul Waldman
1984.32

GRACE HARTIGAN
American, born 1922
Dido, 1960

Oil on canvas, 82 x 91 in.
Gift of Jane and Arthur Stieren
1988.3

CY TWOMBLY
American, born 1929
Untitled, 1971

Chalk, oil pastel, and gouache on paper,
27½ x 39 in.
Gift of Robert L. B .Tobin
1991.9

WILLEM DEKOONING
American, born Netherlands, 1904–1997
The Marshes, 1970

Lithograph, image 31⅝ x 23⅝ in.,
Graham catalogue 7
Gift of the Friends of the McNay
1973.13

PAUL WONNER

American, born 1920

Seven Views of the Model with Flowers, 1962

Oil on three canvases, each 48 x 46 in.
Gift of Robert L. B. Tobin
1999.106

JIM DINE
American, born 1935
Five Paintbrushes, 1973

Etching and aquatint, plate 14⅜ x 27½ in.,
D'Oench catalogue 138
Gift of the Friends of the McNay
1974.46

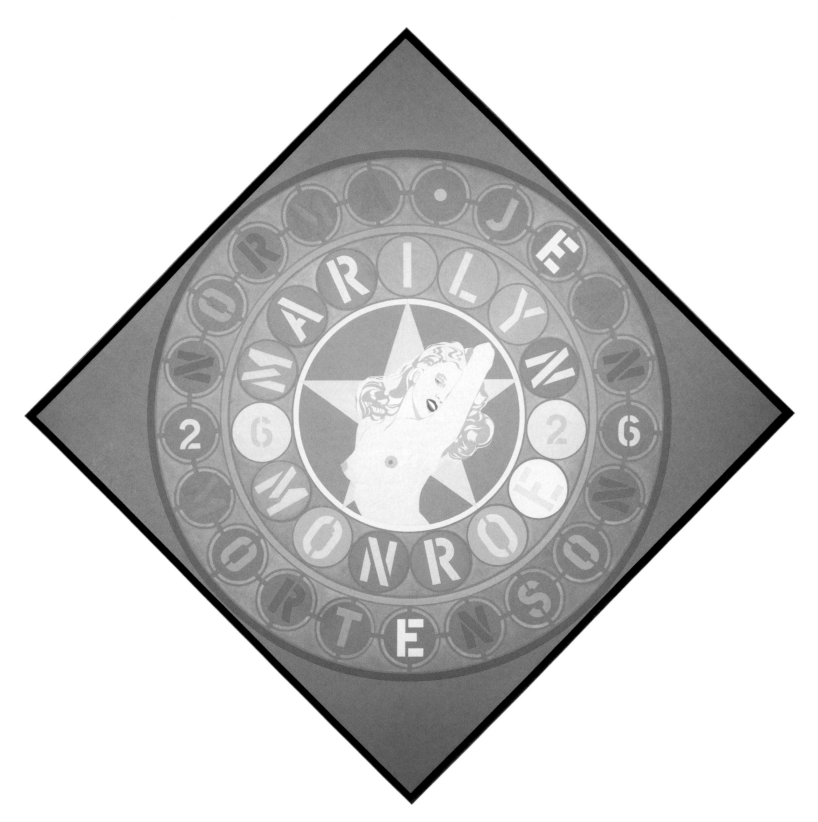

ROBERT INDIANA
American, born 1928
*The Metamorphosis of Norma Jean
Mortenson*, 1967

Oil on canvas, 102 x 102 in.
Gift of Robert L. B. Tobin
1999.94

ROBERT INDIANA
American, born 1928
Decade Auto Portrait, 1961–1972, 1977

Oil on canvas, 72 x 72 in.
Gift of Robert L. B. Tobin
1999.93

ROBERT INDIANA
American, born 1928
**Design for "Freedom Float" in the
Bicentennial Procession I, Overture**
in *The Mother of Us All*, 1976

Collage, 26⅛ x 20 in.
Gift of Robert L. B. Tobin
1978.11.33

ED RUSCHA
American, born 1937
Standard Station, 1966

Screenprint, image 19⅝ x 37⅞ in.
Gift of the Friends of the McNay
1976.17

ED RUSCHA
American, born 1937
Western, 1968

Gunpowder on paper, 11½ x 28¾ in.
Gift of the Estate of William Pitkin
1993.46

ROY LICHTENSTEIN
American, 1923–1997
Cathedral #3, 1969

Lithograph, image 41¹³⁄₁₆ x 27 in.
Gift of Robert H. Halff
1976.15

WOJCIECH FANGOR
American, born Poland, 1922
Black Cross, 1962

Oil on canvas, 52½ x 33¼ in.
Gift of Mr. and Mrs. Edward J. Gesick in
memory of Tom Slick
1977.15

JIM PARKER
American, 1933–1985
Untitled from the *Dot Series,* ca. 1972

Oil on canvas, 50½ x 50½ in.
Gift of Lenore Parker
2000.4

GENE DAVIS
American, 1920–1985
Moroccan Wedding, 1972

Acrylic on canvas, 90 x 61 in.
Gift of Alice N. Hanszen
1974.1

ANDREW WYETH
American, born 1917
Corn Cutting Knife, 1957

Watercolor on paper, 19⅞ x 14¹⁄₁₆ in.
Museum purchase with funds from the
Tobin Foundation
1994.1

CARL RICE EMBREY
American, born 1938
Shells, 1972

Acrylic on panel, 47⅞ x 71⅞ in.
Museum purchase with funds from
Charline and Red McCombs
1998.3

JOHN KOCH
American, 1909–1978
Still Life, Dusk, Setauket, 1963

Oil on canvas, 50¼ x 40 in.
Gift of the Semmes Foundation
1981.21

GEORGE SEGAL
American, 1924–2000
His Hand on Her Back, 1973

Painted fiberglass, 41¾ x 29 x 9 in.
Bequest of Gloria and Dan Oppenheimer
1998.11

JASPER JOHNS
American, born 1930
Decoy II, 1971–73

Lithograph, image 41⁹⁄₁₆ x 29⅝ in.,
Field catalogue 169
Bequest of Mrs. Jerry Lawson
1994.127

JASPER JOHNS
American, born 1930
Ventriloquist, 1986

Lithograph, image 36⅞ x 24⅜ in.,
ULAE catalogue 233
Bequest of Mrs. Jerry Lawson
1994.133

JOSEPH CORNELL
American, 1903–1972
Untitled (Derby Hat), 1972

Photogravure, plate 13¼ x 10⁵⁄₁₆ in.
Gift of the Friends of the McNay
1992.17

ROBERT RAUSCHENBERG
American, born 1925
Sling Shots Lit #5, 1985

Lightbox with lithographs on mylar
and sailcloth, 84½ x 56¼ x 12½ in.
Gift of Robert H. Halff
1985.14

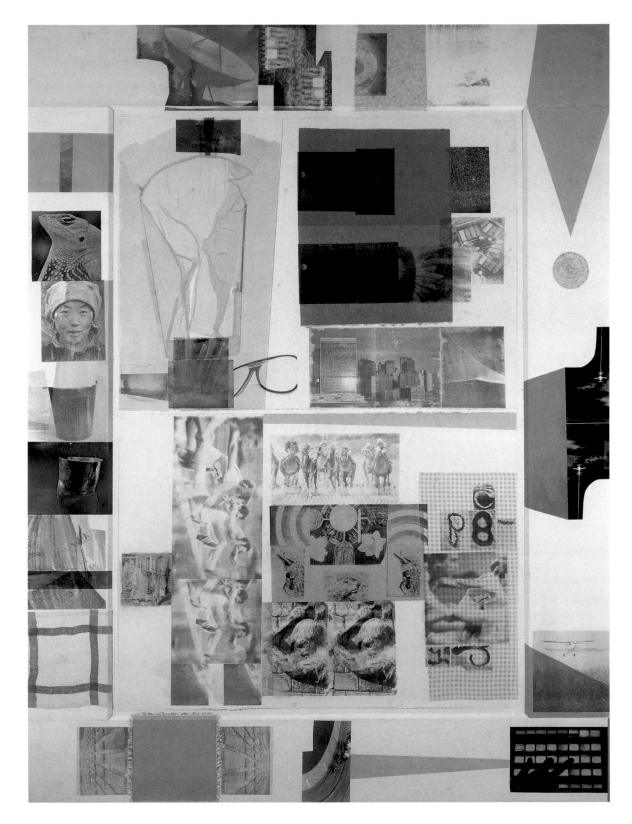

ROBERT RAUSCHENBERG
American, born 1925
Rush #5 from the *Cloister Series*, 1980

Oil on canvas, with rubbings and collage,
96 x 72 in.
Gift of Robert H. Halff
1988.11

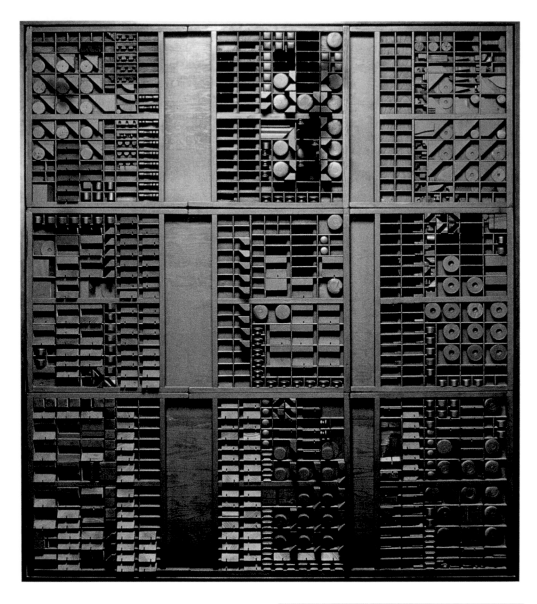

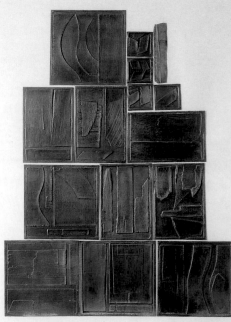

LOUISE NEVELSON
American, born Russia, 1900–1988
End of Day Nightscape V, 1973

Painted wood, 65¼ x 58 in.
Gift of Alice N. Hanszen
1976.20

LOUISE NEVELSON
American, born Russia, 1900–1988
The Great Wall, 1970

Lead-foil relief print, image 23¾ x 17⅝ in.
Gift of Mr. and Mrs. Jack Rodgers
1971.6

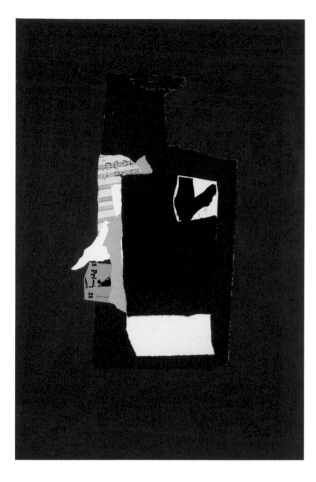

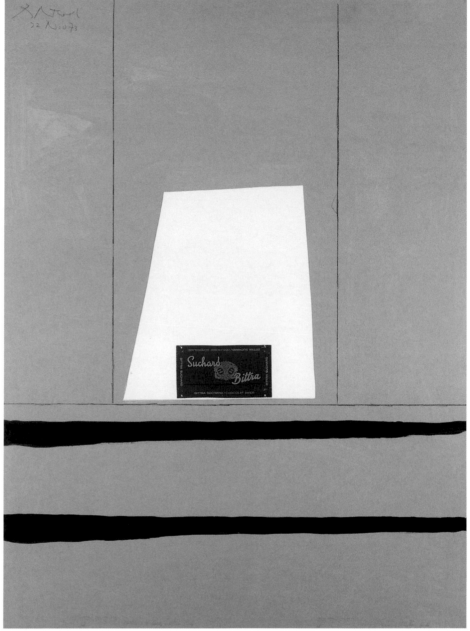

ROBERT MOTHERWELL

American, 1915–1991

The Redness of Red, 1995

Screenprint, lithograph, and collage,
image 24⅛ x 16⅛ in., Belknap catalogue 324
Gift of the Board of Trustees in honor of
John Palmer Leeper's 75th birthday
1996.1

ROBERT MOTHERWELL

American, 1915–1991

Suchard on Orange #5, 1973

Collage and acrylic on board, 48 x 36 in.
Museum purchase with the Alvin Whitley
Fund and Gift of the Dedalus Foundation
1996.14

WALTER DARBY BANNARD
American, born 1934
Bengali Monsoon, 1977

Acrylic, polymer medium, and aquatic
gel on canvas, 66½ x 49 in.
Gift of Dr. Jason Salsbury
1983.1

KIKUO SAITO
American, born Japan, 1939
Crocodile Song, 1978

Oil on canvas, 33⅛ x 91½ in.
Gift of Jeanne Lang Mathews
2001.2

REGINALD ROWE
American, born 1920
Icon, 1978

Acrylic on canvas, 69⅞ x 52⅝ in.
Gift of the artist
1996.7

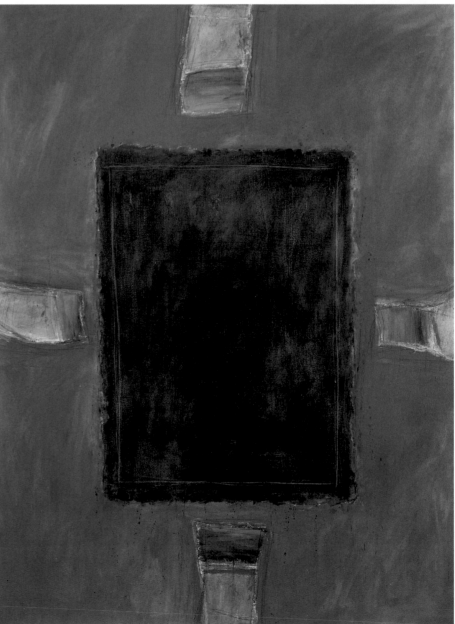

ROBERT MORRIS
American, born 1931
Untitled, 1983–84

Pastel on paper with painted hydrocal
frame, 102 x 108 in. with frame
Gift of Robert L. B. Tobin
1991.8

ROBERT WILSON
American, born 1944
Drawing #5 for Act I, Scene B, in
The Golden Windows, ca. 1981

Graphite on paper, image 14¾ x 21 in.
Gift of Robert L. B. Tobin
TL1999.382.2

KENT RUSH
American, born 1948
Mojón, 1989

Collotype, image 7¾ x 7⅝ in.
Gift of the artist in memory of John Palmer Leeper
1997.23

RICHARD DIEBENKORN
American, 1922–1993
Blue with Red, 1987

Woodcut, image 33¾ x 23 in.
Gift of the Friends of the McNay
1994.192

ALINE FELDMAN
American, born 1928
Nightfall, 1996

Woodcut, image 51⅞ x 40⅛ in.
Gift of Alice C. Simkins in memory of
Elsie Nicholson Simkins
1997.49

JANE FREILICHER
American, born 1924
In Broad Daylight, 1979

Oil on canvas, 70 x 80 in.
Gift of the Semmes Foundation
1980.35

JIM DINE
American, born 1935
Jumps Out at You, No?, 1993

Etching with hand-coloring, plate 12⅝ x 21⅛ in.
Gift of the Board of Trustees in memory of
John Palmer Leeper
1996.20

CHUCK CLOSE
American, born 1940
Self-Portrait, 1992

Aquatint, plate 6¾ x 4⅞ in.
Gift of the Gallery of the McNay
1993.6

ERIC FISCHL
American, born 1948
Untitled (Dog), 1989

Aquatint, plate 33 x 41¾ in.
Gift of the Friends of the McNay
1997.53

KATHY VARGAS
American, born 1950
I Was Little, 1998 and 2001

Gelatin silver print with hand coloring,
22¹⁄₁₆ x 16⁷⁄₈ in.
Promised gift of the artist

CRAIG MCPHERSON
American, born 1948
Yankee Stadium at Night, 1983

Mezzotint, plate 23¹⁵⁄₁₆ x 35⅝ in.
Gift of the Friends of the McNay
1995.34

YVONNE JACQUETTE
American, born 1934
Winging It, 1990

Etching, plate 15⅞ x 19¹⁄₁₆ in.
Gift of Alice C. Simkins in honor of the
40th anniversary of the McNay Art Museum
1994.195

TONY STRAIGES

American, born 1942

Maquette for "Boys Bathing Unit" in
Sunday in the Park with George, 1984

Mixed media, 4½ x 9 x 5 in.

Gift of Robert L. B. Tobin

TL1999.321

SOL LEWITT
American, born 1928
Band of Lines in Four Directions, Square, 1993

Woodblock, image 12½ x 12½ in.
Gift of Janet and Joe Westheimer
1994.197

DONALD JUDD
American, 1928–1994
Untitled #211, 1992

Suite of four woodcuts, each, image 24⅞ x 37½ in.
Museum purchase with funds from the Friends
of the McNay, Raye and Ben Foster, Janet and
Joe Westheimer, Ann Tobin, and JoAnn and
Herman Wigodsky
1999.2.1–4

GEORGE RICKEY
American, born 1904

Horizontal Column of Five Squares
Excentric II, 1994

Stainless steel, 71½ x 134 in. maximum possible
Museum purchase with the Russell Hill Rogers
Fund for the Arts
1997.63

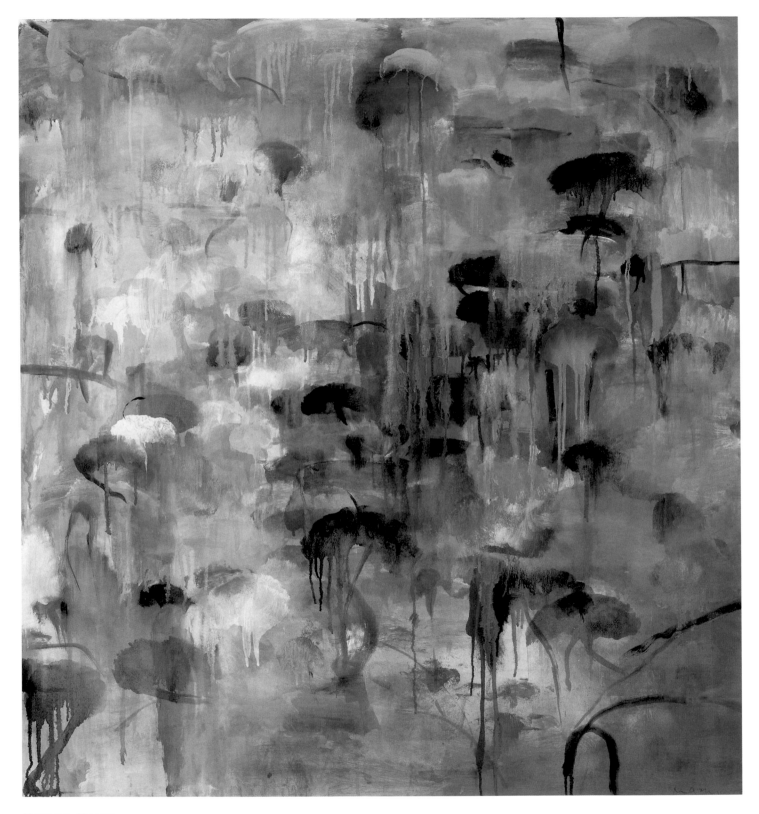

MICHAEL MAZUR
American, born 1935
Untitled, 1996

Monotype with hand-coloring, image 42½ x 42½ in.
Gift of the Friends of the McNay in memory of
John Palmer Leeper
1996.23

KIKI SMITH
American, born 1954
Untitled, ca. 1989

Aquatint, plate 20⅛ x 29¼ in.
Transferred from the San Antonio Art Institute
1997.2

TERRY WINTERS
American, born 1949
Vorticity Field, 1995

Aquatint, plate 22⅜ x 30 in.
Gift of the Friends of the McNay in memory
of John Palmer Leeper
1996.25

CÉSAR A. MARTINEZ
American, born 1944
Cono's Christmas Buck, 1993

Mixed media on panel, 64 x 64 in.
Gift of Robert L. B. Tobin
1999.98

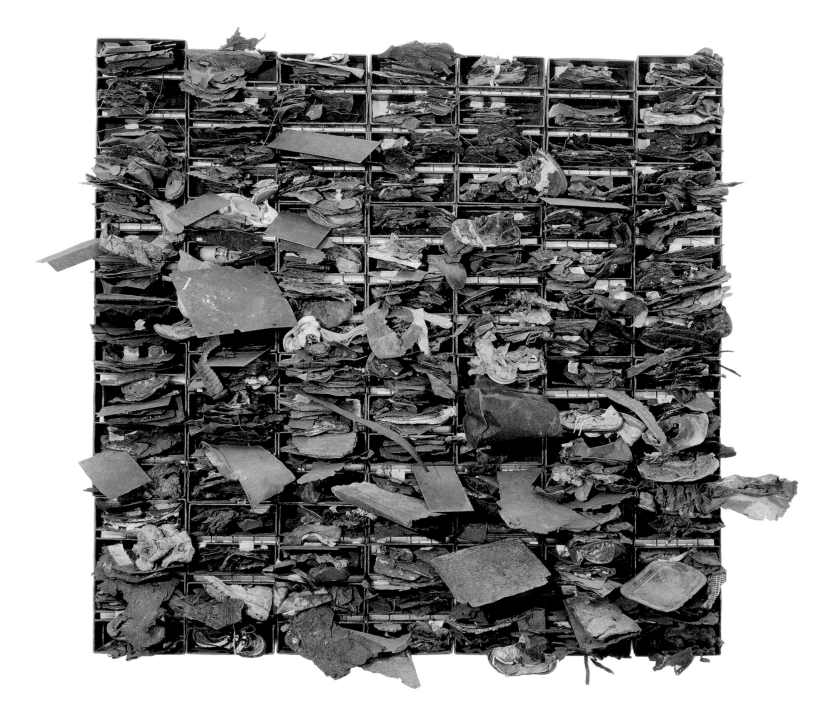

LEONARDO DREW
American, born 1961
Untitled, 1999

Found objects with rust, 99 x 114 x 22 in.
Museum purchase with the Helen and Everett H.
Jones Purchase Fund
2000.2

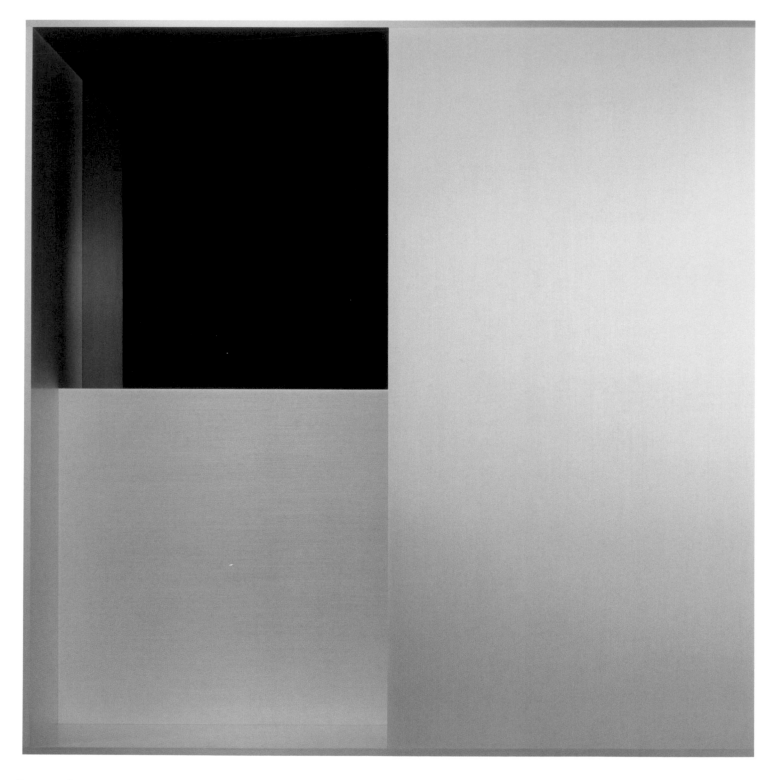

DONALD JUDD
American, 1928–1994
Untitled, 1989

Aluminum with Plexiglas,
39⅜ x 39⅜ x 19⅝ in.
Museum purchase in part with the Alvin
Whitley Fund, with additional funds from
Ann and Frederick Erck
2001.8

JOEL SHAPIRO
American, born 1941
Untitled, 2000

Painted aluminum, 58½ x 31½ x 87 in.
Museum purchase with the Russell Hill Rogers
Fund for the Arts
2001.9

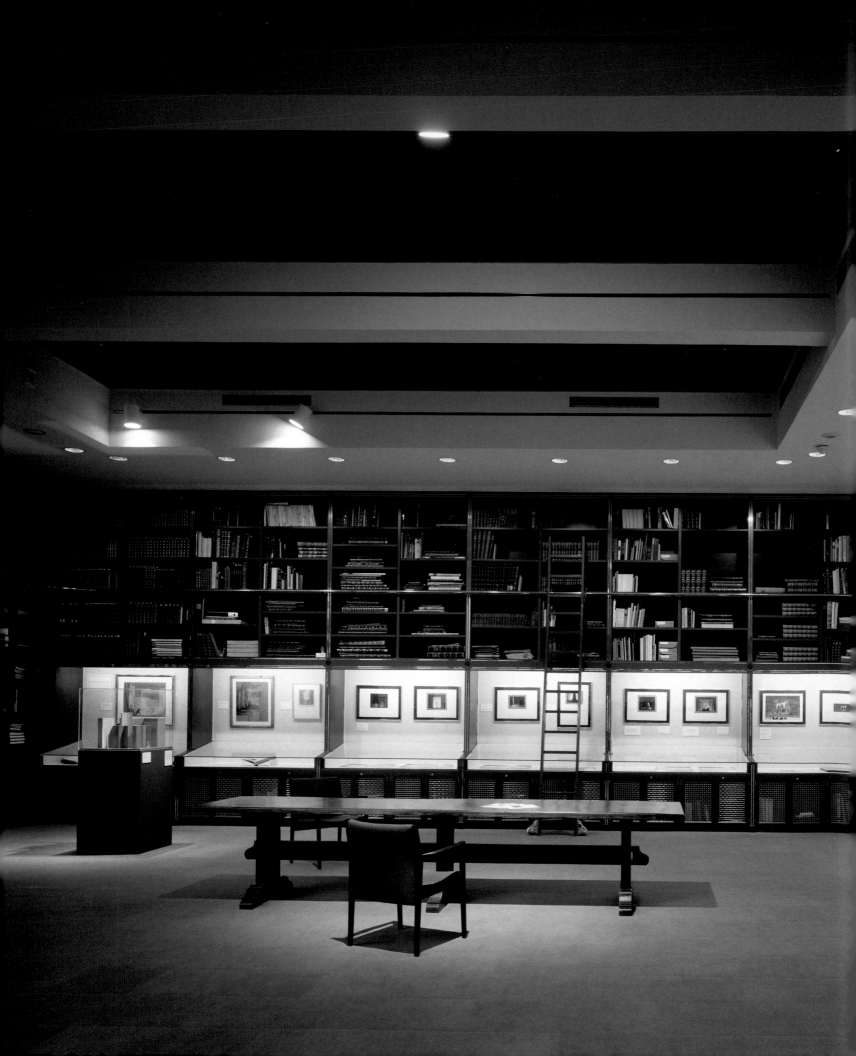

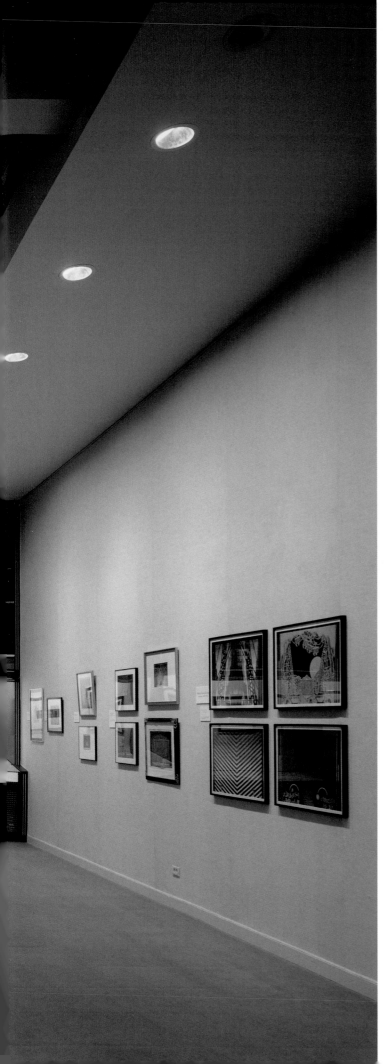

Index of Artists, Titles, and Donors

The names of artists are in small capital letters. Titles of works are in italics. Donors' names are in plain type.

This publication is made possible by the encouragement of Carolyn and Allan Paterson and through the support of the Horse Creek Trust. Generous support of photography and reproduction rights for this publication has been provided by the Semmes Foundation.

Copyright © 2001 by The Marion Koogler McNay Art Museum

All rights reserved. No part of this publication may be reproduced, stored in a retrieval system, or transmitted in any form or by any means, electronic, mechanical, photocopying, or otherwise, without prior written permission from the publisher, except by a reviewer who wishes to quote brief passages in connection with a review written for inclusion in a magazine, newspaper, or broadcast.

The Marion Koogler McNay Art Museum
6000 North New Braunfels
P.O. Box 6069
San Antonio, Texas 78209-0069

Views of the Estelle Blackburn patio: peacock tile mural (p. 1); view with fireplace (p. 2); view of two rectangular tile murals (p. 6)

Long view of the front of the museum (p. 8)

Lang Gallery (pp. 20–21)

Tobin Library for the Theatre Arts
(pp. 240–41)

Library of Congress Catalog Control Number: 2001 135491

ISBN: 0-916677-48-6

Designed by Susan E. Kelly with assistance by Elsa Varela
Jacket designed by John Hubbard
Color separations by iocolor, Seattle
Produced by Marquand Books, Inc., Seattle
 www.marquand.com
Printed and bound by CS Graphics Pte., Ltd., Singapore

Photography credits:
All photographs of the building were taken by
 Hester + Hardaway
All art objects were photographed by Michael Jay Smith with the exception of: pp. 44 (bottom), 47 (top), 66, and 149 by David Wharton, Fort Worth; pp. 105 (top) and 79 (bottom) by Thomas DuBrock, Houston; p. 195 by Peter Brenner, Los Angeles

Copyright credits:
All images of the building: © 1997 Hester + Hardaway
Albers: © 2001 The Josef and Anni Albers Foundation/ Artists Rights Society (ARS), New York
Archipenko: © 2001 Estate of Alexander Archipenko/ Artists Rights Society (ARS), New York
Arp: © 2001 Artists Rights Society (ARS), New York/ VG Bild-Kunst, Bonn
Avery: © 2001 Milton Avery Trust/Artists Rights Society (ARS), New York
Bannard: © Walter Darby Bannard/Licensed by VAGA, New York, NY
Beckmann: © 2001 Artists Rights Society (ARS), New York/VG Bild-Kunst, Bonn
Benois: © 2001 Artists Rights Society (ARS), New York/ADAGP, Paris
Bonnard: © 2001 Artists Rights Society (ARS), New York/ADAGP, Paris
Braque: © 2001 Artists Rights Society (ARS), New York/ADAGP, Paris
Calder: © 2001 Estate of Alexander Calder/ Artists Rights Society (ARS), New York
Campendonk: © 2001 Artists Rights Society (ARS), New York/VG Bild-Kunst, Bonn
Chagall: © 2001 Artists Rights Society (ARS), New York/ADAGP, Paris
Cocteau: © 2001 Artists Rights Society (ARS), New York/ADAGP, Paris
deKooning: © 2001 Willem deKooning Revocable Trust/Artists Rights Society (ARS), New York
Dubuffet: © 2001 Artists Rights Society (ARS), New York/ADAGP, Paris
Dufy: © 2001 Artists Rights Society (ARS), New York/ ADAGP, Paris
Fearing: © Kelly Fearing/Licensed by VAGA, New York, NY
Feininger: © 2001 Artists Rights Society (ARS), New York/VG Bild-Kunst, Bonn
Giacometti: © 2001 Artists Rights Society (ARS), New York/ADAGP, Paris
Gleizes: © 2001 Artists Rights Society (ARS), New York/ADAGP, Paris
Gontcharova: © 2001 Artists Rights Society (ARS), New York/ADAGP, Paris
Gromaire: © 2001 Estate of Marcel Gromaire/ Artists Rights Society (ARS), New York
Grosz: © Estate of George Grosz/Licensed by VAGA, New York, NY
Hayter: © 2001 Artists Rights Society (ARS), New York/ADAGP, Paris
Heckel: © 2001 Artists Rights Society (ARS), New York/VG Bild-Kunst, Bonn
Hepworth: © Alan Bowness, Hepworth Estate
Indiana: © 2001 Morgan Art Foundation Ltd./ Artists Rights Society (ARS), New York
Jawlensky: © 2001 Artists Rights Society (ARS), New York/VG Bild-Kunst, Bonn
Judd: © Donald Judd Foundation/Licensed by VAGA, New York, NY
Lichtenstein: © Estate of Roy Lichtenstein
Kandinsky: © 2001 Artists Rights Society (ARS), New York/ADAGP, Paris
Klee: © 2001 Artists Rights Society (ARS), New York/ VG Bild-Kunst, Bonn
Kollwitz: © 2001 Artists Rights Society (ARS), New York/VG Bild-Kunst, Bonn
Larionov: © 2001 Artists Rights Society (ARS), New York/ADAGP, Paris
Laurencin: © 2001 Artists Rights Society (ARS), New York/ADAGP, Paris
Leger: © 2001 Artists Rights Society (ARS), New York/ADAGP, Paris
LeWitt: © 2001 Sol LeWitt/Artists Rights Society (ARS), New York
Magritte: © 2001 C. Herscovici, Brussels/Artists Rights Society (ARS), New York

Maillol: © 2001 Artists Rights Society (ARS), New York/ADAGP, Paris
Marin: © 2001 Estate of John Marin/Artists Rights Society (ARS), New York
Matisse: © 2001 Succession H. Matisse, Paris/Artists Rights Society (ARS), New York
Miro: © 2001 Artists Rights Society (ARS), New York/ ADAGP, Paris
Moholy-Nagy: © 2001 Artists Rights Society (ARS), New York/VG Bild-Kunst, Bonn
Mondrian: © 2001 Artists Rights Society (ARS), New York/Beeldrecht, Amsterdam
Moore: Courtesy of the Henry Moore Foundation
R. Morris: © 2001 Robert Morris/Artists Rights Society (ARS), New York
Motherwell: © Dedalus Foundation, Inc./Licensed by VAGA, New York, NY
Munch: © 2001 The Munch Museum/The Munch-Ellingsen Group/Artists Rights Society (ARS), New York
Nevelson: © 2001 Estate of Louise Nevelson/Artists Rights Society (ARS), New York
Nicholson: © 2001 Artists Rights Society (ARS), New York/DACS, London
O'Keeffe: © 2001 The Georgia O'Keeffe Foundation/ Artists Rights Society (ARS), New York
Pascin: © 2001 Artists Rights Society (ARS), New York/ADAGP, Paris
Picasso: © 2001 Estate of Pablo Picasso/Artists Rights Society (ARS), New York
Pollock: © 2001 The Pollock-Krasner Foundation/ Artists Rights Society (ARS), New York
Rauschenberg: © Robert Rauschenberg/Licensed by VAGA, New York, NY
Richier: © 2001 Artists Rights Society (ARS), New York/ADAGP, Paris
Rickey: © George Rickey/Licensed by VAGA, New York, NY
Rivers: © Larry Rivers/Licensed by VAGA, New York, NY
Rouault: © 2001 Artists Rights Society (ARS), New York/ADAGP, Paris
Schmidt-Rottluff: © 2001 Artists Rights Society (ARS), New York/VG Bild-Kunst, Bonn
Segal: © George and Helen Segal Foundation/Licensed by VAGA, New York, NY
Shahn: © Estate of Ben Shahn/Licensed by VAGA, New York, NY
Shapiro: © 2001 Joel Shapiro/Artists Rights Society (ARS), New York
D. Smith: © Estate of David Smith/Licensed by VAGA, New York, NY
O. Smith: Courtesy of Rosaria Sinisi, Brooklyn, NY
T. Smith: © 2001 Estate of Tony Smith/Artists Rights Society (ARS), New York
Soutine: © 2001 Artists Rights Society (ARS), New York/ADAGP, Paris
Tapies: © 2001 Artists Rights Society (ARS), New York/ADAGP, Paris
Tobey: © 2001 Artists Rights Society (ARS), New York/ProLitteris, Zurich
Utrillo: © 2001 Artists Rights Society (ARS), New York/ADAGP, Paris
Villon: © 2001 Artists Rights Society (ARS), New York/ADAGP, Paris
Vuillard: © 2001 Artists Rights Society (ARS), New York/ADAGP, Paris
Vlaminck: © 2001 Artists Rights Society (ARS), New York/ADAGP, Paris
Wilson: Courtesy Byrd Hoffman Water Mill Foundation
Wood: © Estate of Grant Wood/Licensed by VAGA, New York, NY
Youngerman: © Jack Youngerman/Licensed by VAGA, New York, NY